Pacific
Island Style

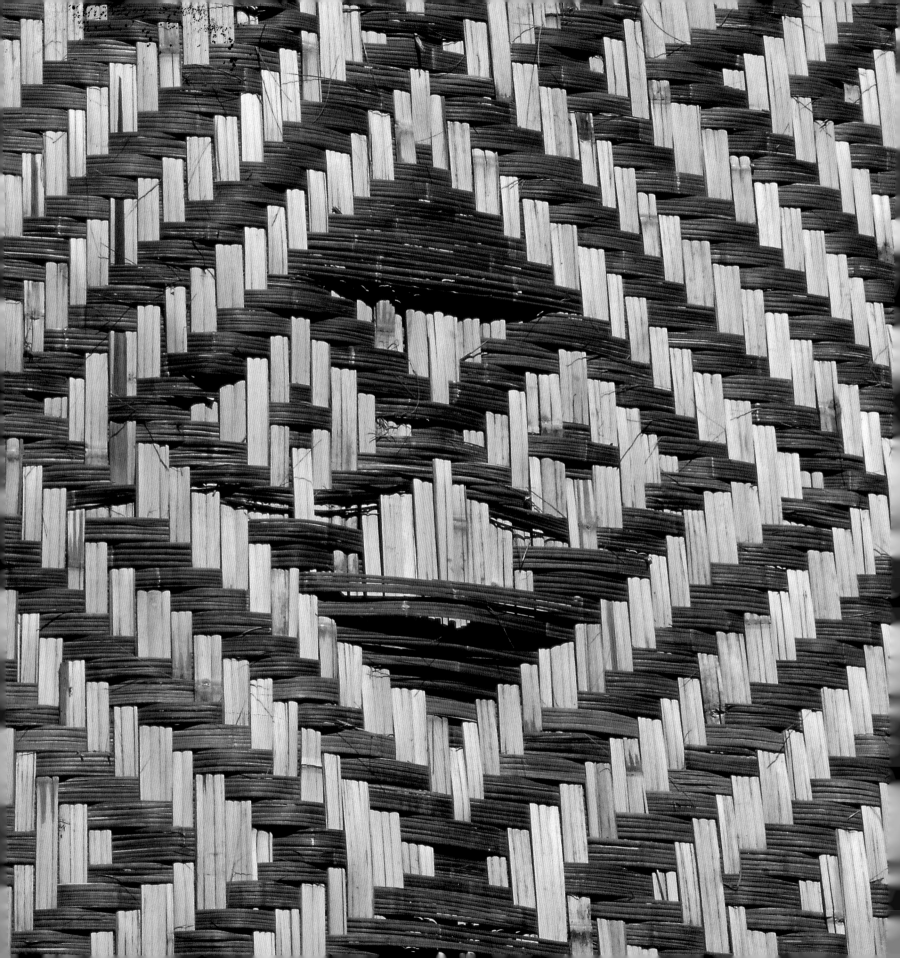

Pacific
Island Style

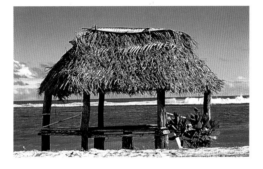

Glenn Jowitt and Peter Shaw

Thames & Hudson

To my mother
and all my friends in the Pacific

First published in the United Kingdom in 1999 by Thames & Hudson Ltd,
181A High Holborn, London WC1V 7QX

First published in hardcover in the United States of America in 2000 by
Thames & Hudson Inc., 500 Fifth Avenue, New York, New York 10110

British Library Cataloguing-in-Publication Data
A catalogue record for this book is available from the British Library

Library of Congress Catalog Card Number 99-65178
ISBN 0-500-23772-7

Printed and bound in China by Everbest Printing Co.

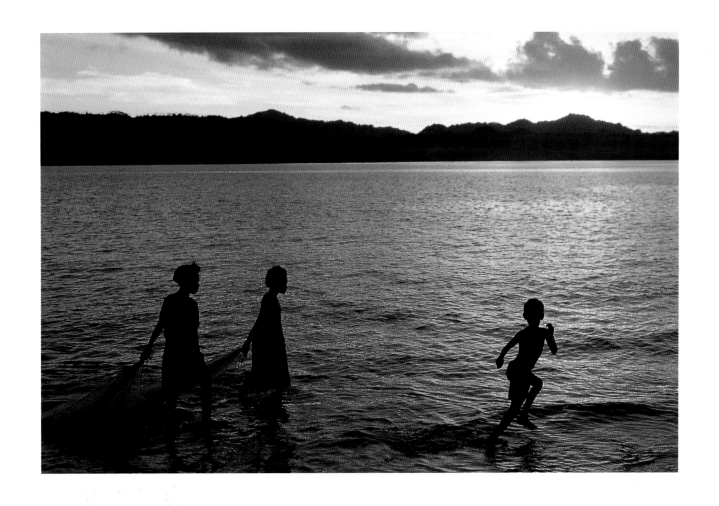

The first experience can never be repeated.
The first love, the first sunrise, the first
South Sea Island, are memories apart...

R.L. STEVENSON

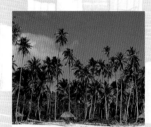

CONTENTS

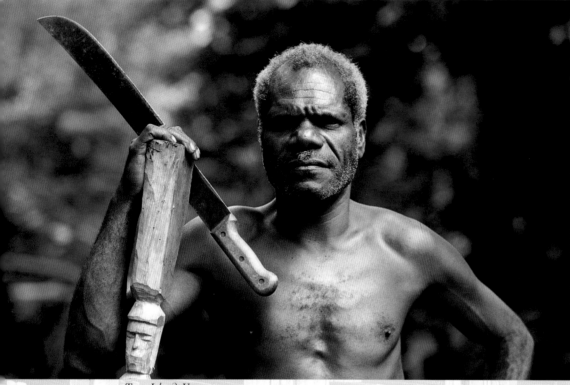

Tana Island, Vanuatu

Tongatapu, Tonga

Apia, Samoa

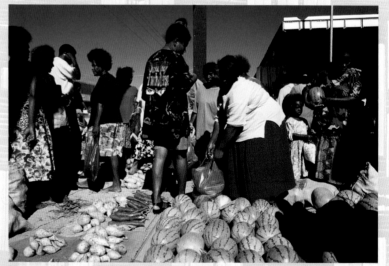

Honiara, Solomon Islands

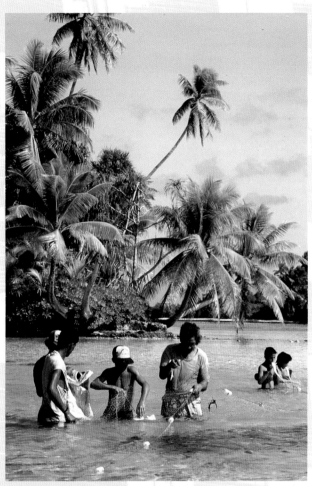

Rakahanga, Cook Islands

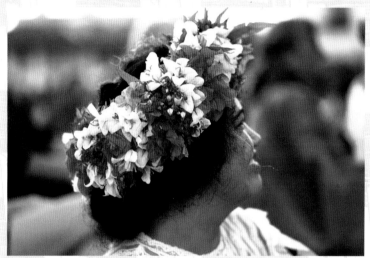

Tahiti, French Polynesia

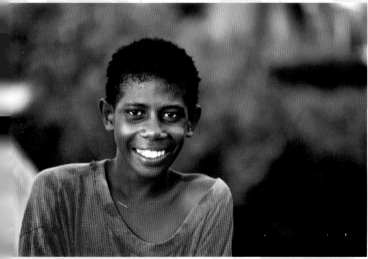

Espiritu Santo, Vanuatu

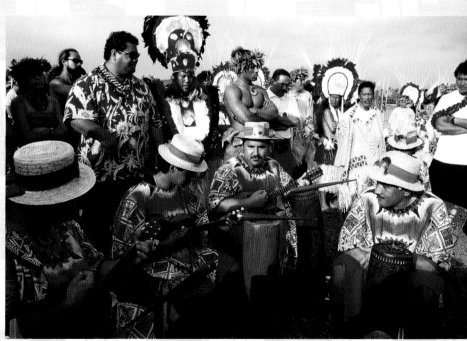

Tahitian dancers, Apia, Samoa

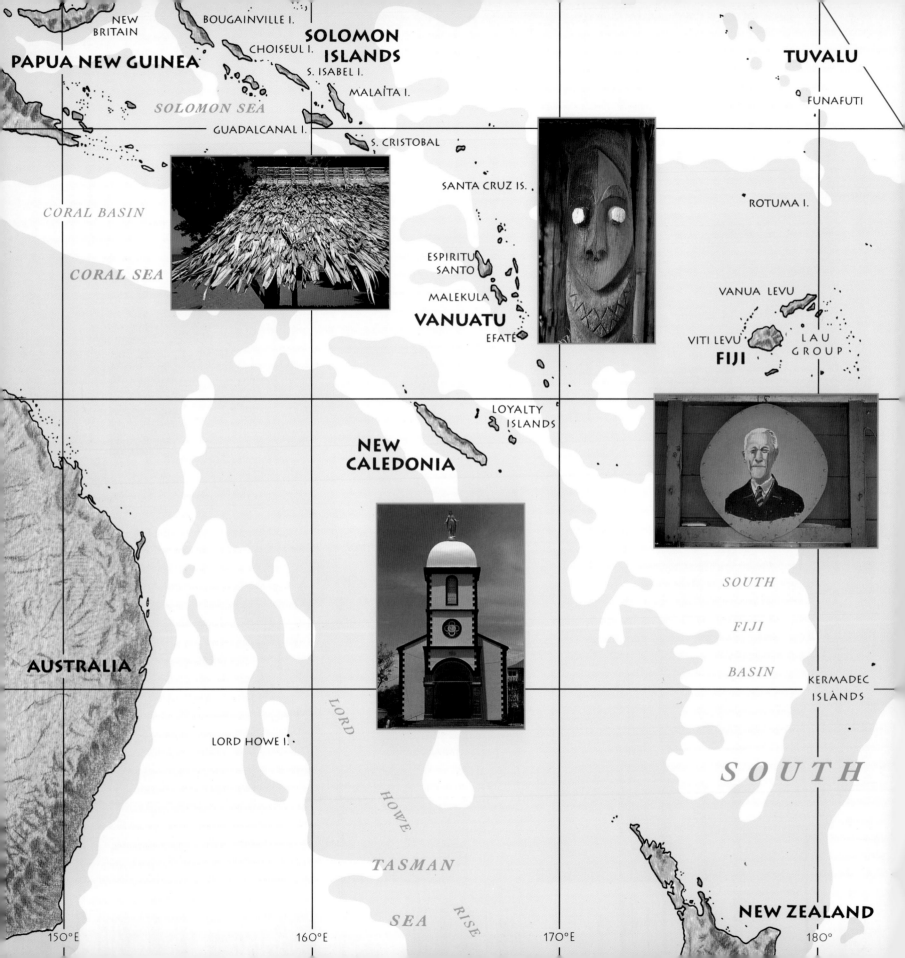

PAPUA NEW GUINEA

NEW
BRITAIN

BOUGAINVILLE I.

CHOISEUL I.

SOLOMON
ISLANDS

S. ISABEL I.

MALAÏTA I.

SOLOMON SEA

GUADALCANAL I.

S. CRISTOBAL

CORAL BASIN

CORAL SEA

SANTA CRUZ IS.

ESPIRITU
SANTO

MALEKULA

VANUATU

EFATÉ

TUVALU

FUNAFUTI

ROTUMA I.

VANUA LEVU

VITI LEVU

FIJI

LAU
GROUP

LOYALTY
ISLANDS

NEW
CALEDONIA

AUSTRALIA

LORD HOWE I.

LORD

HOWE

RISE

TASMAN

SEA

SOUTH

FIJI

BASIN

KERMADEC
ISLÀNDS

SOUTH

NEW ZEALAND

150°E 160°E 170°E 180°

MARQUESAS

CAROLINE I.

10°S

NORTHERN COOK ISLANDS

TUAMOTU ARCHIPELAGO

SAVAI'I

UPOLU

AMERICAN SAMOA

SAMOA

SAMOA BASIN

MOOREA

TAHITI

FRENCH

NIUE

COOK ISLANDS

20°S

HA'APAI GROUP

POLYNESIA

TONGA

TONGATAPU

RAROTONGA

30°S

PACIFIC OCEAN

SOUTHWEST PACIFIC BASIN

170°W

160°W

150°W

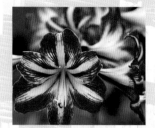

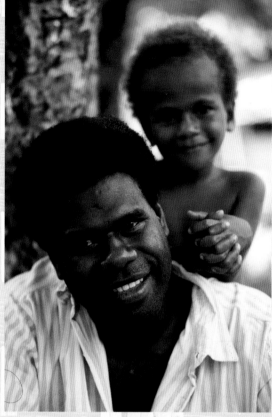

The islands with which this book is concerned are all located within what is loosely termed "Oceania". Common to them all is the surrounding Pacific Ocean. It dominates the rhythm of people's lives, and determines the climate, the flora and fauna as well as that communality of life which is so characteristic of the South Pacific.

Because of its colonisation during the nineteenth century and our familiarity with the often bitter struggles for independence which it occasioned in the twentieth, the fact that Oceania had a pre-colonial history can be all too easily overlooked. In fact it was the last area on earth to be settled, the last to be "discovered" by Europeans and the last to be colonised and de-colonised.

Each of our eight territories had distinctive languages and cultures thousands of years before Europeans ever set foot on their shores. Yet the history of the last one hundred years is the record of the way in which these cultures changed as the result of European influence. In many cases traditional practices existed alongside newly introduced ones; in others they completely died out; in still others it was European culture which adapted.

The imposition of colonial status on these islands was often highly damaging. To begin with, almost all were given new names by their English, French, German or Dutch

Tahiti,
French Polynesia

Espiritu Santo,
Vanuatu

INTRODUCTION

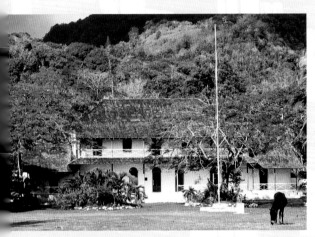

Makea Palace, Avarua,
Cook Islands

masters. In his quaintly titled volume *Peeps at Many Lands: Oceania* Frank Fox in 1912 drew attention to the "sterility of invention" which the newly arrived Europeans showed in naming the various islands of the South Pacific.

Most of the titles are utterly inappropriate, especially those in which the prefix "New" tells of a lack of imagination falling back on the device of using again some name of the Old World. "New Caledonia" is not in the least suggestive of Scotland. "New Ireland" is a coral island just on the equator. In disgust at such a bad English name, the Germans, having entered into possession, called it "New Mecklenburg." The English called another island nearby "New Britain," because in shape, size, foliage, climate and inhabitants it was as utterly unlike Britain as possible. The Germans succeeding to control, called it "New Pommern," for similar reasons. The "New Hebrides," "New Guinea," "New Zealand," are equally silly names, telling at once of a vandal desire to destroy the old and beautiful native names and of a poverty of resource to find even tolerable substitutes. But ugly names cannot destroy the beauty of these Isles of Paradise.

Noumea,
New Caledonia

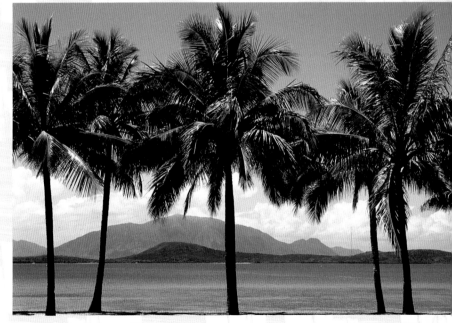

It was the beauty and magnificence of these islands which struck all who came. The most eloquent testimony to this can be found in Robert Louis Stevenson's 1896 book *In the South Seas* in which he records his first Oceanic

landfall at dawn on 28 July 1888 in the Marquesas Islands of French Polynesia.

The first experience can never be repeated. The first love, the first sunrise, the first South Sea Island, are memories apart, and touched the virginity of sense.... Not one soul aboard the Casco had set foot upon the islands, or knew, except by accident, one word of any of the island tongues; and it was with something of the same anxious pleasure as thrilled the bosom of discoverers that we drew near these problematic shores. The land heaved up in peaks and rising vales; it fell in cliffs and buttresses; its colour ran through fifty modulations in a scale of pearl and rose and olive; and it was crowned above by opalescent clouds. The suffusion of vague hues deceived the eye; the shadows of clouds were confounded with the articulations of the mountain; and the isle and its unsubstantial canopy rose and shimmered before us like a single mass.... On our port beam we might hear the explosions of surf; a few birds flew fishing under the prow; there was no other sound or mark of life, whether of man or beast, in all that quarter of the island.... The coco-palm, that giraffe of vegetables, so graceful, so ungainly, to the European eye so foreign, was seen to be crowding on the beach, and climbing and fringing the steep sides of the mountains. Rude and bare hills embraced the inlet upon either hand; it was enclosed to the landward by a bulk of shattered mountains. In every crevice of that barrier the forest harboured, roosting and nesting there like birds about a ruin; and far above, it greened and roughened the razor edges of the summit.... a bird sang on the hillside; the scent of the land and of a hundred fruits or flowers flowed forth to meet us...

*Moorea,
French Polynesia*

*Rarotonga,
Cook Islands*

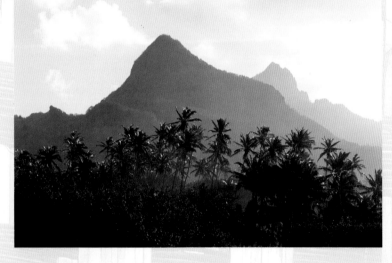

It is all still there, the colour, the sounds, the magnificence of the peaks, the clouds. Stevenson returned to the South Pacific and stayed, as did so many others, for the rest of his life. He lived at Vailima, inland from Apia on the island of Upolu in Samoa. His house was a large two-storied villa with extensive verandahs for shade and French doors to allow the breeze to cool the rooms inside. This is a distinctly European house, built to last.

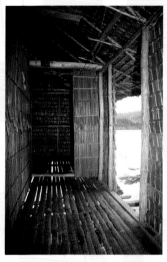

In contrast, the traditional Samoan *fale* is a quite different phenomenon in that it has no walls at all. In the hot climate of these South Pacific islands situated near the equator every dwelling bears witness to its builders' attempts to ensure that maximum advantage is taken of air movement. Houses are usually built near the sea, where the breezes are freshest. The New Caledonian *case*, the Tongan *fale tonga*, the *bure* of Fiji are all made from local materials treated in such a way as to make them light. Air can easily pass through walls made of woven bamboo or sago palm or thatched reeds supported on frames made of local hardwoods. Such houses are always vulnerable to hurricanes but once destroyed are immediately rebuilt.

Above: Marovo Lagoon, Solomon Islands

Left: Samoa

Below: (clockwise from far left), Fiji, Samoa, Samoa, Fiji, Fiji, Solomon Islands

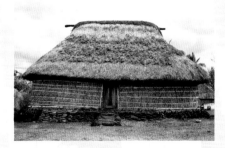

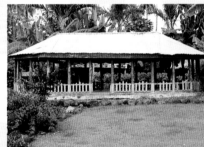

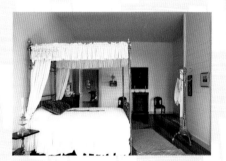

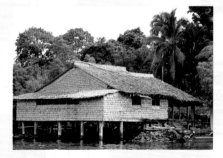

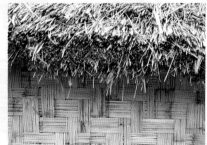

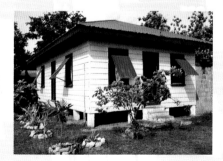

Throughout the South Pacific a different type of dwelling has come into being since the 1950s, the "hurricane house", so called because of its construction in more durable materials so that it will withstand the impact of the fierce winds and rain of the summer season. In Tonga the traditional dome-shaped roof of the *fale tonga* was originally made from coconut mats; now this has been replaced with corrugated iron which can be easily bent into the traditional shape. In Fiji, too, iron roofs are becoming more common, although there are villages where a deliberate decision has been made to retain the traditional pandanus leaf roofing and woven reed walls instead of using timber or concrete block and iron.

It is above all this adaptation of traditional Pacific Island culture in the colonial and post-colonial era that has so fascinated the New Zealand photographer Glenn Jowitt. He has had a continuous association with these islands since 1980 when he visited five of them to record material for an exhibition of his work held at the Auckland City Art Gallery. Later work with the

Above: Solomon Islands

Rarotonga, Cook Islands

New Zealand Geographic magazine deepened his knowledge and experience of the Pacific. So, too, did his acquaintance and friendship with Pacific Island families who had come to live in Auckland, New Zealand – the world's largest Polynesian city.

"In the very beginning, what drew me to the Pacific Island community in New Zealand was their colour sense, the way they dressed, the way they painted and furnished their houses – and their warmth towards a stranger," he recalls.

"I was introduced to the ceremonial presentation of *tivaevae* at a Cook Island wedding and was fascinated to see the way in which the past was so intimately knitted into the present lives of these people. Recording these things is an adventure. As an outsider looking into

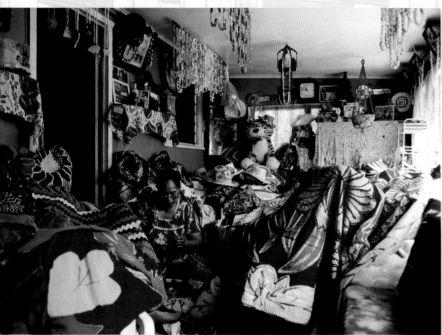

Cook Islands

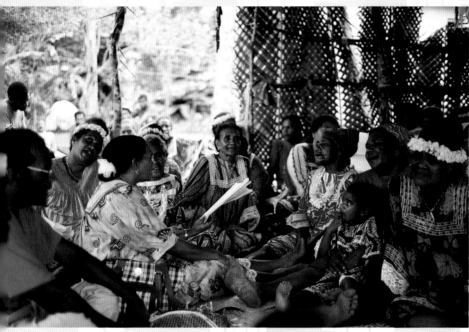

these cultures you are learning all the time so it is highly stimulating."

Jowitt's interest led him into an attempt to document these gradually changing Pacific Island cultural activities and processes in all their diversity. The task allowed him to express his enthusiasm for the turquoise and orange painted *whare* of the Cook Islands; for the carved house guards outside Fijian *bure* with their yellow flourescent plastic eyes instead of shell; for the many beautiful churches built from coral from the reef. This book is the record of the continuing story of Glenn Jowitt's involvement with Pacific Island culture.

Lifou, New Caledonia

Right: (clockwise from top left), Fiji, Fiji, New Caledonia, Cook Islands

Following spread: Noumea, New Caledonia

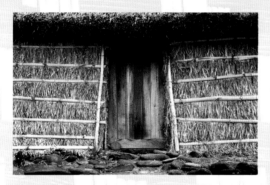

17

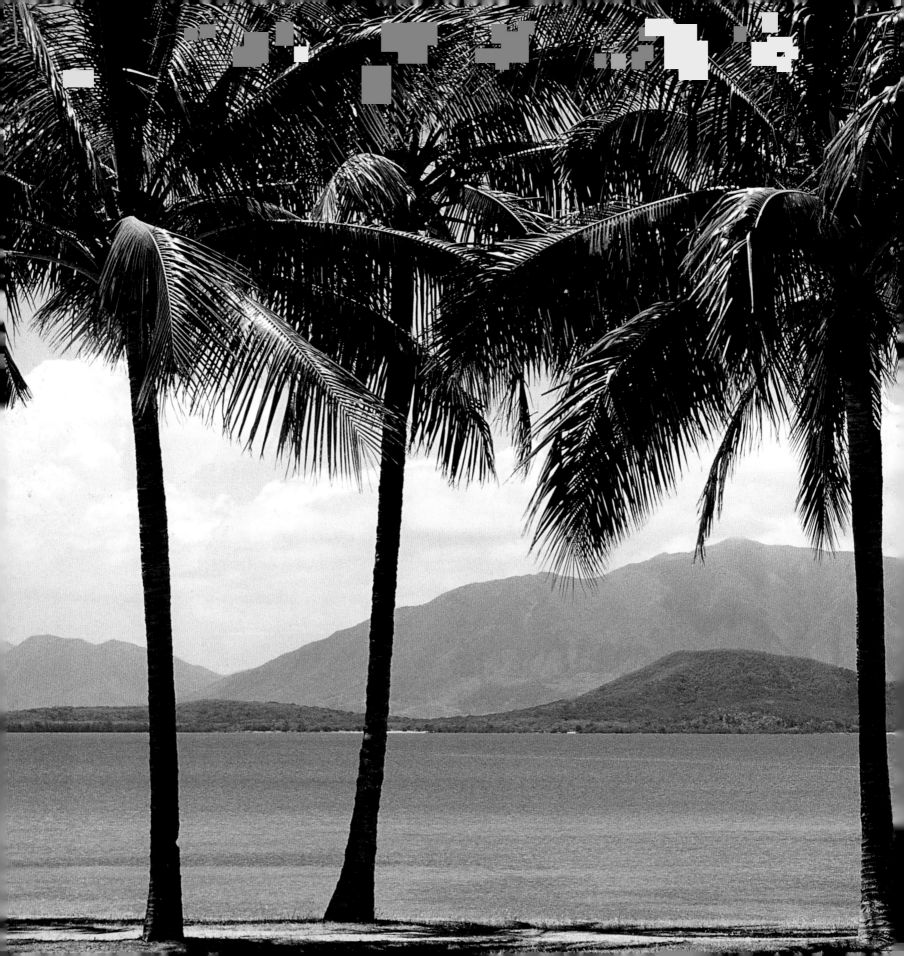

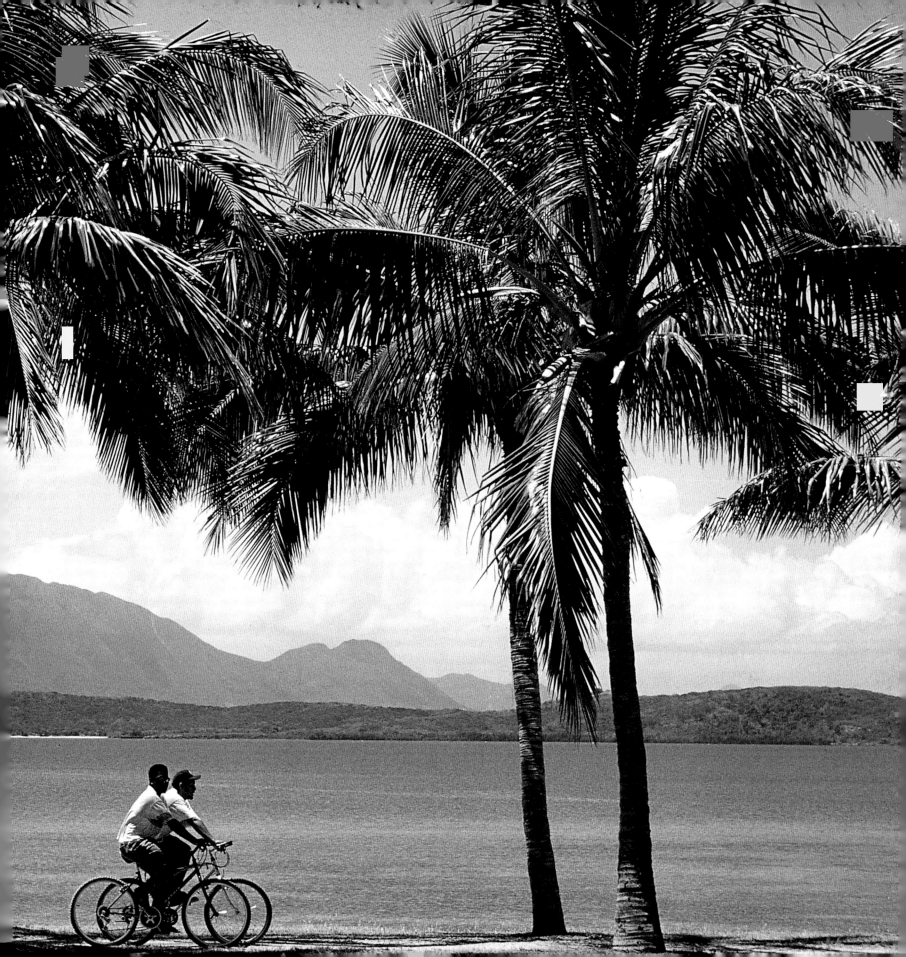

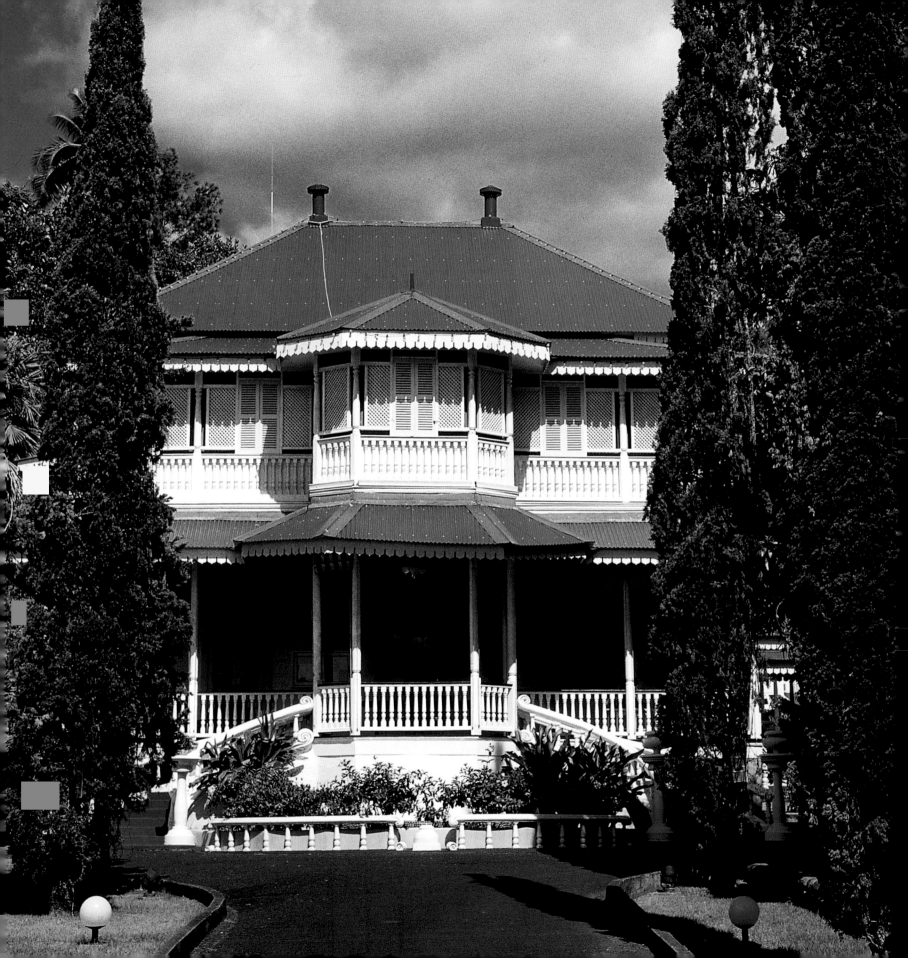

TAHITI

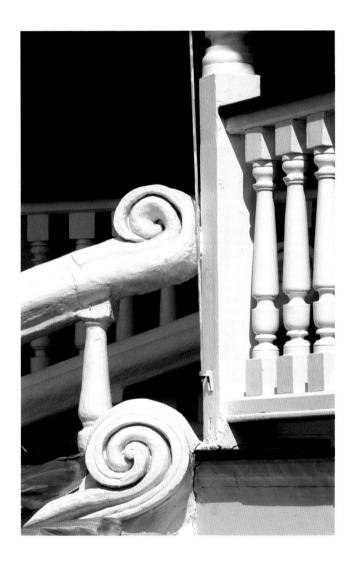

The island of Tahiti is one of 130 which make up French Polynesia. It was formed from two immense volcanic cones which provide a dramatic silhouette rising over two thousand metres above sea level. The lushly vegetated mountains, which drop abruptly into deep green valleys, are highly eroded and uninhabited. Settlement is clustered around the coastal strip which surrounds the island. Like its near neighbour Moorea, Tahiti is encircled with gleaming white sandy beaches. Both islands are protected from the impact of the sea's wilder moods by barrier reefs.

Now the Arue Town Hall on the eastern side of Tahiti, this magnificent two-storied home was originally designed and built by architect Victor Raoulx in 1892 as the home of the Austrian Consul. The timber is redwood imported from California. Elaborately decorated with shutters and balustrades, the verandah combines concrete with wood and is designed to provide shade and to cool the flow of air.

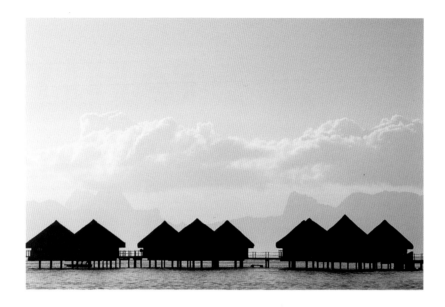

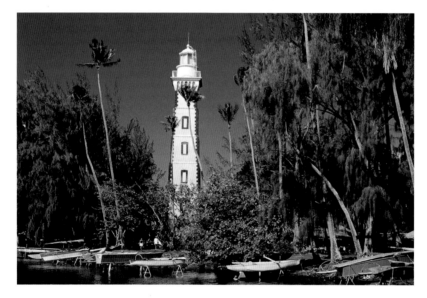

Tahitian life is focussed on the sea. *Whare* (houses) connected by bridges are built on stilts over the lagoon. At Point Venus on the eastern side of the island stands Tahiti's only lighthouse, built in 1867 by Robert Stevenson, the Scottish lighthouse engineer and father of Robert Louis Stevenson.

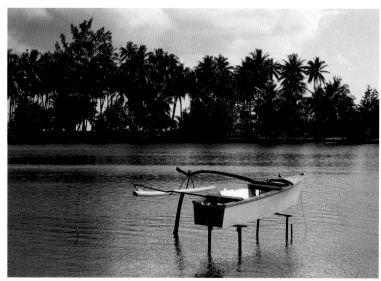

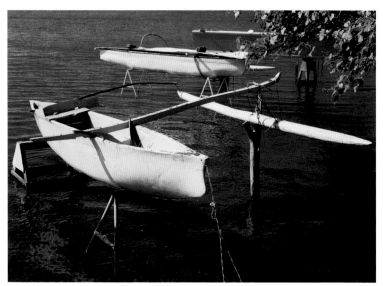

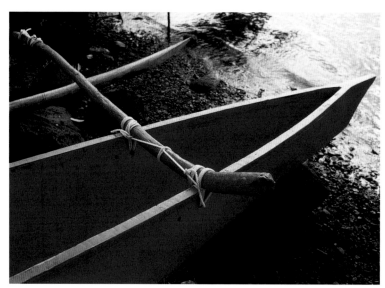

At some stage every Tahitian boy has a *va'ai* or canoe, and at lunch time on Fridays in Papeete, they take to the sea in anything from sleek racing canoes to simple dugouts, often practising for forthcoming races. Outriggers provide stability in choppy conditions.

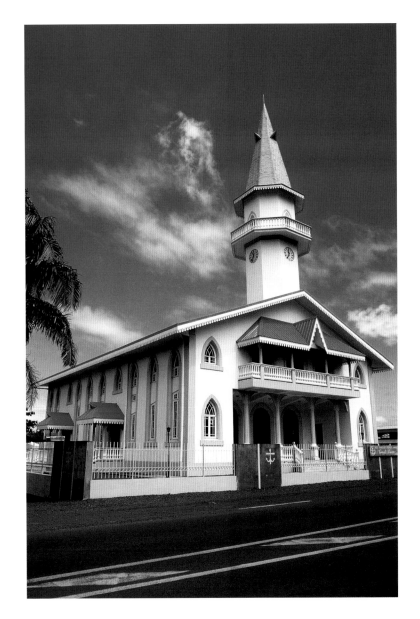

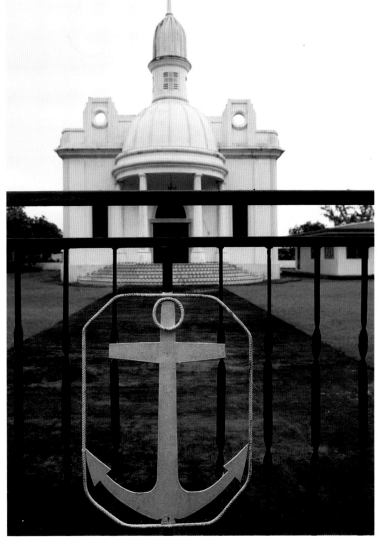

The Tione Temple of the Protestant Evangelican Church of Polynesia was built at Papara on Tahiti as recently as 1996. Its design combines traditional Gothic features with decorative details from large wooden houses built in the late nineteenth century.

The imposing evangelical church nearby at Mataiea dates from the 1890s and was built in a highly durable coral and limestone mixture. The anchor on the gate emphasises again the integral relationship between the sea and Tahitian culture.

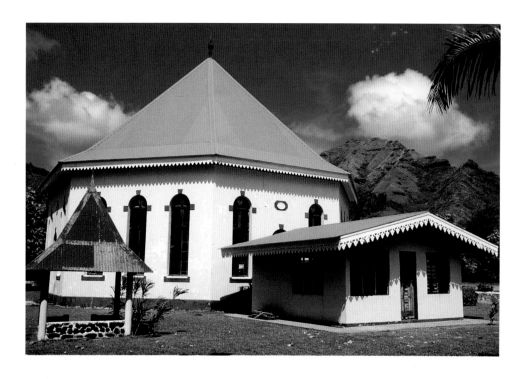

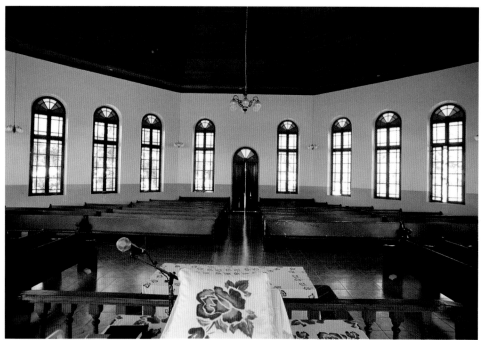

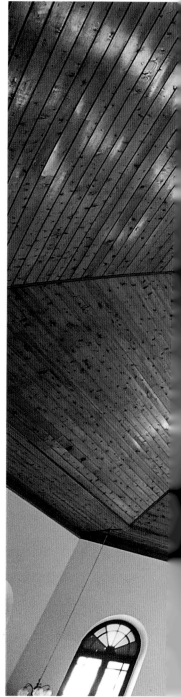

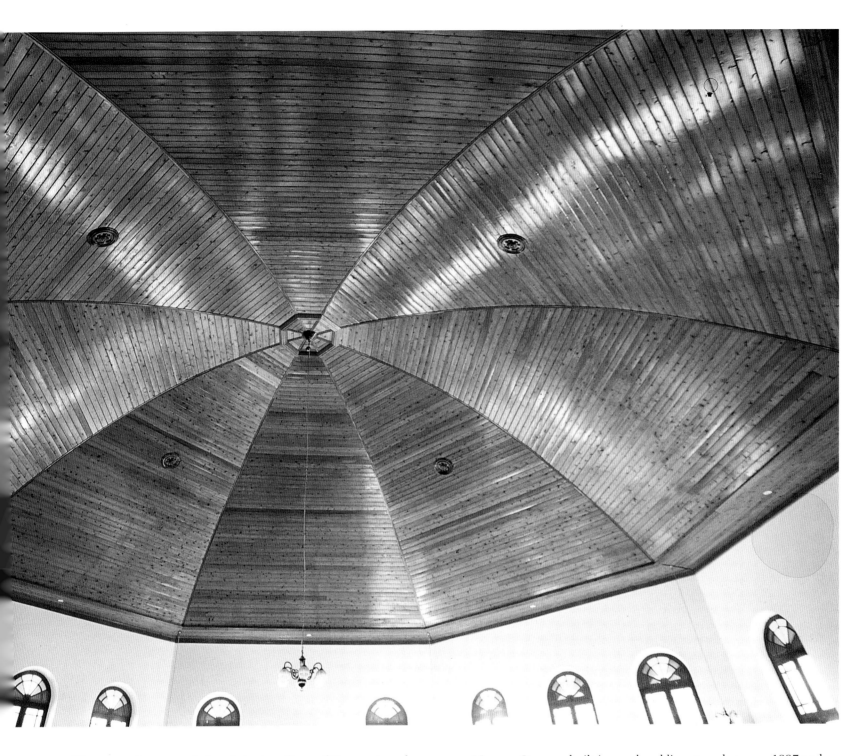

The unusual octagonal church in the village of Papetoai on the island of Moorea was built in 1822 making it the island's first protestant church. Its eight sides represent the eight tribes of Moorea. It was rebuilt in coral and limestone between 1887 and 1901. The two outbuildings are a sacred well and a kitchen used when catering for large occasions.

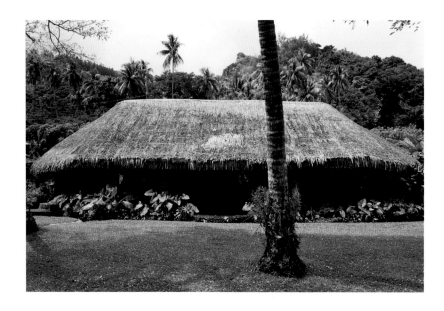

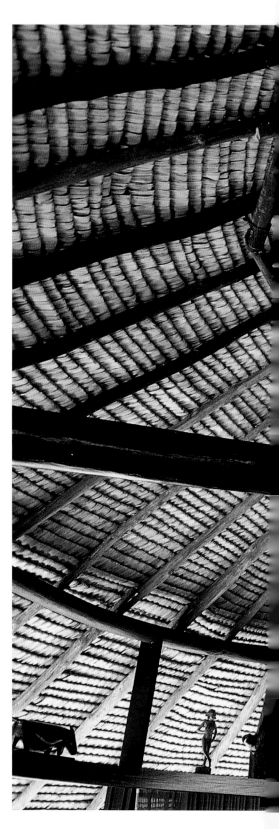

This private house was built in traditional style by the architect William Albert Robinson in 1935. Because the air temperature on Tahiti is so consistently warm there is no need to close off walls but rather to ensure that the flow of cooling air remains constant. The huge shading roof is made of the broad-leafed pandanus palm which is dried and then woven into large panels. These are fixed to rafters and posts made from the local ironwood or *tamanu*.

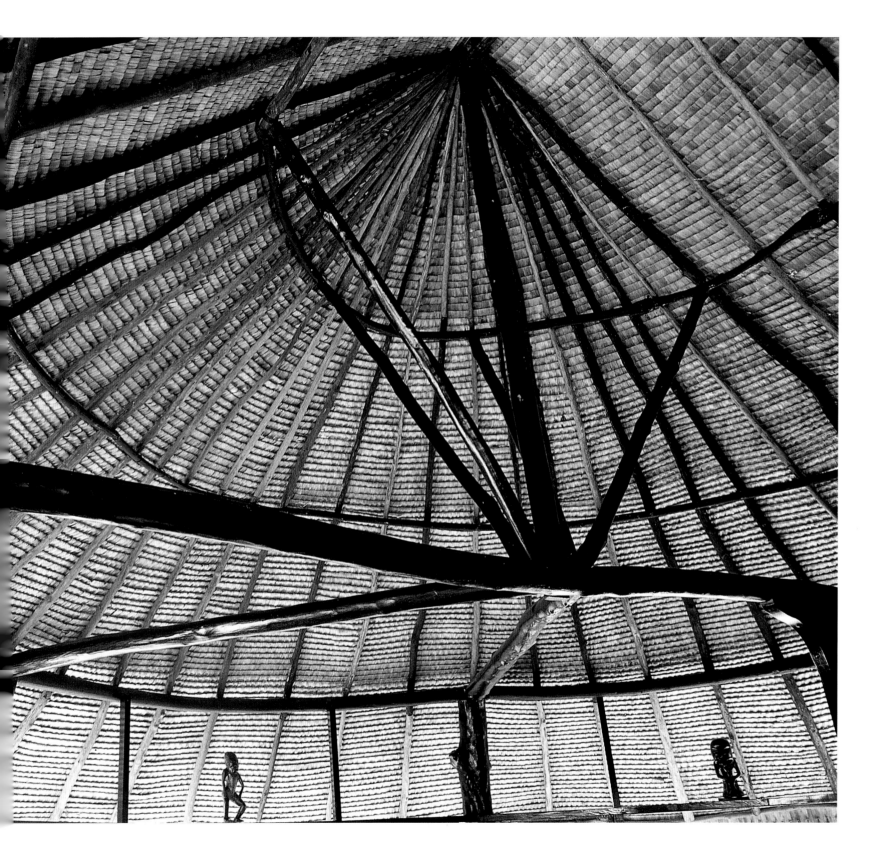

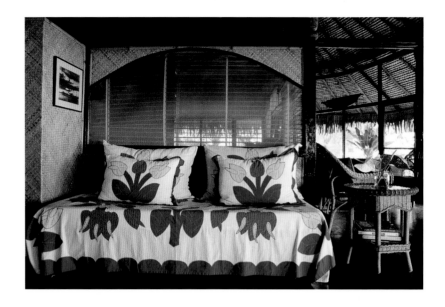

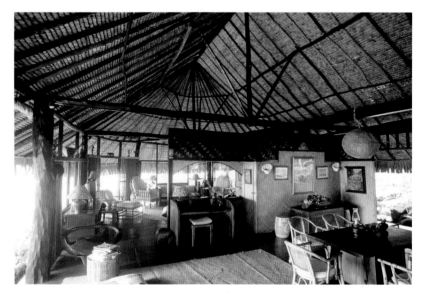

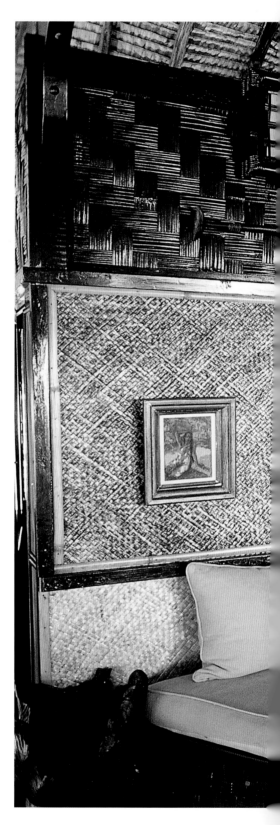

Interior walls are made of bamboo panels woven in a wide variety of colours and patterns. They are strategically placed to give privacy or to define the functions of specific rooms. There is a direct relationship with the surrounding garden because there are no exterior walls.

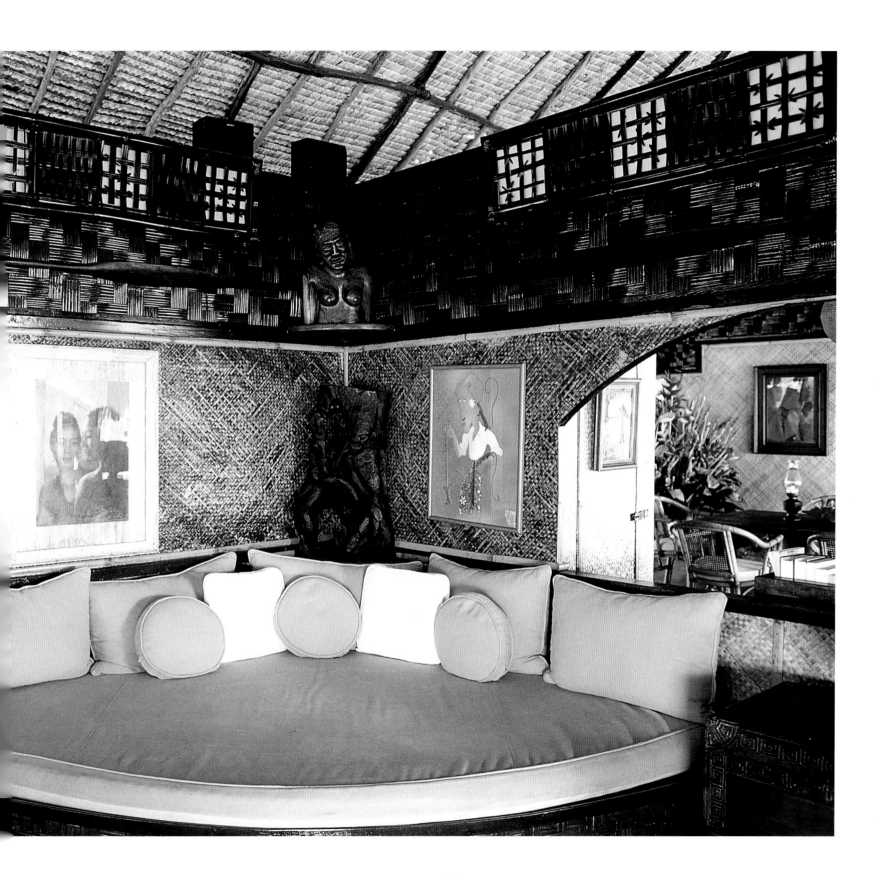

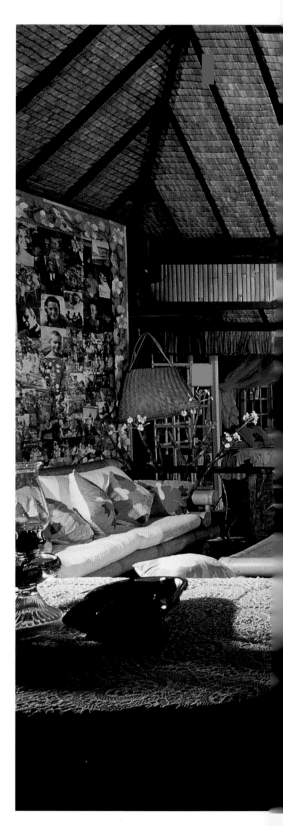

Situated at Punaauia on Tahiti, this 1960s private house was redesigned in 1996 by its owner, Janine Silvian, following a disastrous fire. It uses traditional design and materials, has the usual pandanus leaf roof supported on coconut palm posts and is almost entirely open planned.

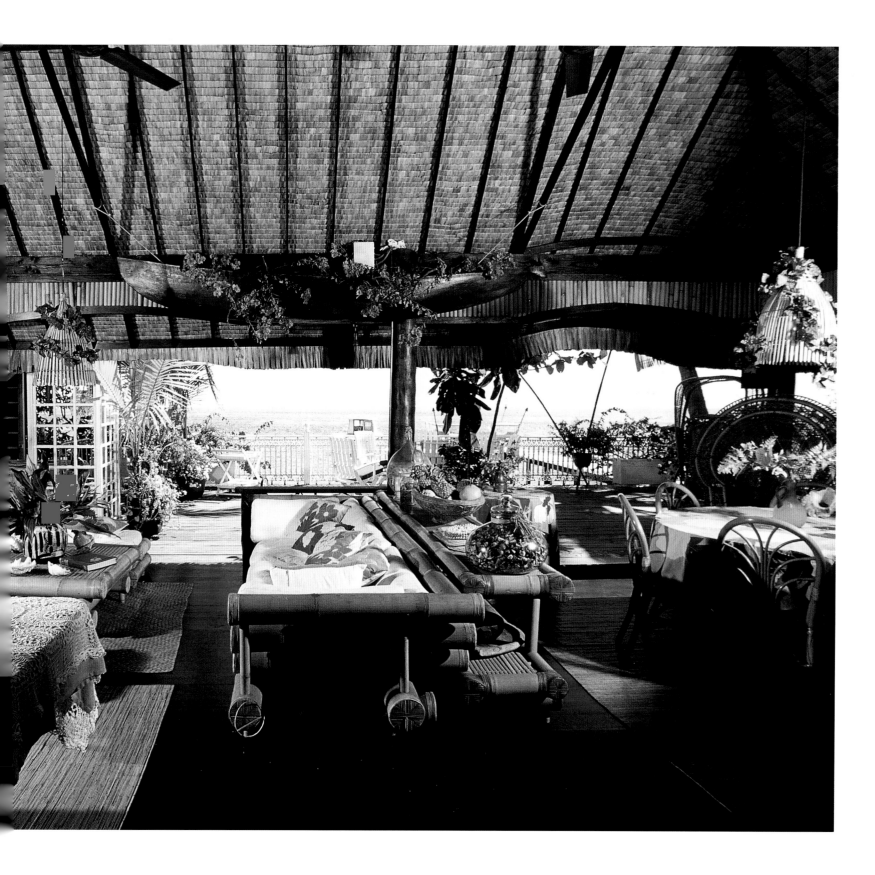

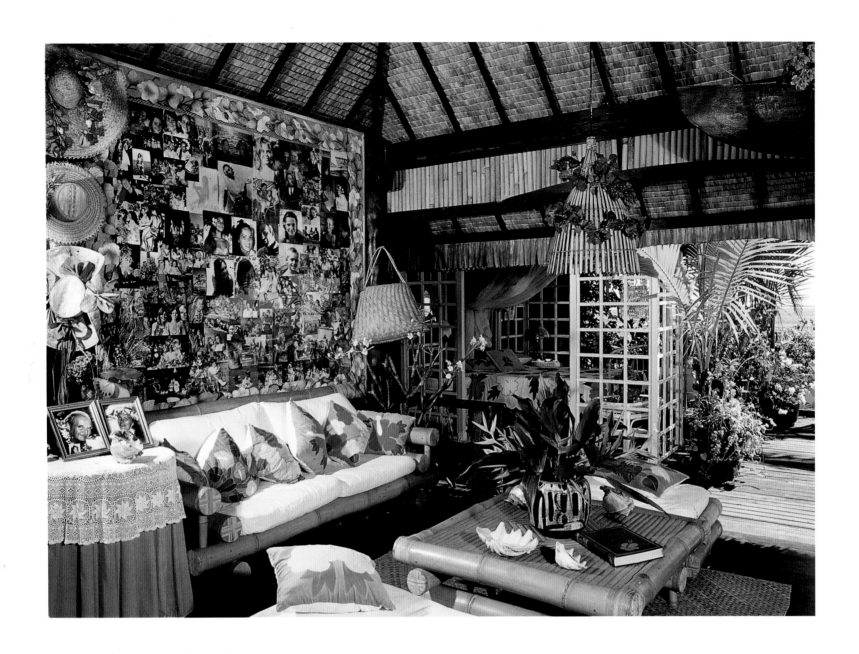

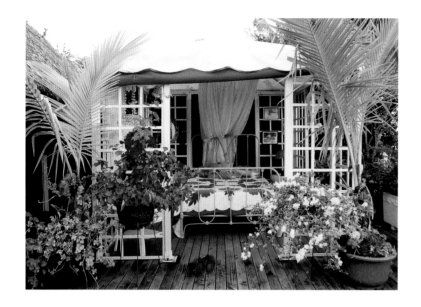

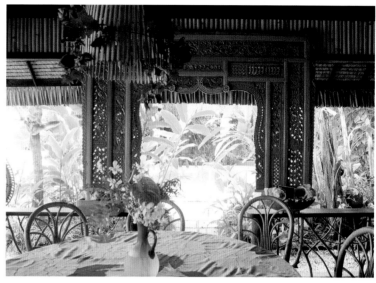

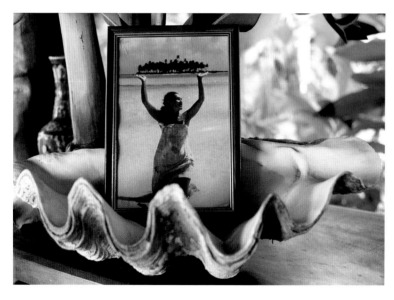

Although there are no walls, the panorama is broken up and the view cleverly framed by screens of various kinds. Silvian's photographer husband was responsible for the mural which forms a diary of their Gauguinesque life together. Her portrait is arrestingly displayed in an enormous clam shell. The whole house is alive with bright colour designed to form dramatic contrasts with the omnipresent blue of the sea and the lush green garden foliage.

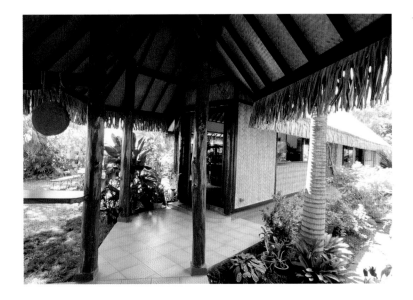
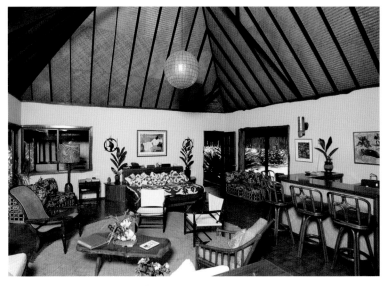
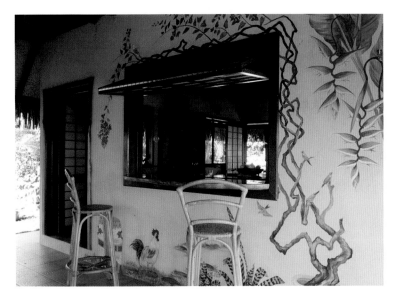

The Rutgers House combines both modern and traditional elements. It was originally built in 1954 but was blown down during a typhoon in 1983. Teak from the garden was used for new joinery and for the *whare* style roof. The solid walls supported on coconut palm posts are of plastered brick and decorated with painted murals of rural Tahitian life.

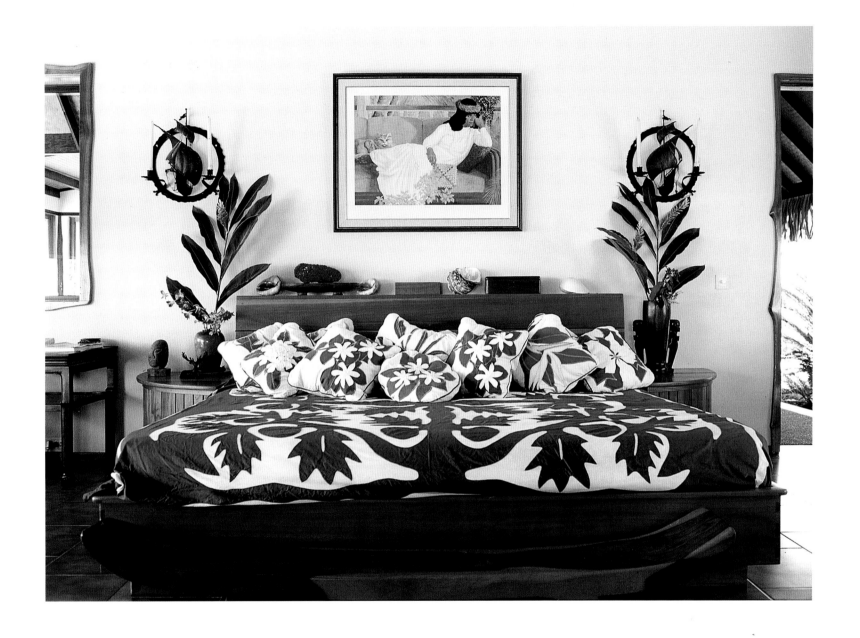

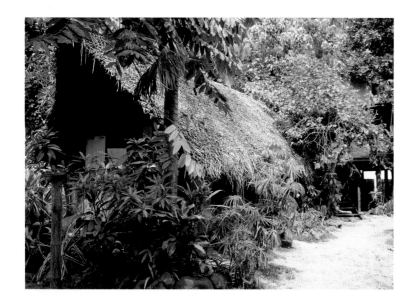

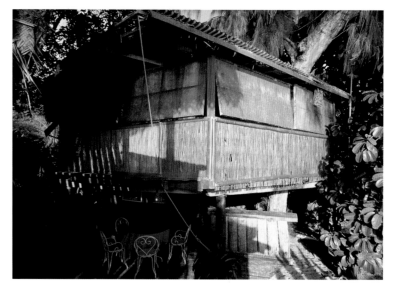

Part of this 1983 house at Punaauia, Tahiti was built in a tree whose branches were incorporated into the structure. The walls are bamboo panels which, although fragile, allow the air to breathe through the house. The roof of the cooking and dining area is made of woven coconut palm fronds with coconut log rafters and posts. The whole structure is nestled amid dense foliage which almost obscures its form.

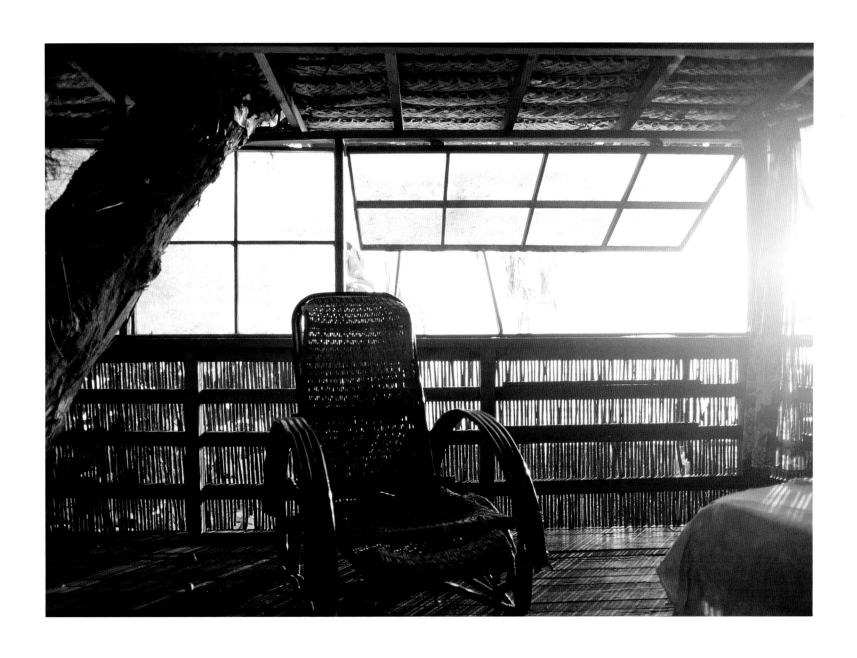

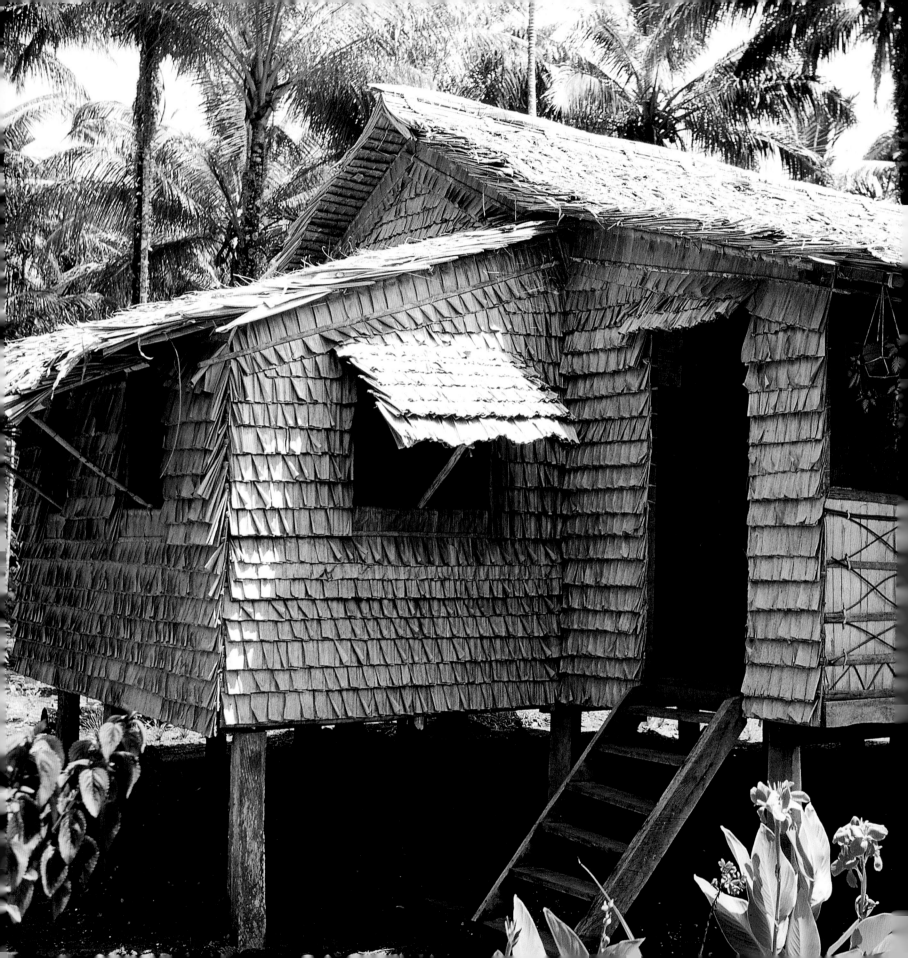

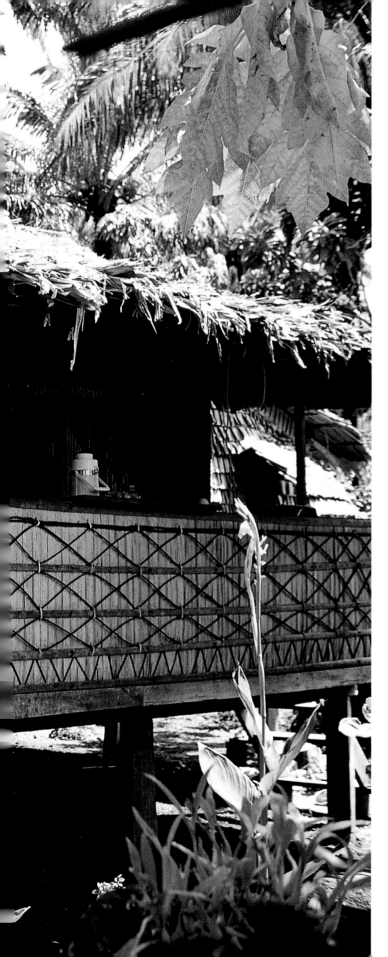

SOLOMON ISLANDS

The Solomon Islands take their modern name from the biblical king. Bestowed on them in 1586 by the Spanish explorer Alvaro de Mendana de Neira, the name expressed his fervent anticipation that the islands would yield up riches to rival King Solomon's. The islands were later explored by the British, Dutch and French. The Japanese invaded the British Solomon Islands Protectorate in 1942 and bitter fighting raged for three years, particularly on Guadalcanal. The protectorate was granted full independence from Britain in 1978 and remains a member of the Commonwealth.

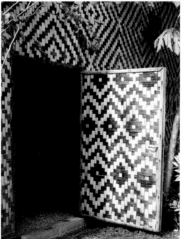

The Solomons consist of a double chain of rugged volcanic islands and coral atolls. The climate is equatorial with constant heat and humidity. Rain forest covers much of the mountainous land but there are also low settled plateaus and coastal terraces. Active volcanoes both on land and under the sea cause frequent earthquakes.

This sago palm house is situated on the Marovo Lagoon, the longest lagoon in the Southern Hemisphere.

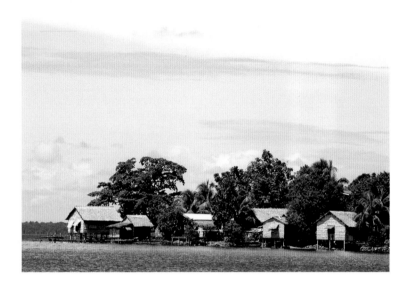

Pole houses dot the coastline around the Marovo Lagoon in the New Georgia Group. Situated close to the high water line, it is possible to fish from their verandahs or from nearby rocks. The sea breeze helps to keep the houses dry, essential in a climate where insects invade anything damp.

A yellow-fronted lori perches on the hat of a plantation worker.

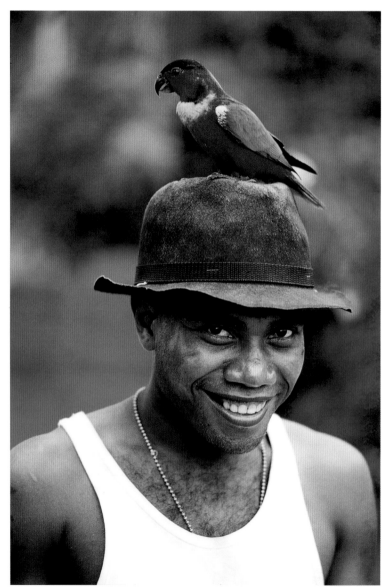

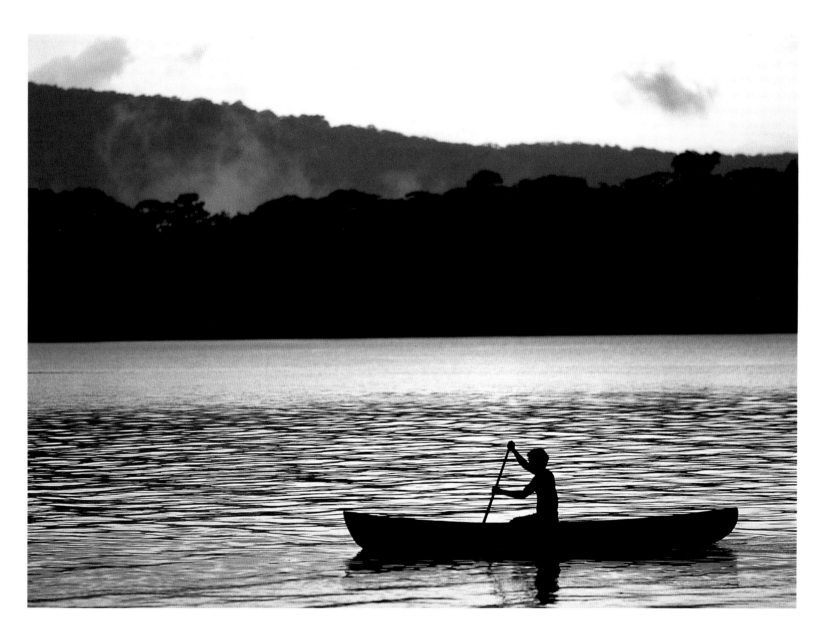

Because Marovo Lagoon is protected from ocean swells, dugout canoes have no need for outriggers.

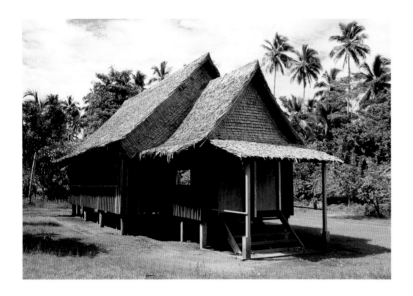

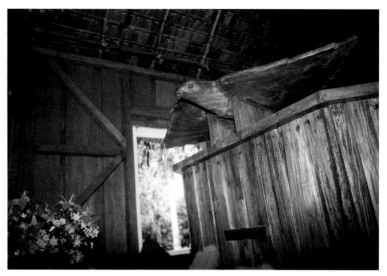

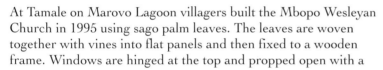

At Tamale on Marovo Lagoon villagers built the Mbopo Wesleyan Church in 1995 using sago palm leaves. The leaves are woven together with vines into flat panels and then fixed to a wooden frame. Windows are hinged at the top and propped open with a stake. Since air flow is essential, the houses are built on stilts. Melanesian roofs are invariably steeply pitched to cope with torrential rainfall. The eagle on the lectern is carved from *vasa*, a local hardwood which is a substitute for ebony.

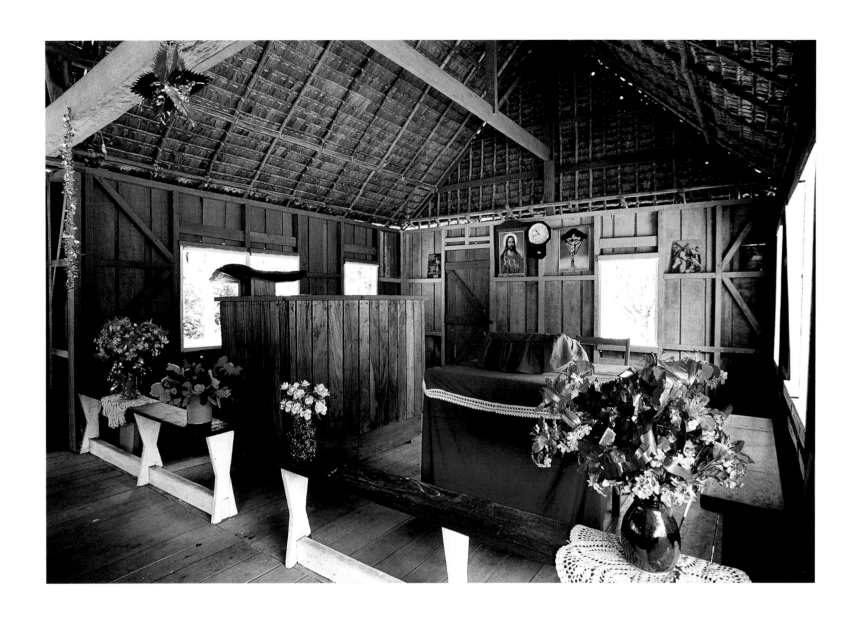

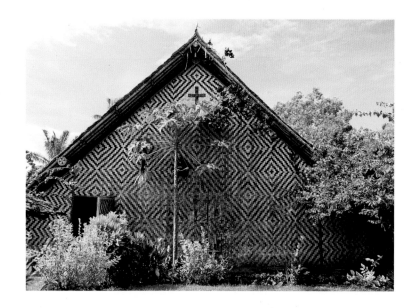

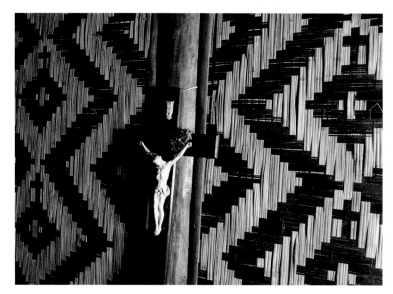

The walls of St Martin's Roman Catholic Church at Tenaru on Guadalcanal exhibit intricate woven patterns made from cane. Since Roman Catholic and Anglican missionaries arrived in the Solomons in the 1840s, Christianity has become a way of life for most inhabitants. In this church, crosses have been incorporated into the traditional patterns.

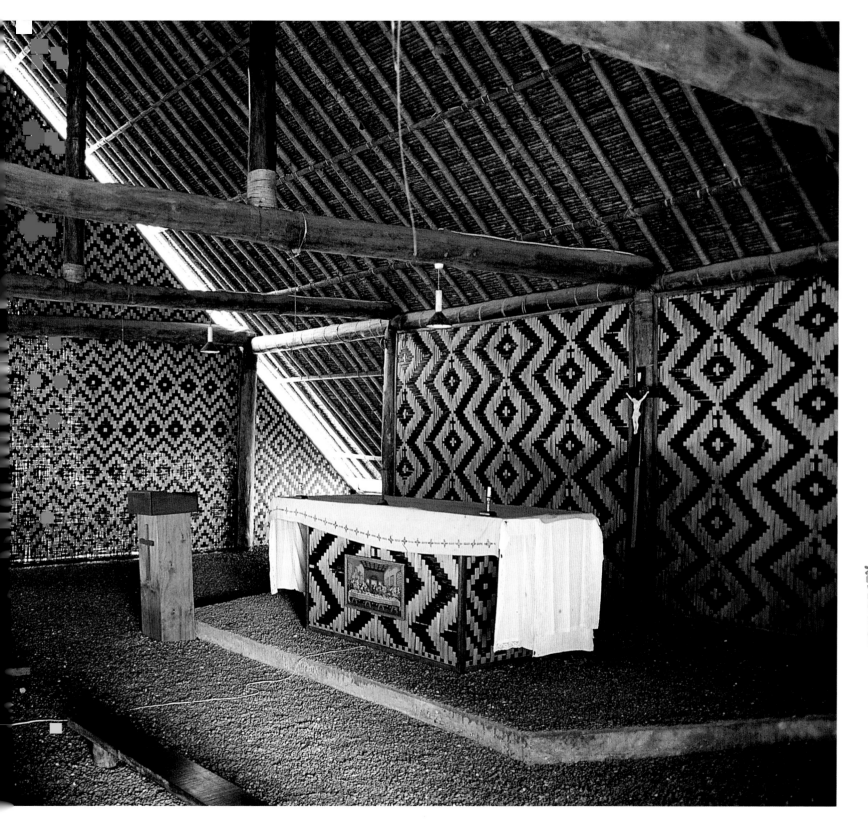

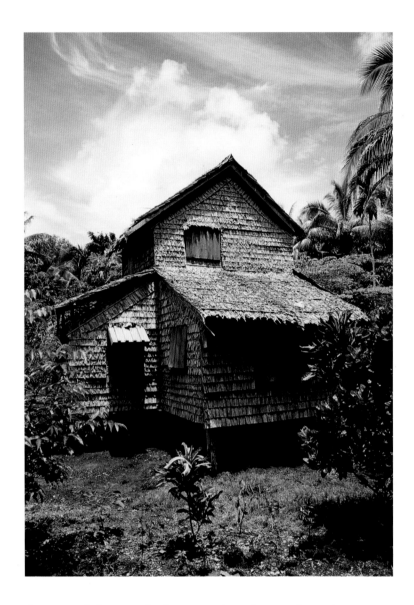

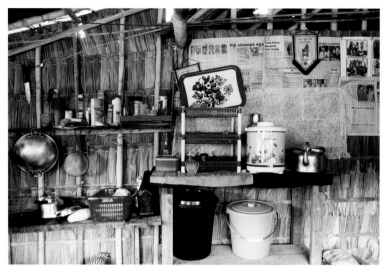

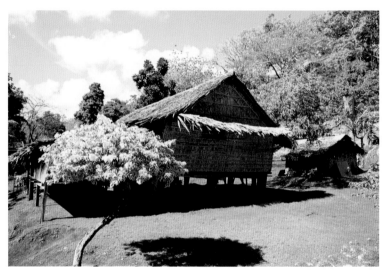

A two-storied sago palm house, such as the one above, is a comparative rarity. All houses, however, have wide overhanging eaves to provide shade. They are built above the ground because the water level can rise dramatically in tropical downpours and lagoons can suddenly fill with water.

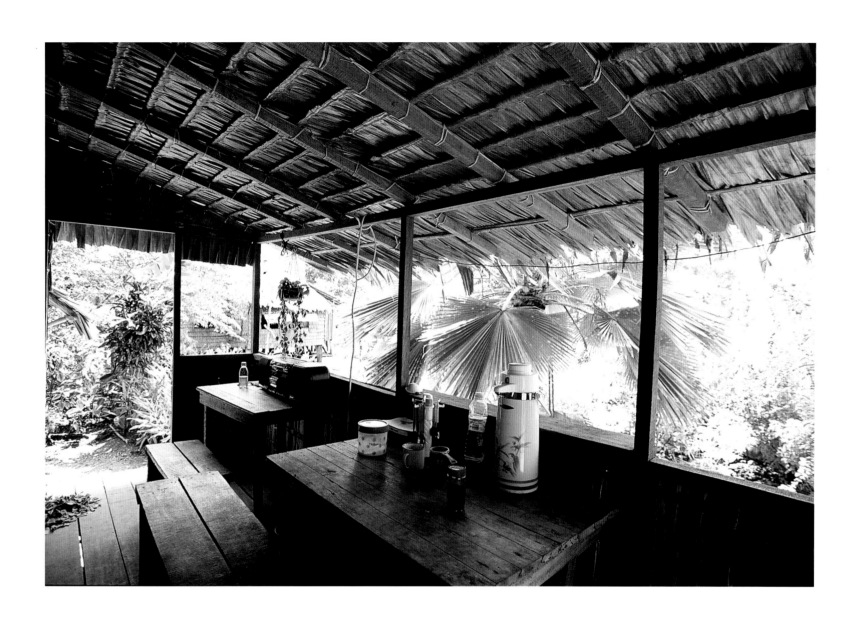

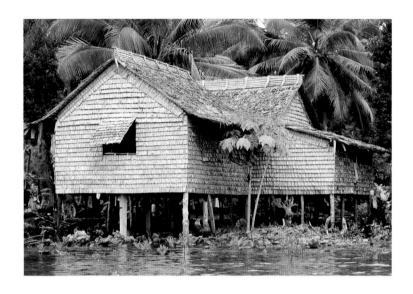

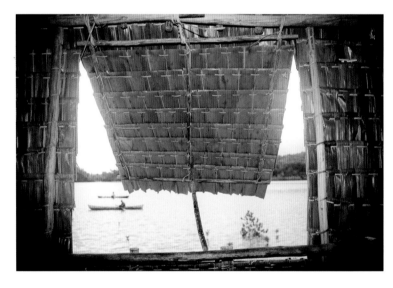

A sago palm house with a classic top-hinged window.

(Opposite) Mosquito nets are vital in sleeping rooms such as this. The wooden joinery around the window is a sign of European influence on traditional building practices.

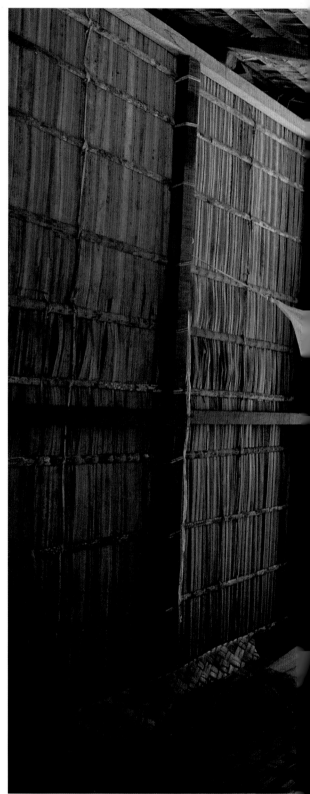

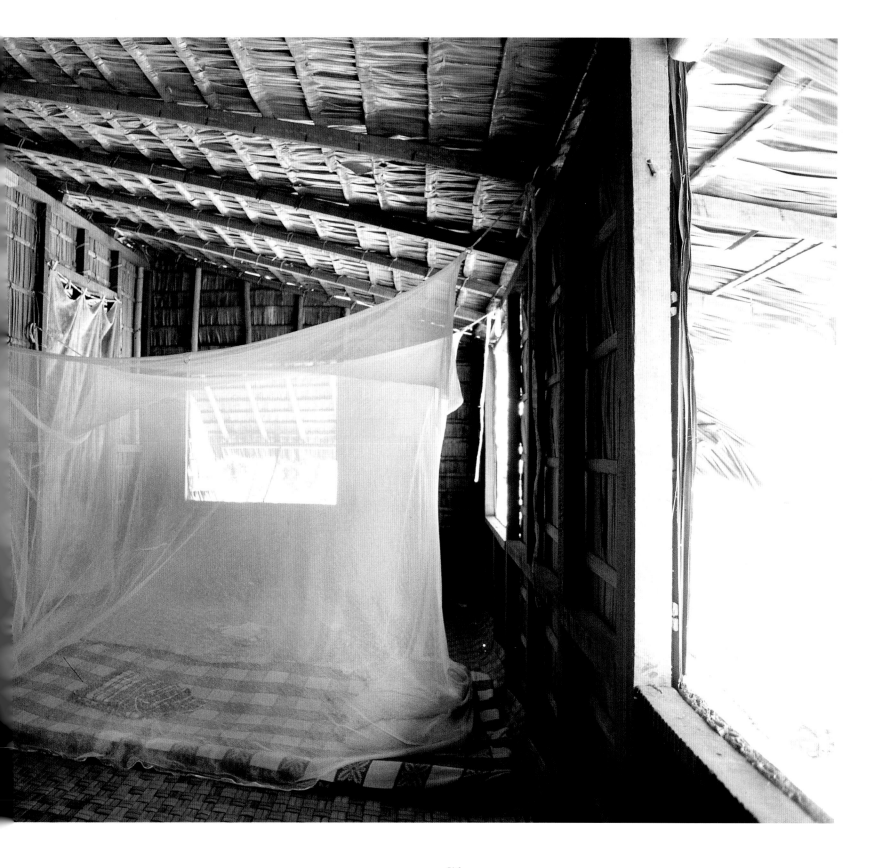

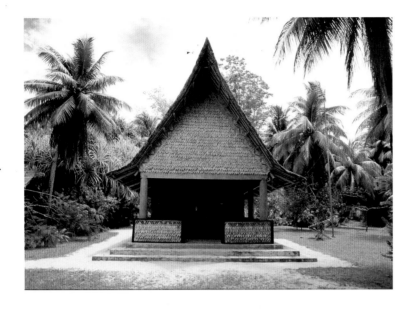

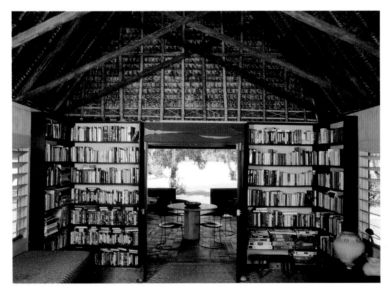

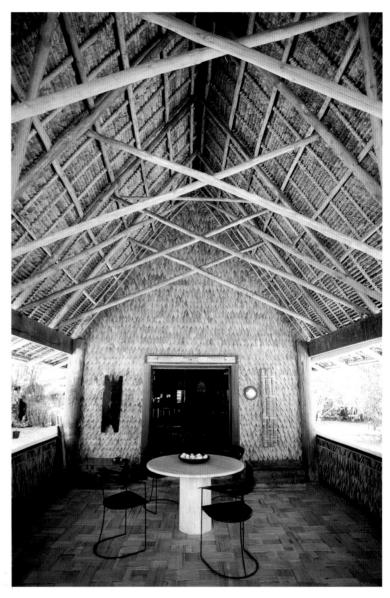

This private house on the island of Tavanipupu combines Melanesian and European styles. The floor is woven bamboo, the walls and roof sago palm, and the post and beam supports are made with a local hardwood. The design is far from traditional and interiors are furnished with some classic lightweight pieces which have proved appropriate in the hot climate.

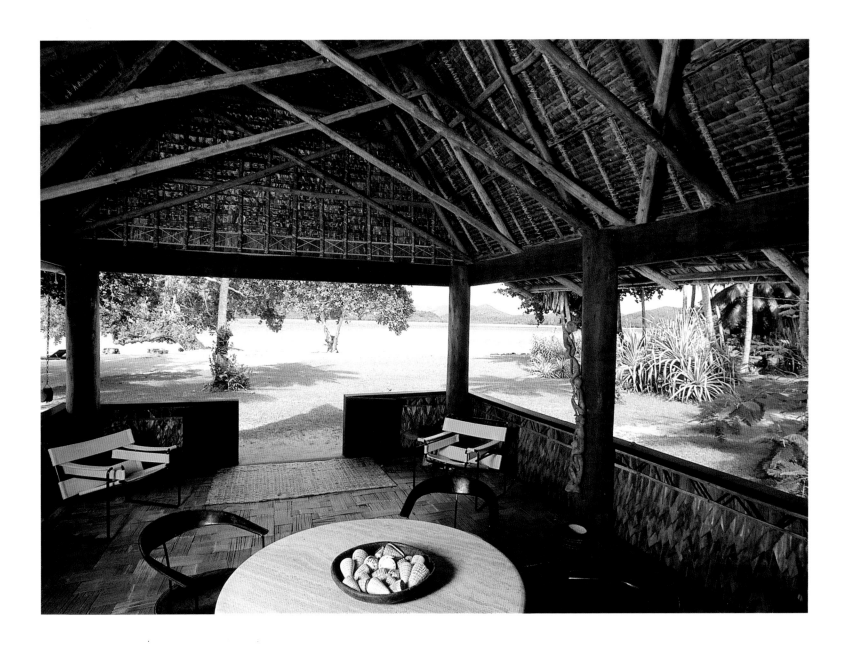

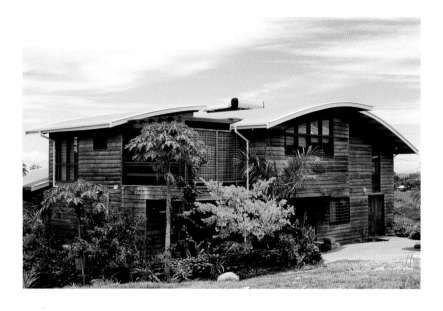

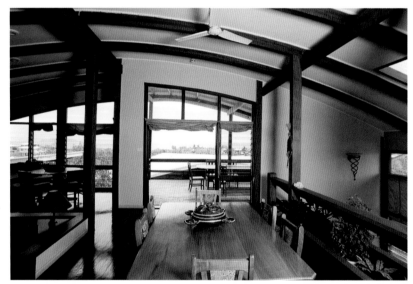

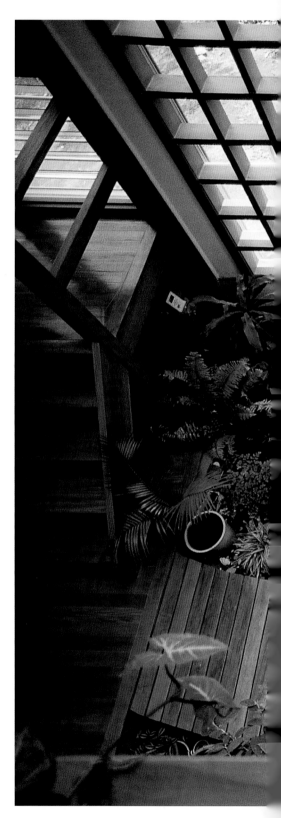

When ex-Chicago architect Don Boykin moved to Honiara, the capital of the Solomons, situated on the island of Guadalcanal, he designed contemporary houses using local timbers, wherever possible opening them up to their surroundings. Sometimes, fine mesh was used instead of glass in this hilltop house, catching cooling draughts rising from the sea below and allowing rain to water the plant-filled entranceway .

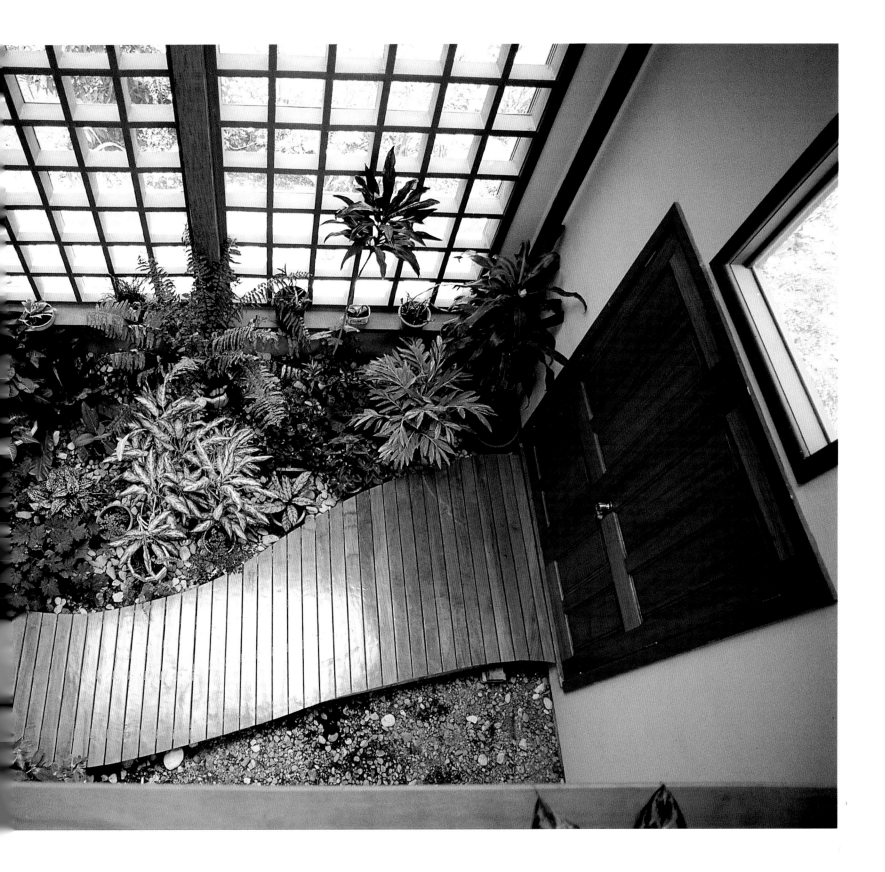

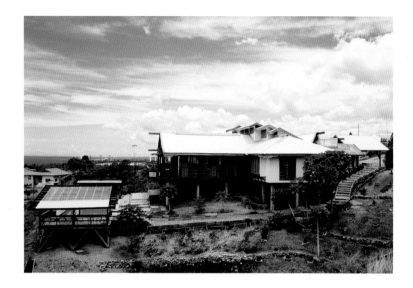

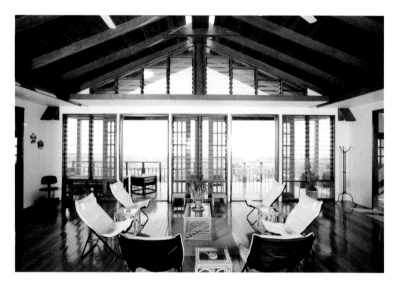

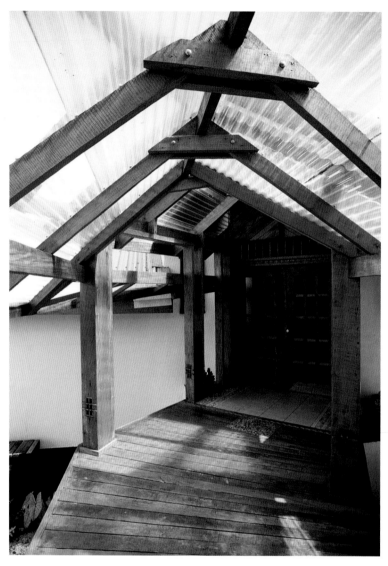

Another house by Don Boykin sited on the hills above Honiara. This one, built on poles, maximises every opportunity for the flow of air by using fine mesh instead of glass where possible, and making extensive use of pergolas and louvred windows which can be altered to control air direction. In the distance is the island of Savo, scene of major battles in World War II.

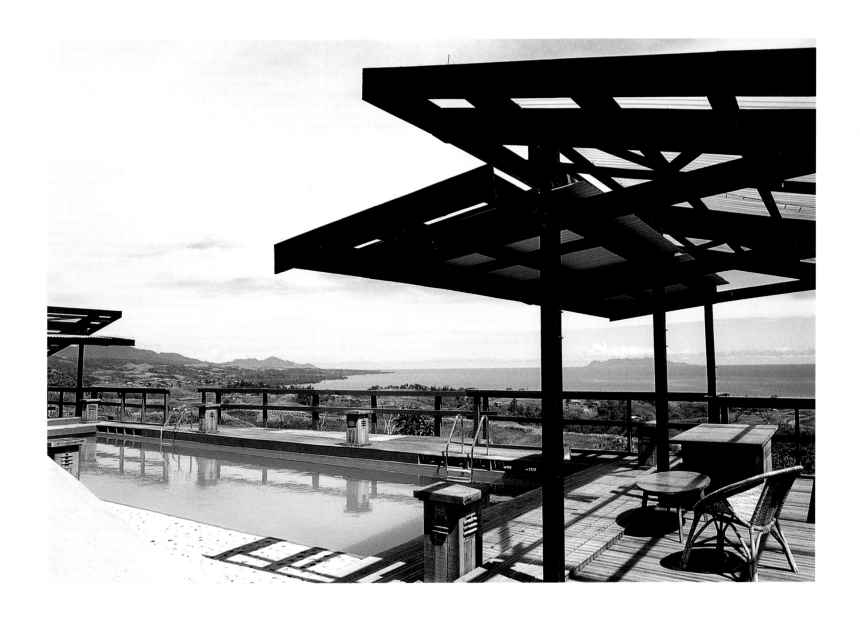

COOK ISLANDS

The Cook Islands are only fifteen in number but they are dispersed over 2.2 million square kilometres of the Pacific. Rarotonga is a high volcanic island like Tahiti, its central heights invariably hung with rain clouds while the coasts are sunny. Aitutaki is a volcanic island surrounded with an atoll-like barrier reef; other islands have rolling hills; Mauke and Mitiaro are flat; and Manihiki, Rakahanga and Penrhyn are coral atolls.

The Cooks are the islands of flowers. The bright yellows and reds of the *au* or hibiscus are everywhere; the perfume of the frangipani hangs in the air. Men and women wear flowers as a matter of course.

This modern house designed for themselves in 1991 by Joan and David Cragg at Avarua on Rarotonga is filled with flowers. The native ginger or *teuila* grows everywhere in a variety of colours.

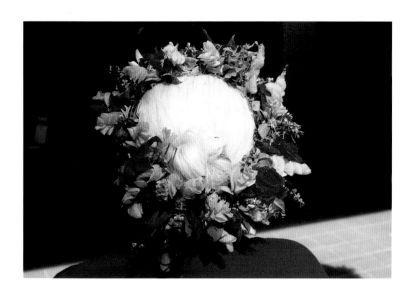

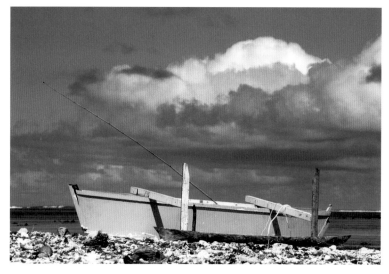

A wreath or *ei katu* made of bougainvillea adorns the white hair of a Cook Island woman.

Classic Pacific images are found all around the Cook Islands' coastline: a boat with an outrigger and surf beating on a palm-fringed beach.

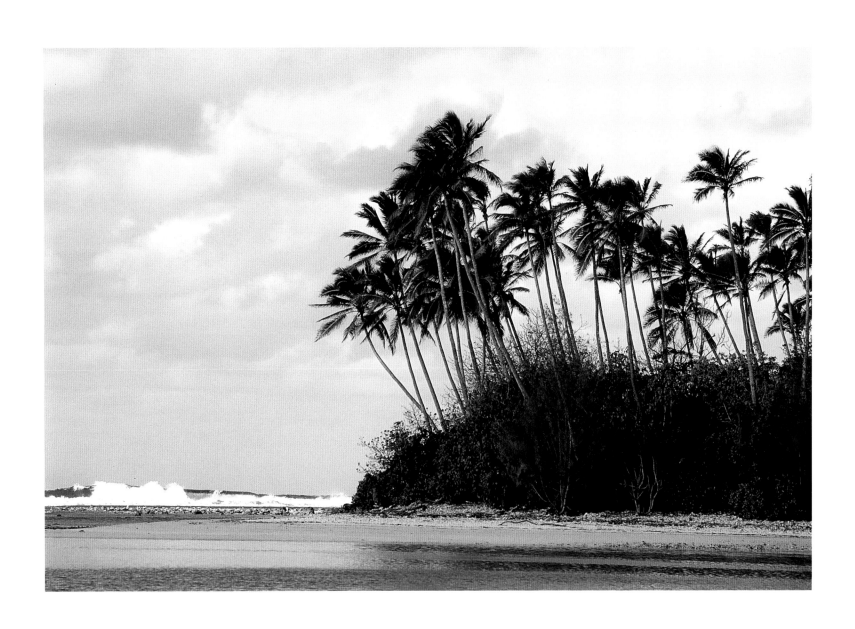

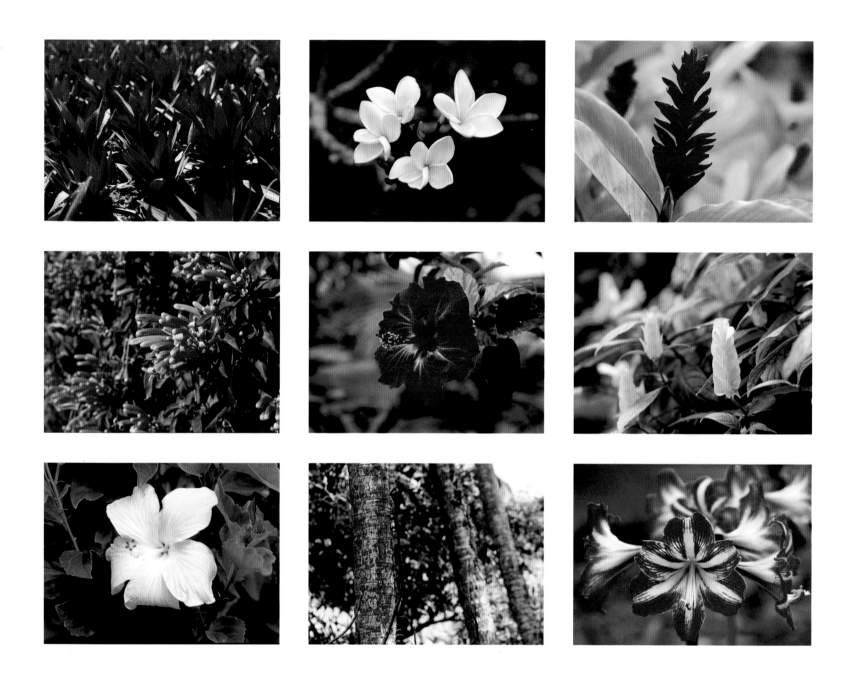

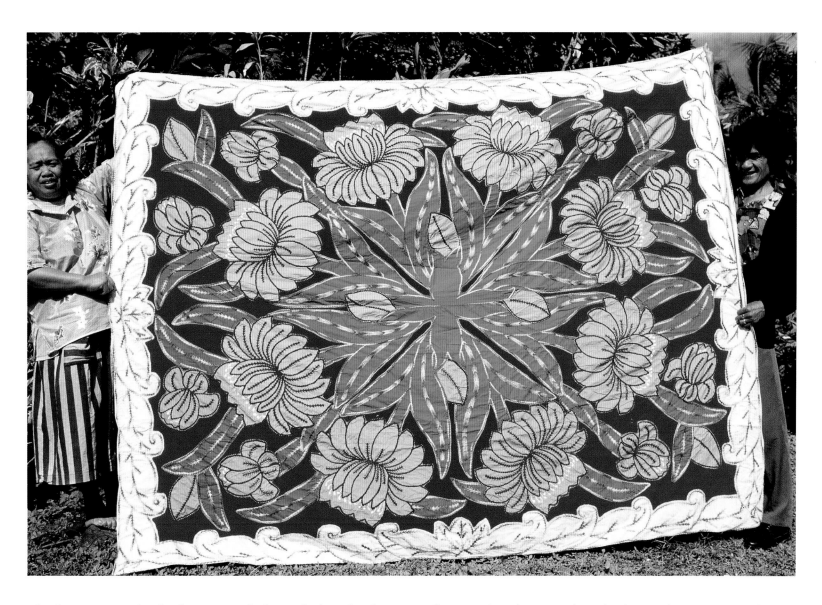

The distinctive Cook Island *tivaevae*, or bedspreads, have bright patterns and pictures sewn on them. The shapes and colours are drawn from the flowers which grow everywhere. (Opposite, reading across left to right) *Tradescantia discolor, Pulmeria* (frangipani), *Alpinia purpurata* (red ginger), *Pyrostegis venusta* (flame vine), *Hibiscus, Pachystachys lutea, Hibiscus, Cocos nucifera* (coconut palm), *Hippeastrum* (lily). A design is first created and each woman has a specific part of the pattern to complete. Cutting and matching of the shapes is done before sewing can begin under the watchful eye of the designer.

All the churches are profusely decorated with flowers, both real and painted. The symmetry of the placement of objects and furnishings expresses the Cook Islanders' love of order.

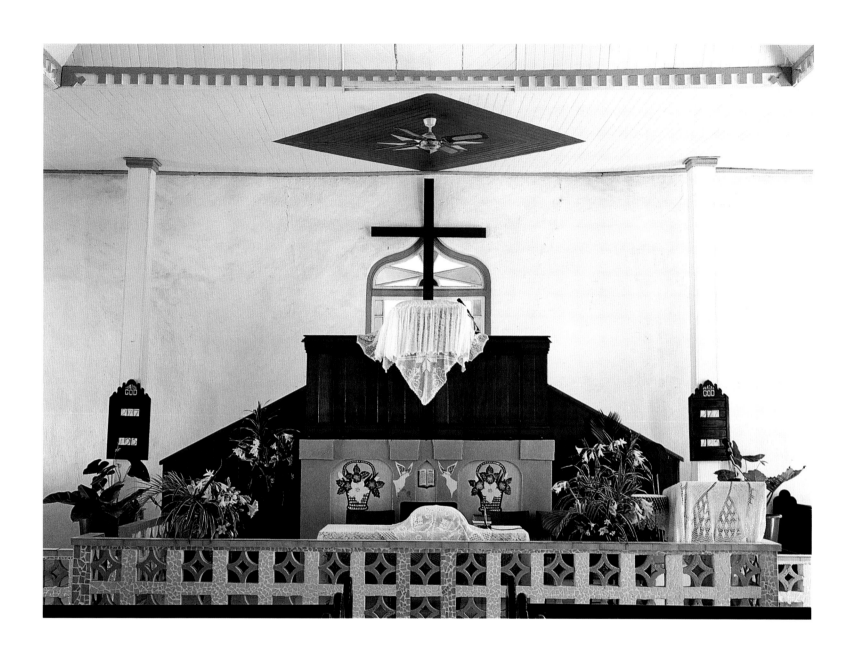

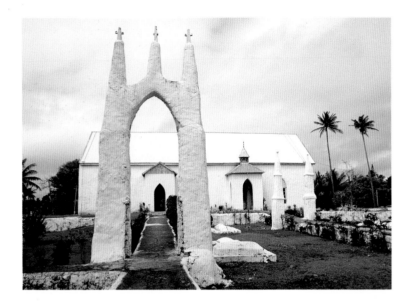

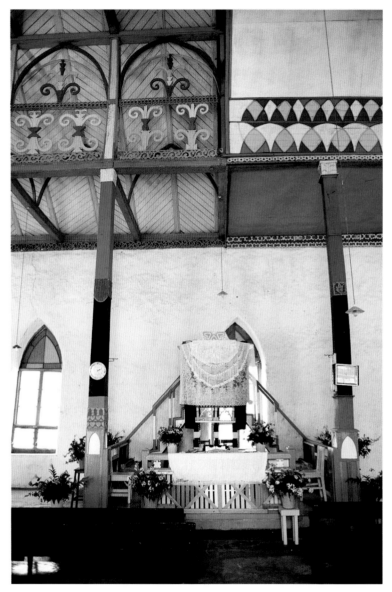

In the neighbouring villages of Ngatiarua and Aretoa on the island of Mauke no one could agree on the design of the entrances or interior decoration for a new Cook Islands Christian Church. Because a single building was to be shared between the two communities, the compromise solution was to incorporate two entirely different interior paint schemes within one building.

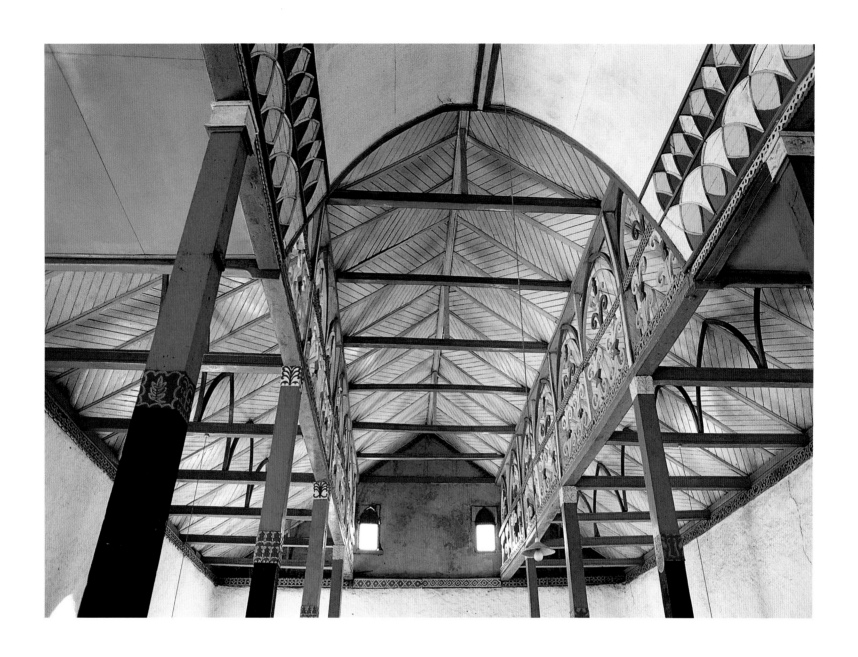

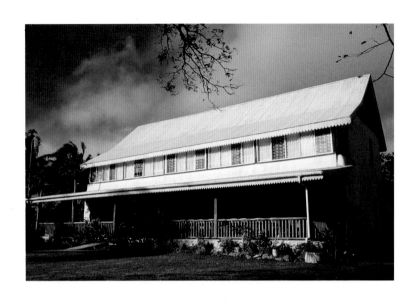

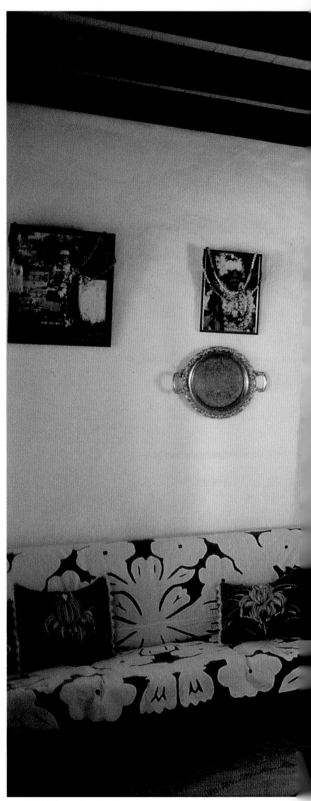

The home of the Queen of Arorangi, Tinomana Ruta Tuoro Ariki II, dates from 1828 and is called *Au Maru* meaning "calm and peaceful". A second floor was added in 1849 so that the Queen's house would not be dwarfed by the minister's house and the church.

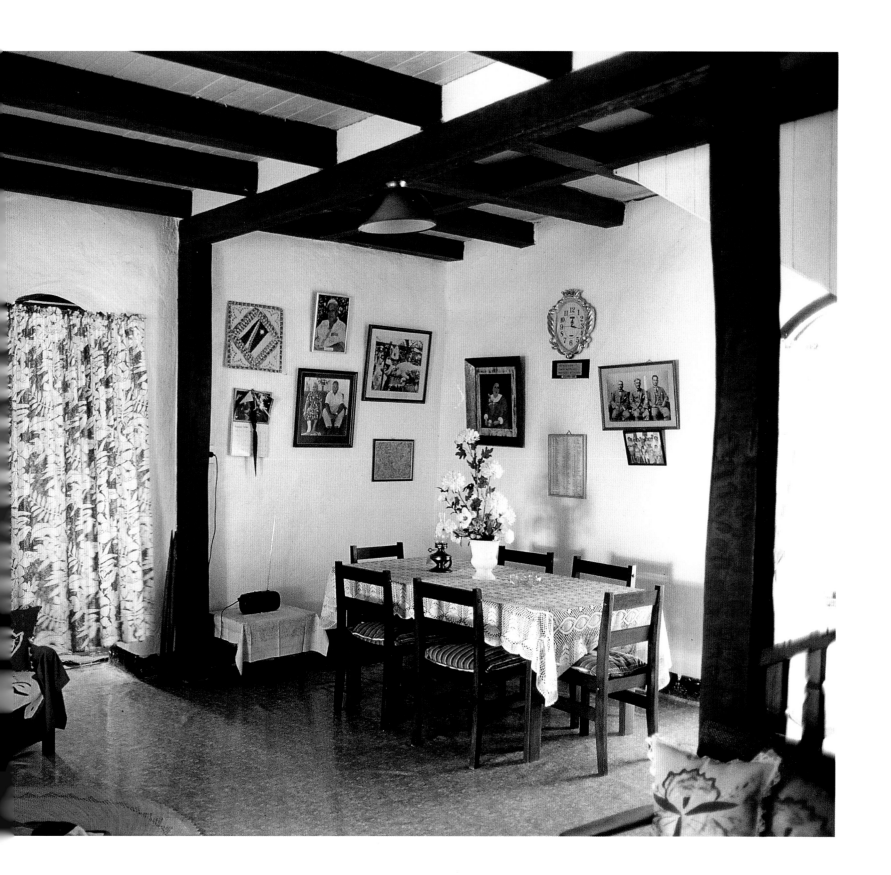

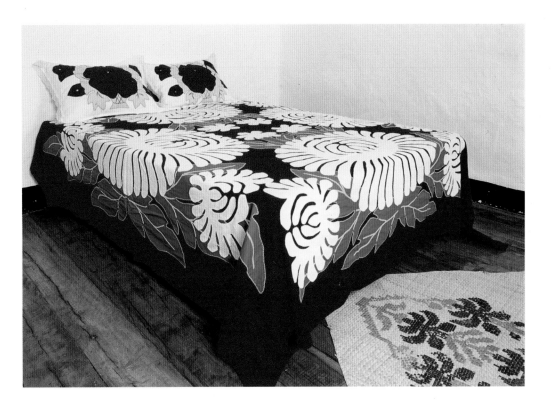

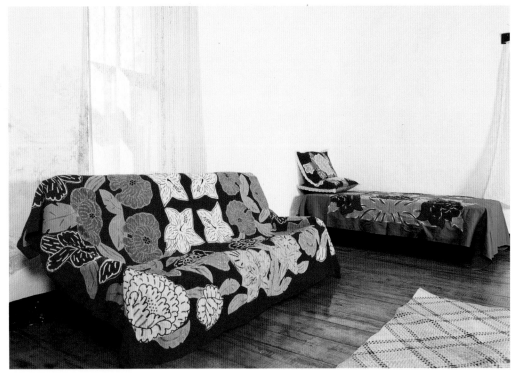

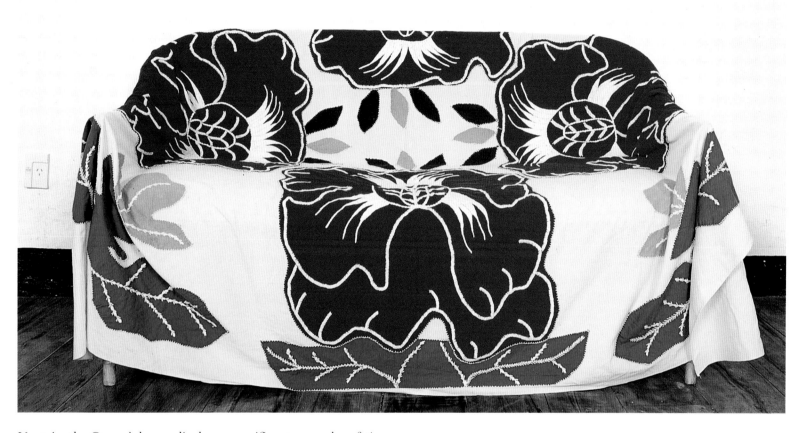

Upstairs the Queen's house displays magnificent examples of *tivaevae* used as covering for both beds and sofas. Each would have been made by eight to ten women working collaboratively.

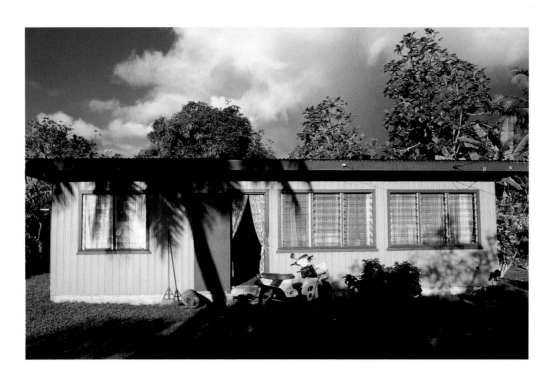

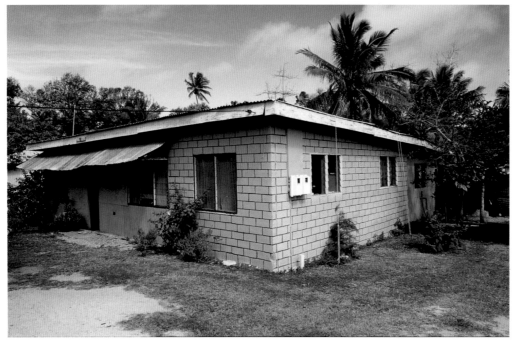

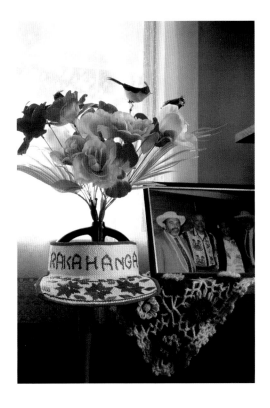

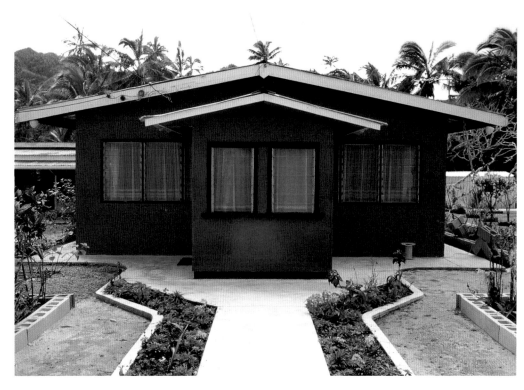

Hurricane houses, designed in the 1950s, replaced traditional houses, which proved too vulnerable to tempestuous weather conditions that can destroy whole settlements in a matter of minutes. For protection, even iron roofs are roped to the ground during the hurricane season (below opposite).

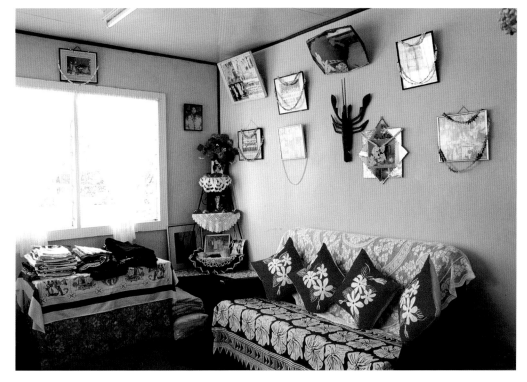

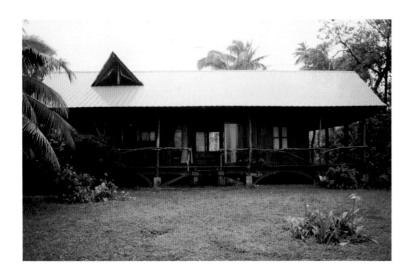

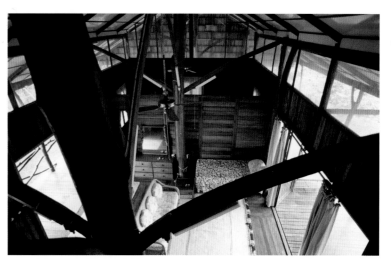

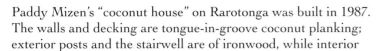

Paddy Mizen's "coconut house" on Rarotonga was built in 1987. The walls and decking are tongue-in-groove coconut planking; exterior posts and the stairwell are of ironwood, while interior railings use the wood of the avocado tree. The trunk of a dead tree protrudes right through the middle of the house.

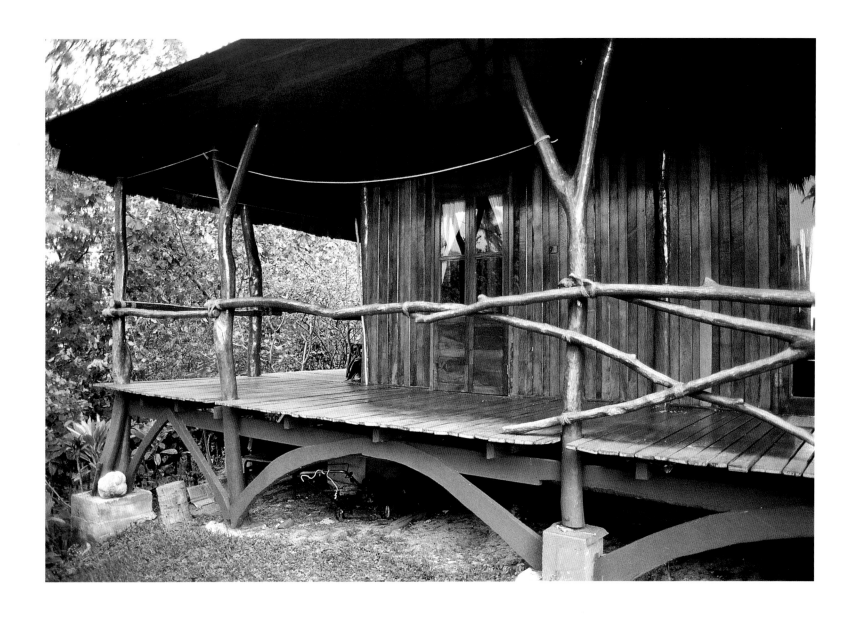

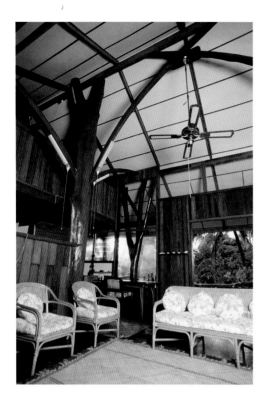 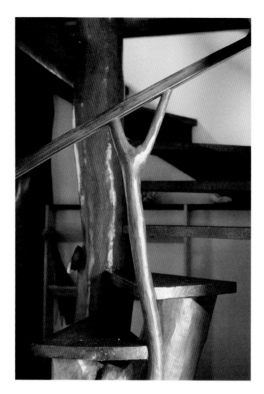 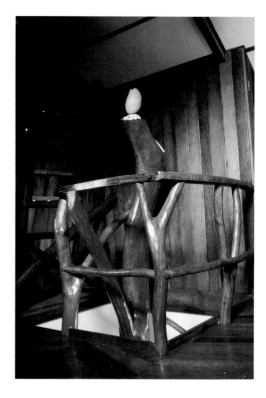

In the lounge, the stairwell and the landing at the top of the stairs, the natural contours of the ironwood and avocado timber have been retained, ensuring that the spirit of the original tree is brought into the house.

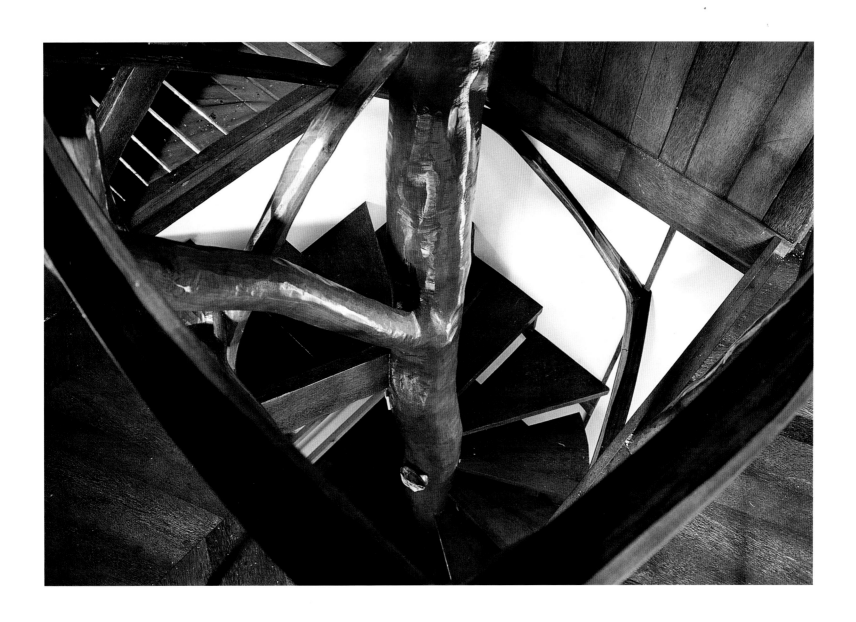

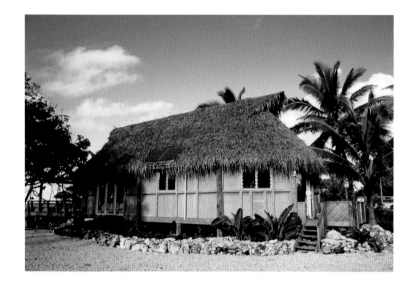
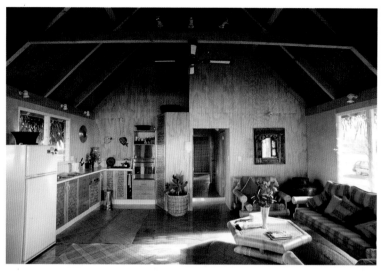
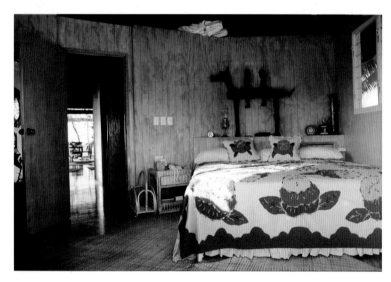
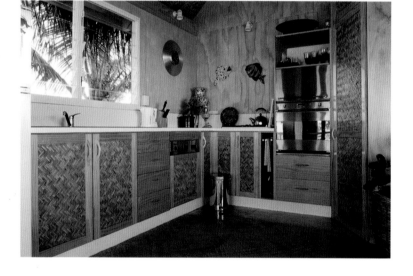

Des and Casey Eggleton's 1996 house at Matavera on Rarotonga combines the cultures. It has a plaited coconut palm roof; bamboo panels have been woven into the doors; and the white pine walls have been imported from New Zealand. The house is situated right on the beach with direct access to the sea even while dining.

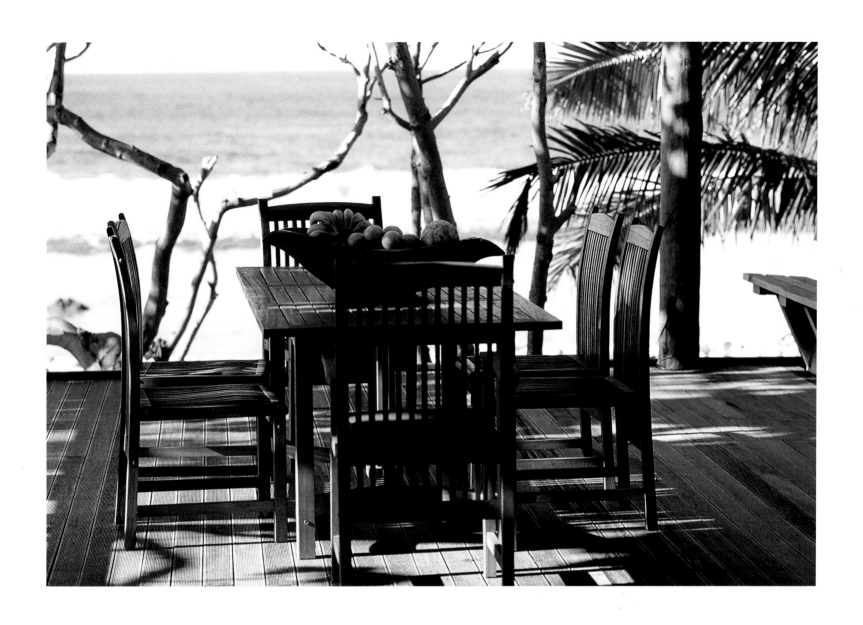

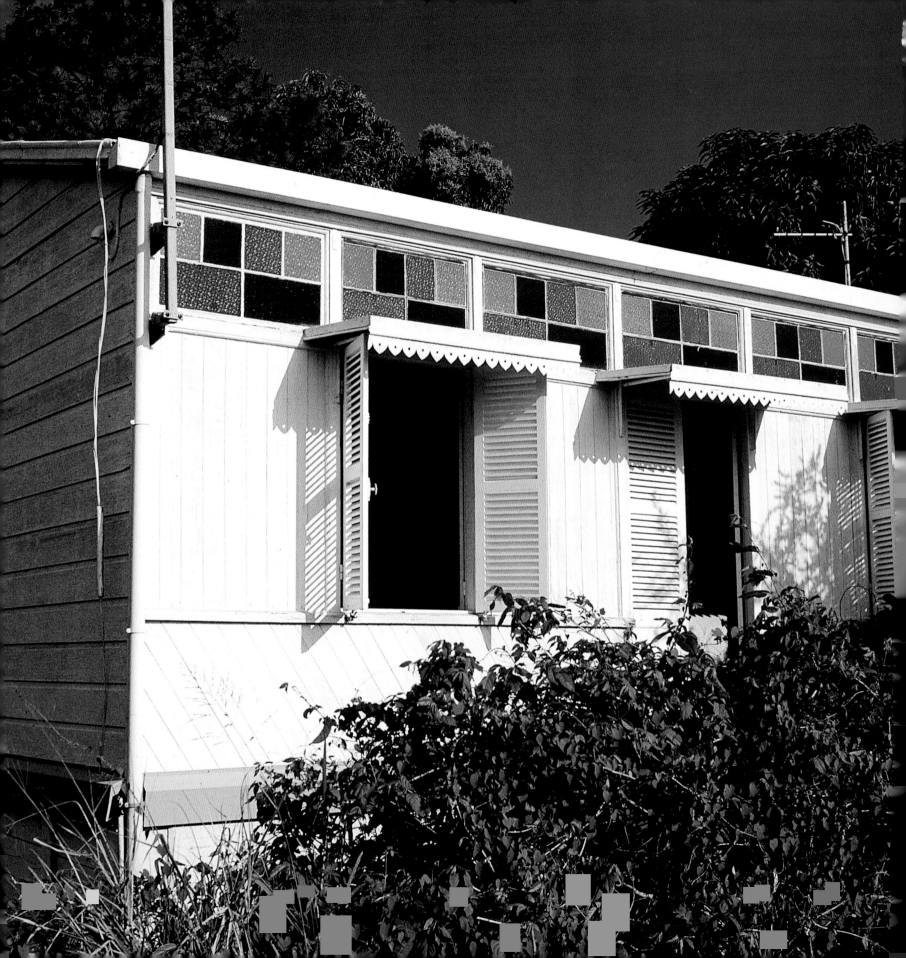

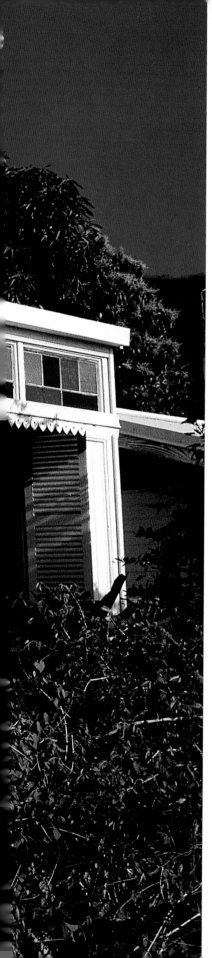

NEW CALEDONIA

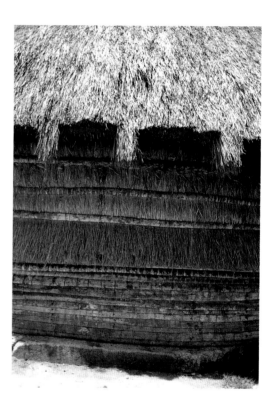

Architecture in New Caledonia is a fascinating blend of the traditional, the French Colonial and the modern. Because the sun is so bright, it is shade more than anything else that people want. Windows tend to be shuttered so that air can be let into a house while the sun is blocked out. Once the sun goes the shutters are thrown open.

Although a French territory, New Caledonia was actually named by Captain James Cook in 1774 because its mountains reminded him of the Scottish Highlands – Caledonia was the Roman name for Scotland. The islands were annexed in 1853 by the Emperor Napoleon III as a penal colony. The native Kanak people, who have borne colonial rule ever since, guard their culture tenaciously.

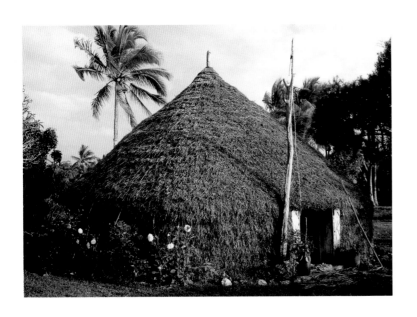

A traditional house or *case* on the island of Lifou has an enveloping roof of thatched reed called *paille* from the French word for straw. The thick thatched walls absorb heat during the day and retain it during the night.

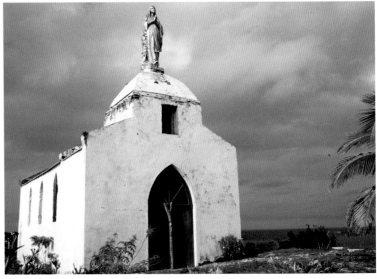

The Church of Notre Dame de Lourdes sits on a hilltop at the north of Lifou. Built in 1890, its narrow Gothic windows are very small. Its squat tower, where a spire would normally be, is dominated by a statue of the Virgin.

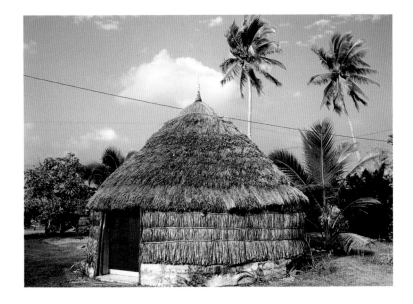

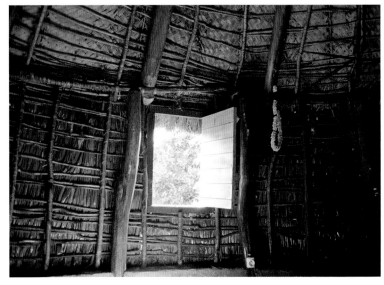

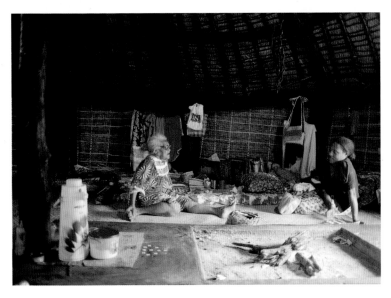

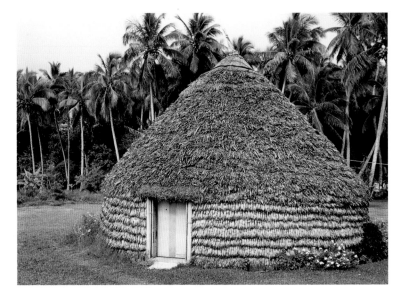

These traditional *case* are in the village of We on Lifou Island, in the Loyalty Islands group east of the main island. They are made of thatched reeds stitched with vines over an ironwood frame.

Such is the fragility of these houses that at night a fire is burned inside to keep wood eating termites at bay and also to prevent the timbers rotting in the tropical damp.

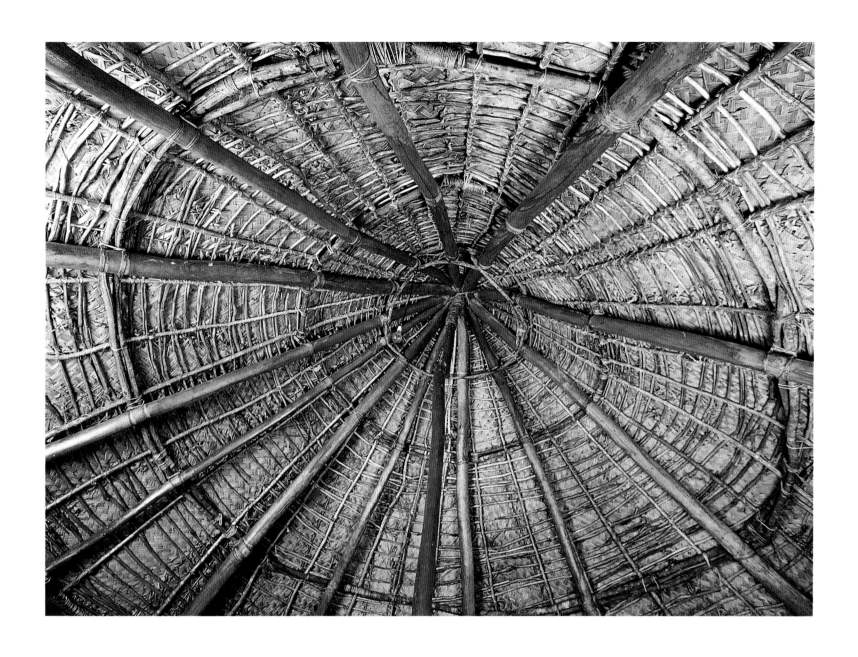

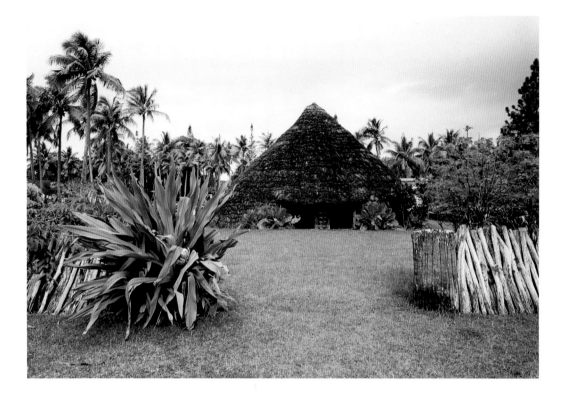

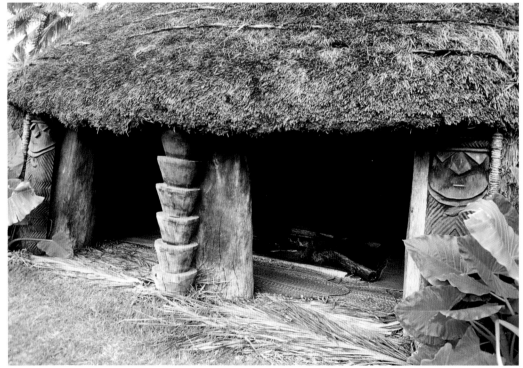

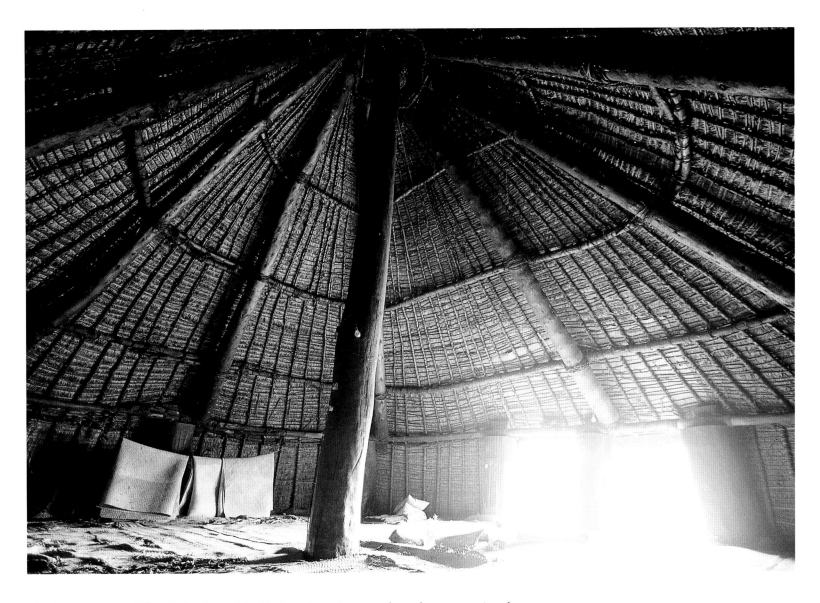

The largest *case* on Lifou is dominated inside by a huge ironwood trunk representing the chief Sihaze. Dating from 1842, it was rebuilt in 1976 after a fire. This is a sacred building to which entry is governed by strict rules of protocol. At its door guardian figures keep watch. Today it is used mainly for ceremonial purposes.

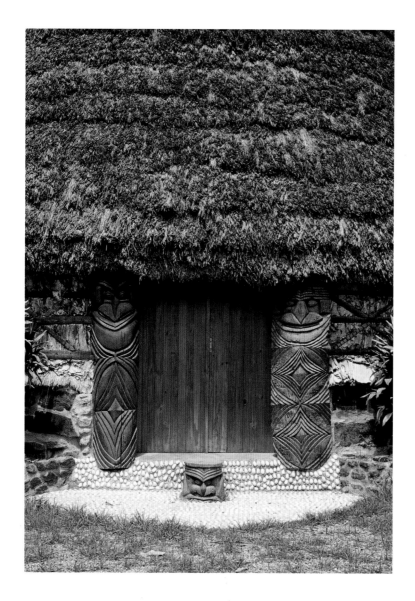

The height of the chief's house in comparison with those surrounding it at St. Louis near Noumea denotes his seniority.

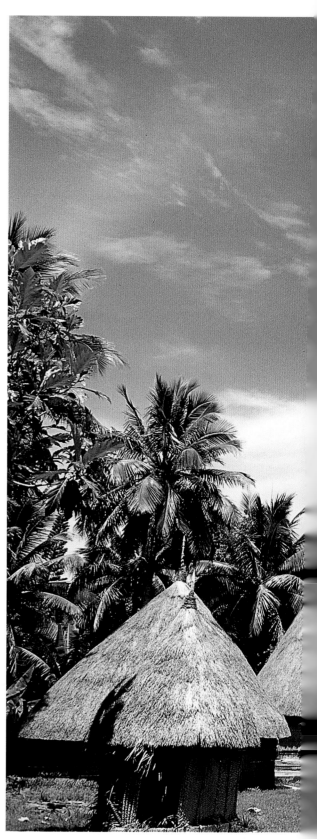

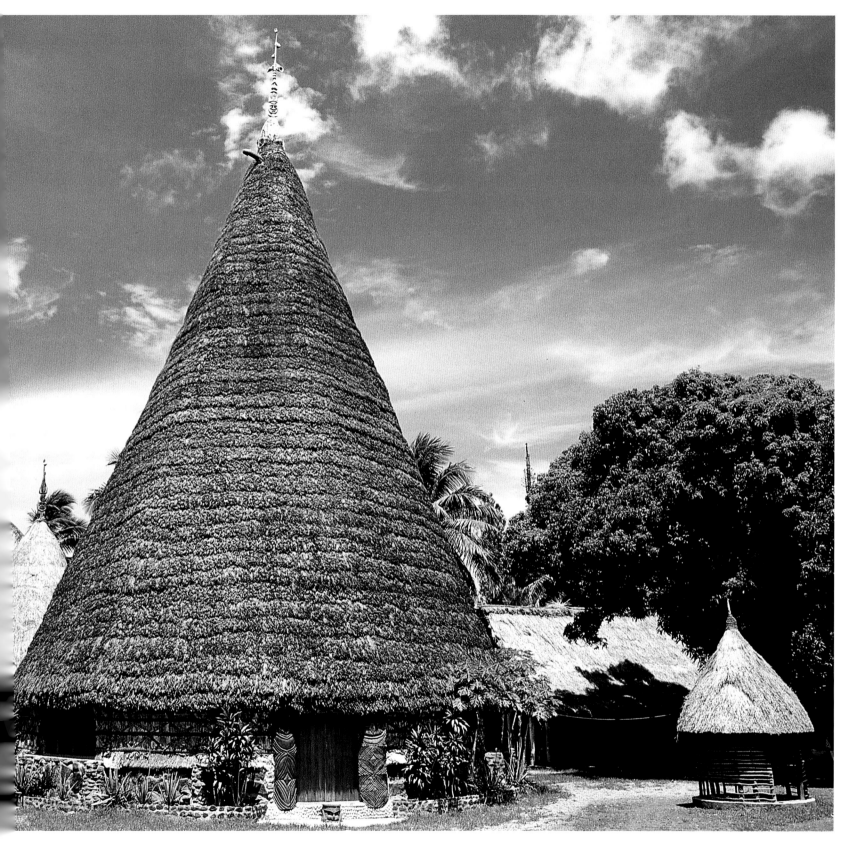

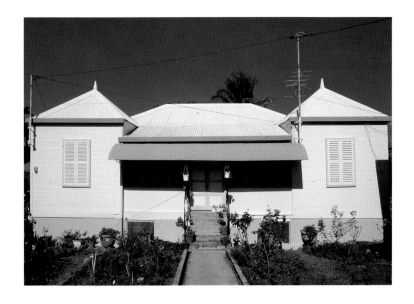
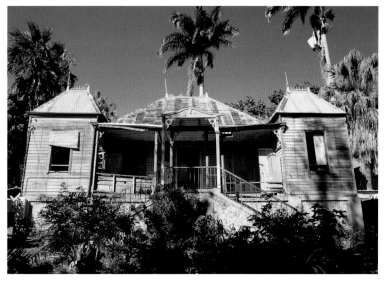
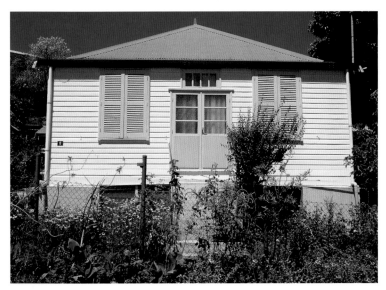
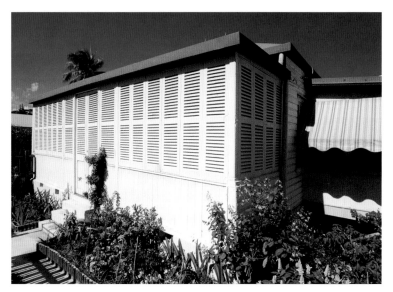

Typical prefabricated small colonial houses, often made out of
Australian or New Zealand timbers, were common in the period
1840 to 1890. Shutters are their dominant feature.

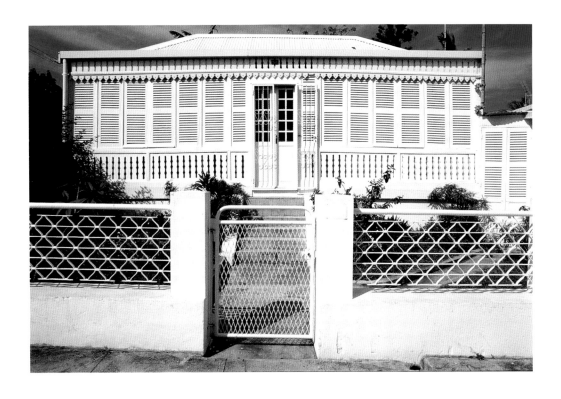

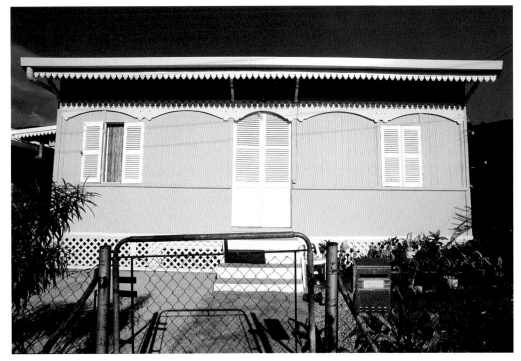

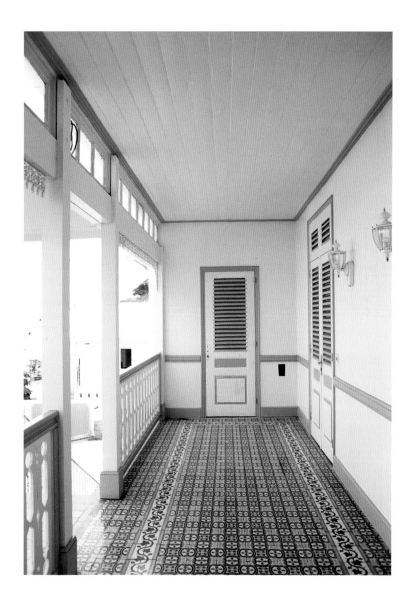

This colonial house, originally built in the 1870s, has seen the attentions of an interior designer in recent years.

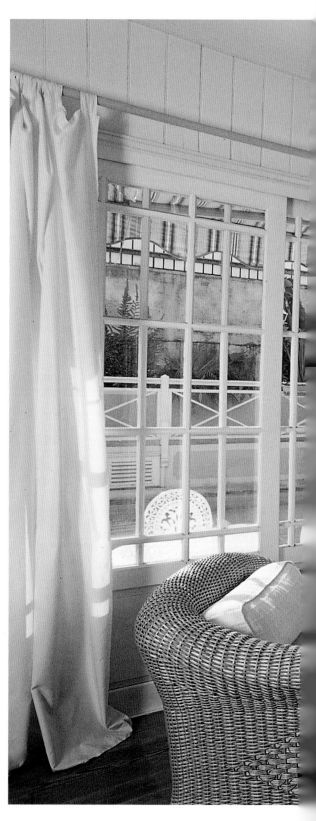

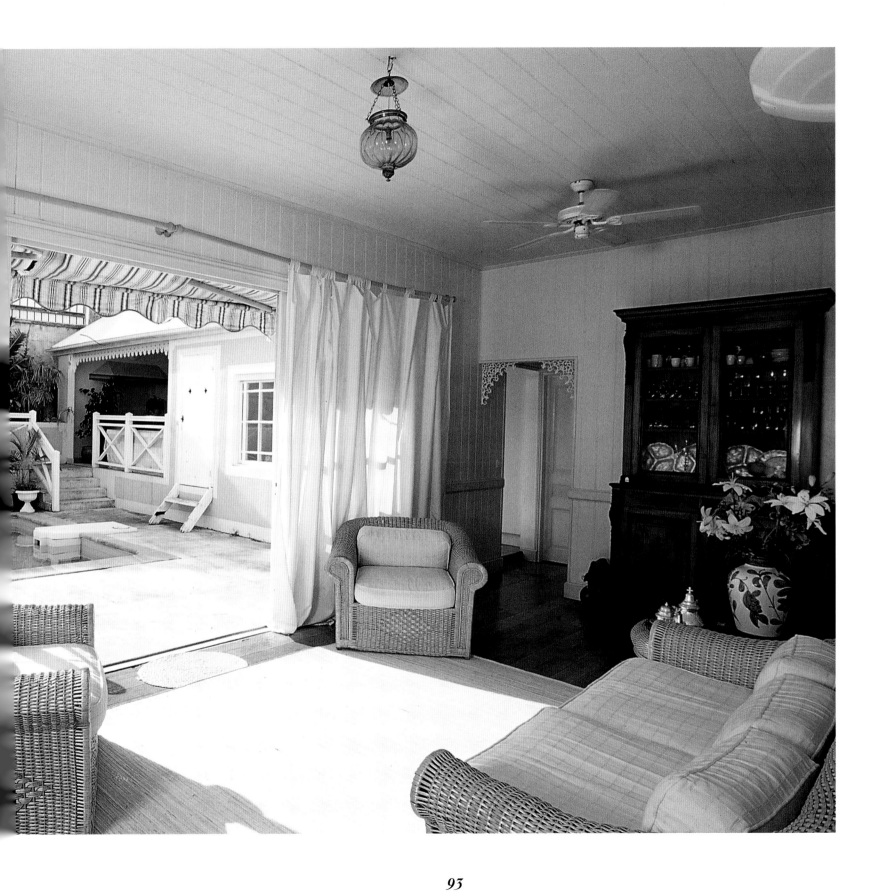

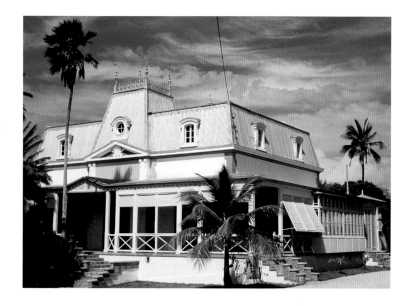

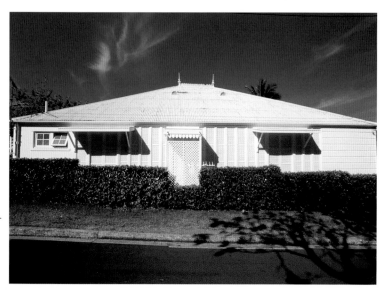
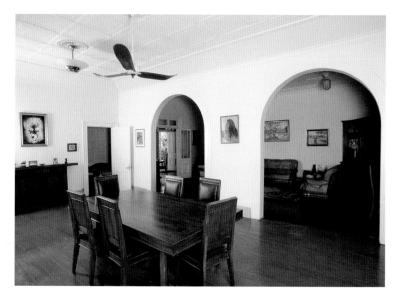

Top left, top right and opposite is Château Hagen at Noumea, built in American cedar in 1889 by Marcel Preverrand de Sonneville, a wealthy commercial trader. Its Mansard roof topped with iron work finials and dormer windows give it a distinctively French Colonial appearance. The verandah is shaded with top hung blinds which open by rolling up. The bottom three pictures show quite a different style of house, built in 1875 and recently renovated.

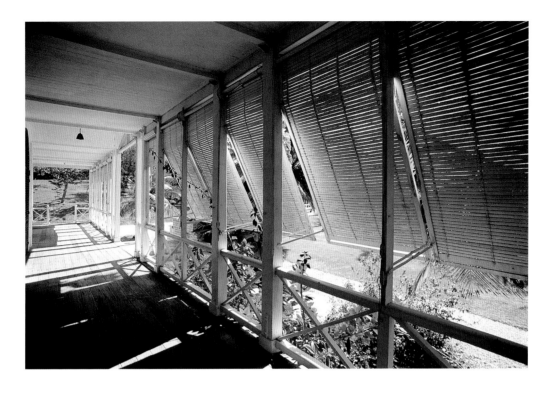

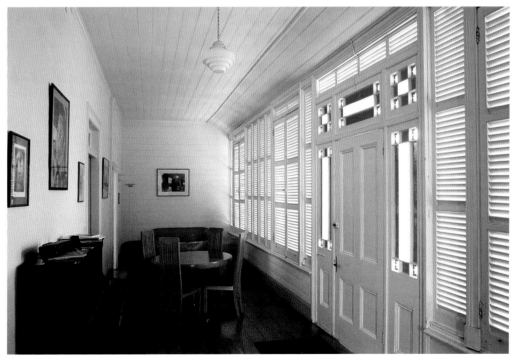

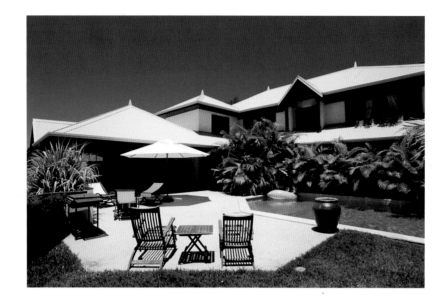

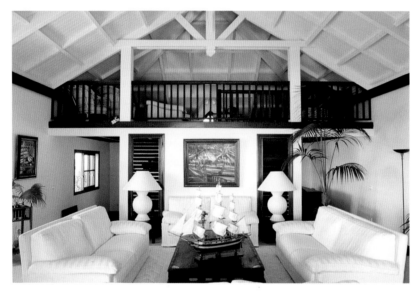

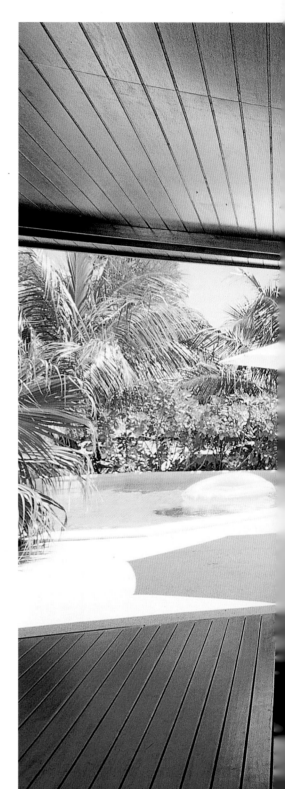

Daniel and Sylvie Leroux's Noumea house was built in 1996. They have used both shutters and outdoor rooms without walls to ensure coolness and comfort.

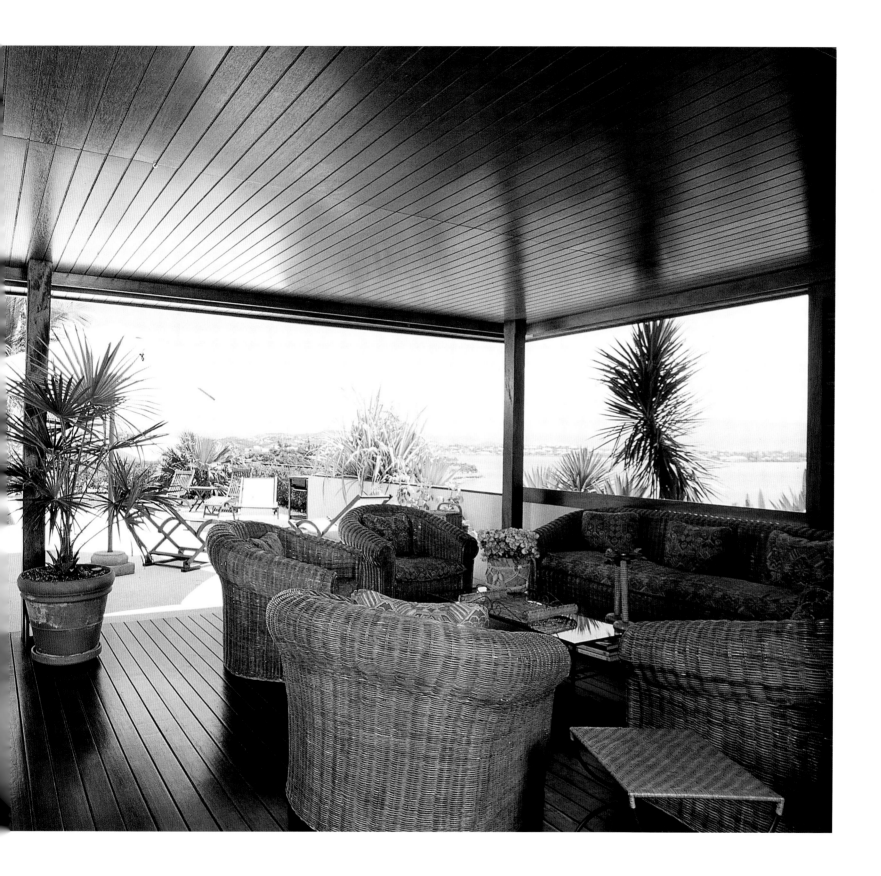

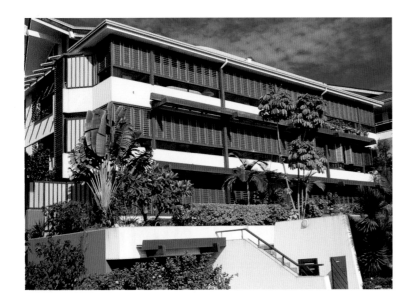
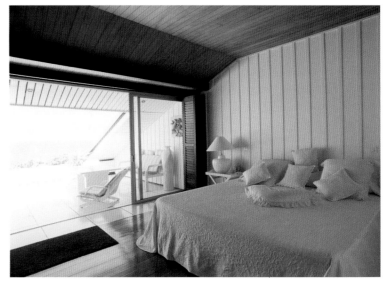
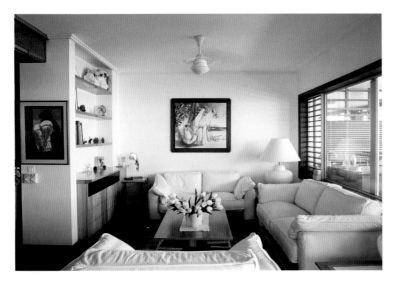
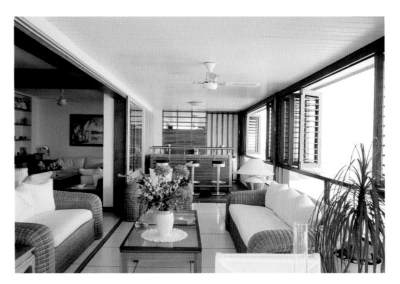

Designed by architect Willy Porcheron in 1993, this Noumea apartment block has little need for glazed windows. Folding louvred shutters in pencil cedar extend the entire length of the building and permit sensitive control of sunlight and air movement.

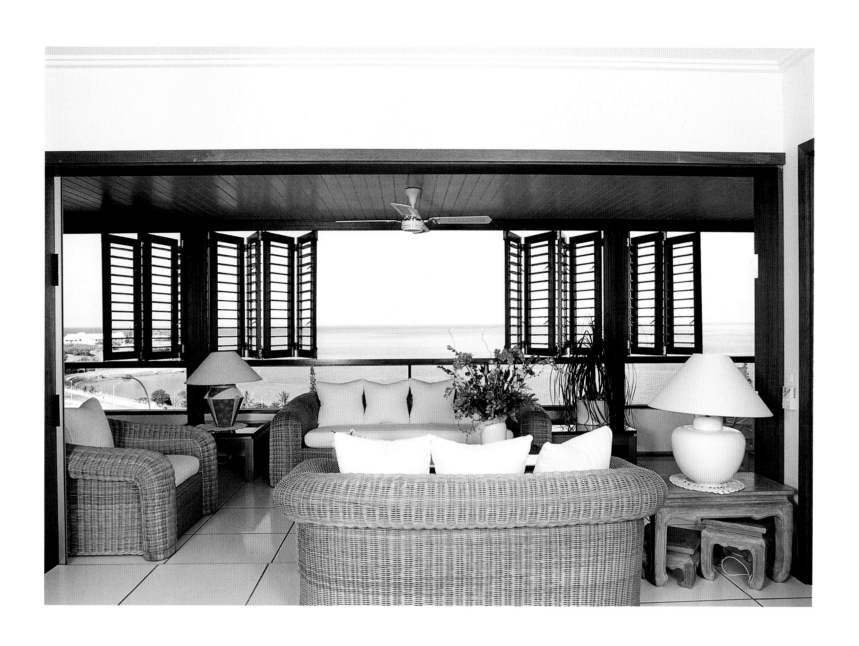

TONGA

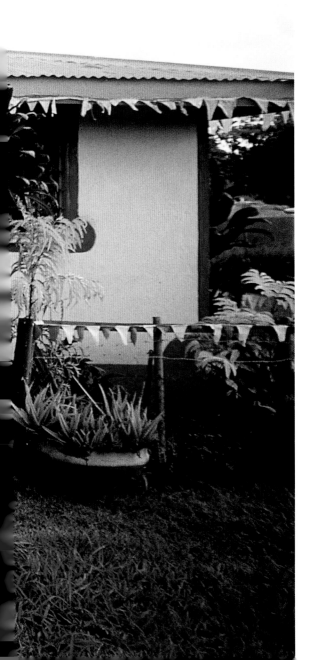

Pule'anga Tonga, the Kingdom of Tonga, consists of 169 islands in the southwestern Pacific. Its capital, Nuku'alofa on the island of Tongatapu, is the home of its constitutional monarch King Taufa'ahau Tupou IV. Two thirds of the population live on

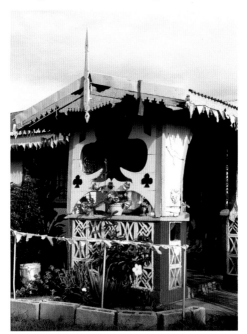

Tongatapu, most of them in villages, where for some their homes are the traditional *fale tonga*, an oval-shaped building with a curved thatched or iron roof with sides made of woven reeds. Most live in colourfully painted wooden houses (known as "hurricane" houses) characterised by fretted or turned wood decoration popular in the colonial era.

This house is in the village of Ha'atafu on Tongatapu.

101

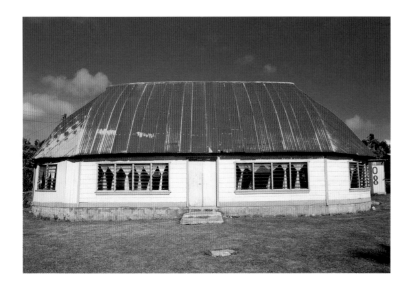

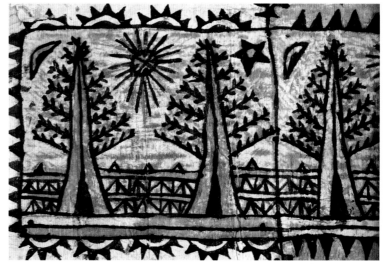

Because of Tonga's relative distance from the equator it has a semitropical climate, making it cooler and less humid than more northern islands. The *fale tonga* therefore has closed in walls and a more solid appearance. The traditional thatched reed roof has now largely given way to the more durable iron one.

Tonga's traditional *tapa* cloth is called *ngatu*. It is made from the dried bark of the *hiapo* tree (paper mulberry tree) which is soaked and beaten with a mallet to expand it and create a thick sheet. These are then glued together and decorated with dye from the *koka* tree. This motif is known as the Tree of Life.

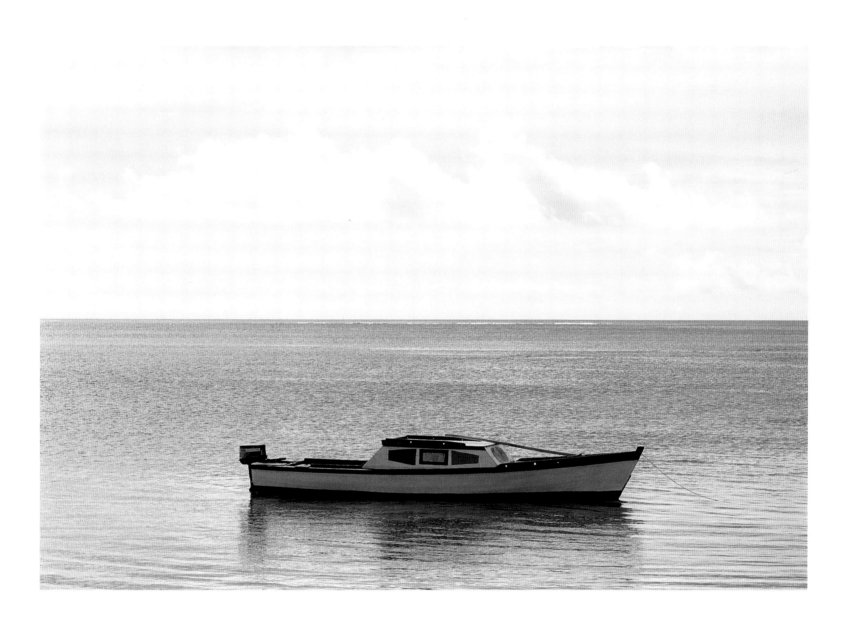

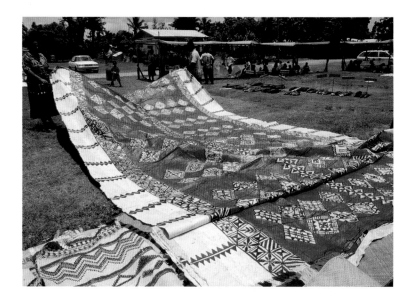

Every November at Navutoka village on Tongatapu the women of the Free Wesleyan Church of Tonga fund raise by exhibiting their *ngatu* and their best pandanus mats decorated with coloured wool trim.

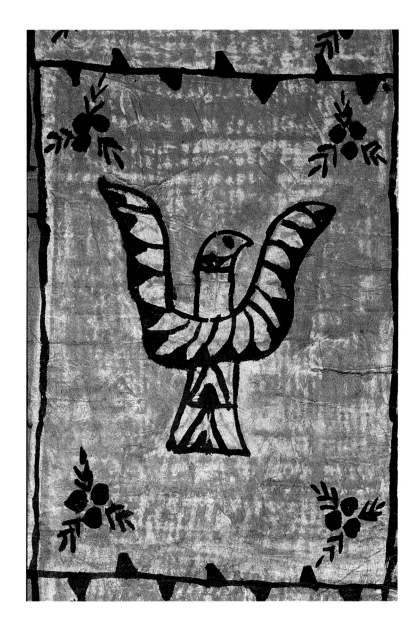

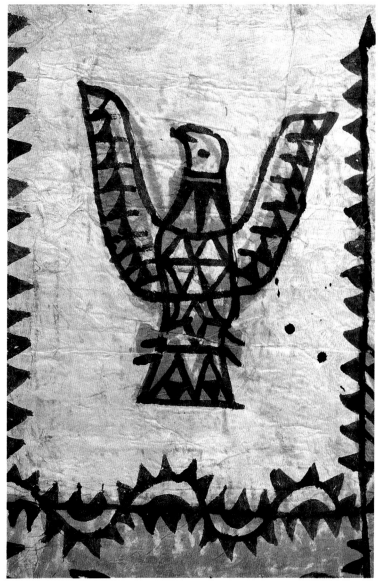

This *ngatu* illustrates the Dove of Peace motif. It is an honour to receive such a cloth since it is a sign of love and respect and is usually given in commemoration of special events.

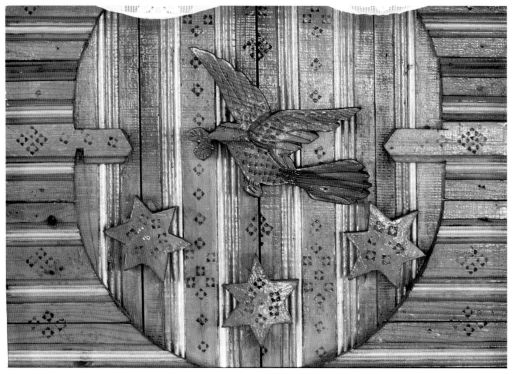

106

Sione Mausia was the builder of this 1979 building for the Free Church of Tonga at Navutoka on Tongatapu. The church was built by local people under his supervision. The carved Dove of Peace bears his signature.

The Free Church of Tonga at the village of Ha'atehio Si'i on the
middle group of islands called Ha'apai was built in 1997 by
Tonife'ao and members of the local congregation. The altar rail
is made of concrete moulded in high relief then painted.

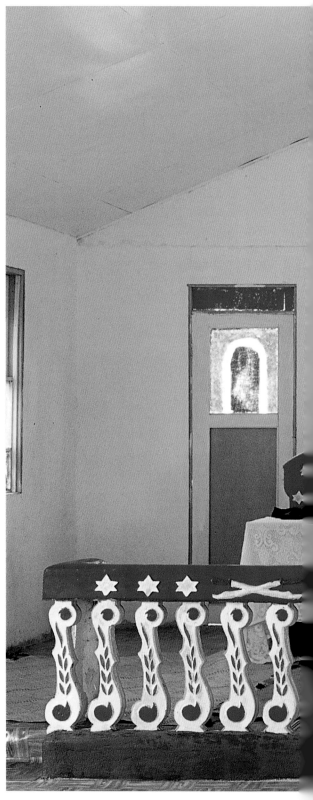

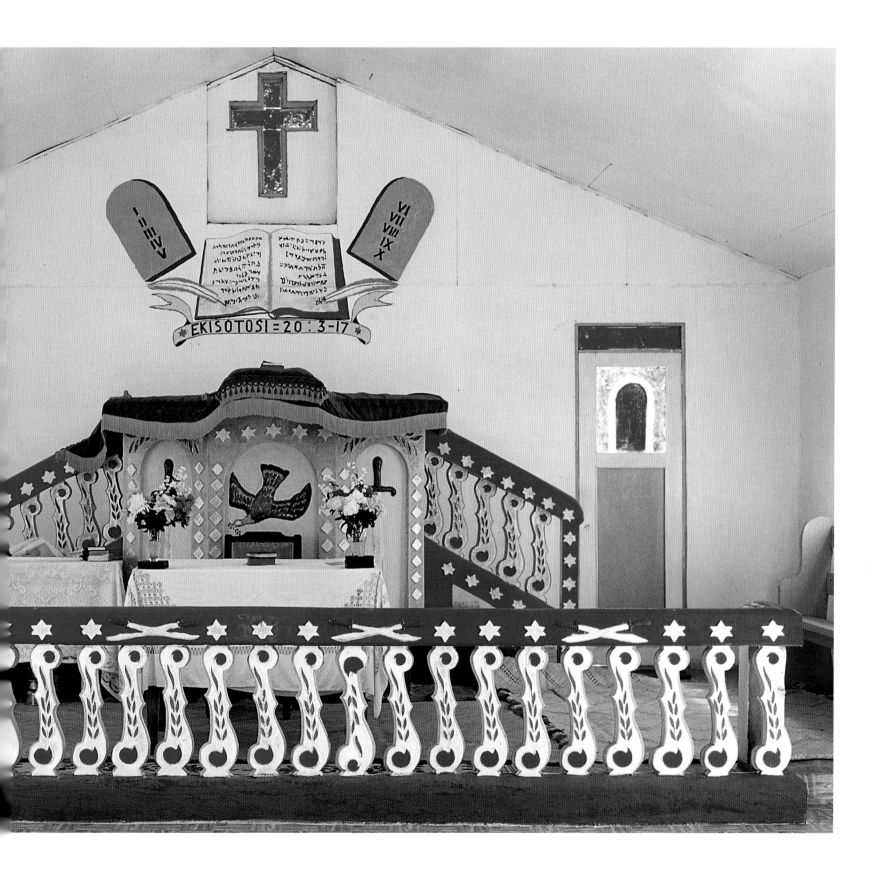

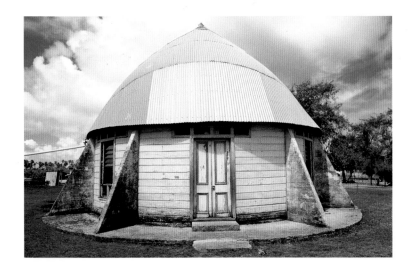

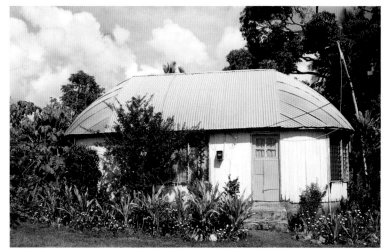

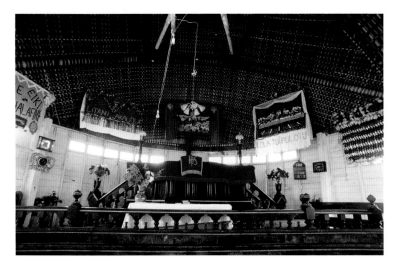

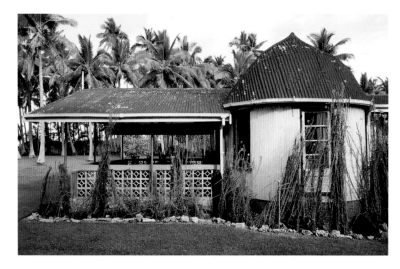

The *fale tonga*-shaped church at Lotofoa in the Ha'apai group of islands was built in 1925 but later given an iron roof and reinforced with buttresses. No one in Tonga forgets the severe damage caused by Cyclone Isaacs in 1982.

The concept of the basic *fale tonga* (top) has been further developed with a lean-to addition in the house above and opposite. It was designed in 1964 by Dr S. Tapa in the village of Kalonga on Tongatapu.

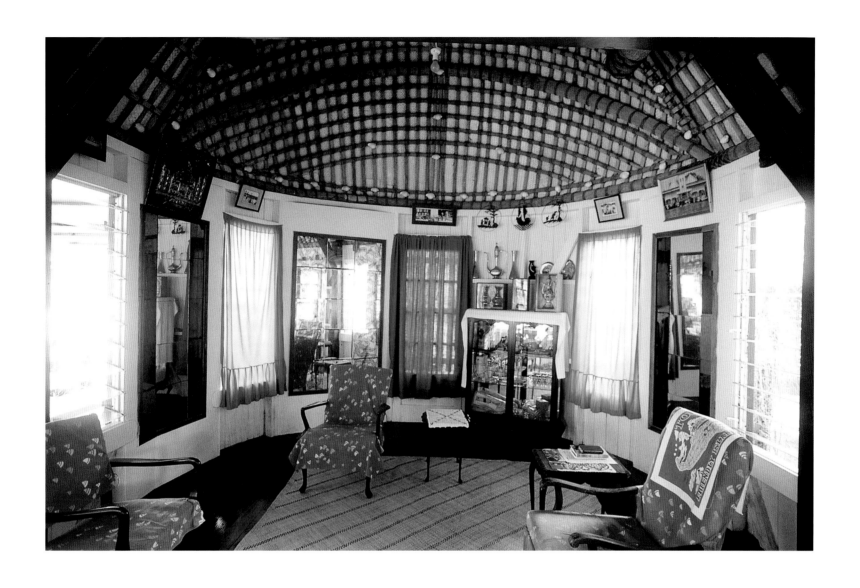

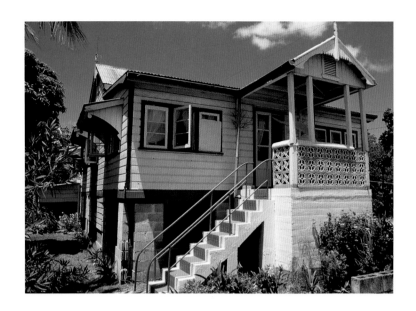

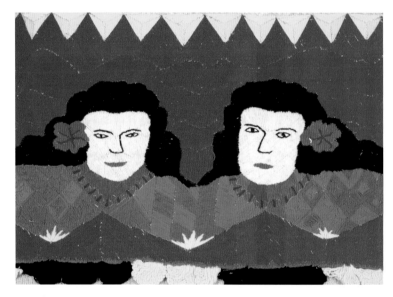

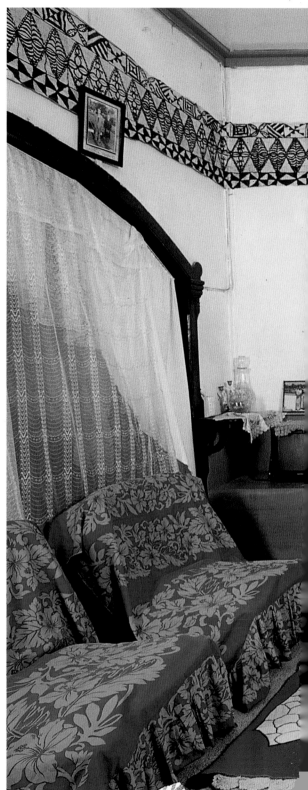

A villa-like house in the village of Vaini on Tongatapu dates from 1952. The layout of the room is typical, with its mat of woven wool depicting two mermaids, its *ngatu* frieze and the family portraits hung high on the wall at regularly spaced intervals.

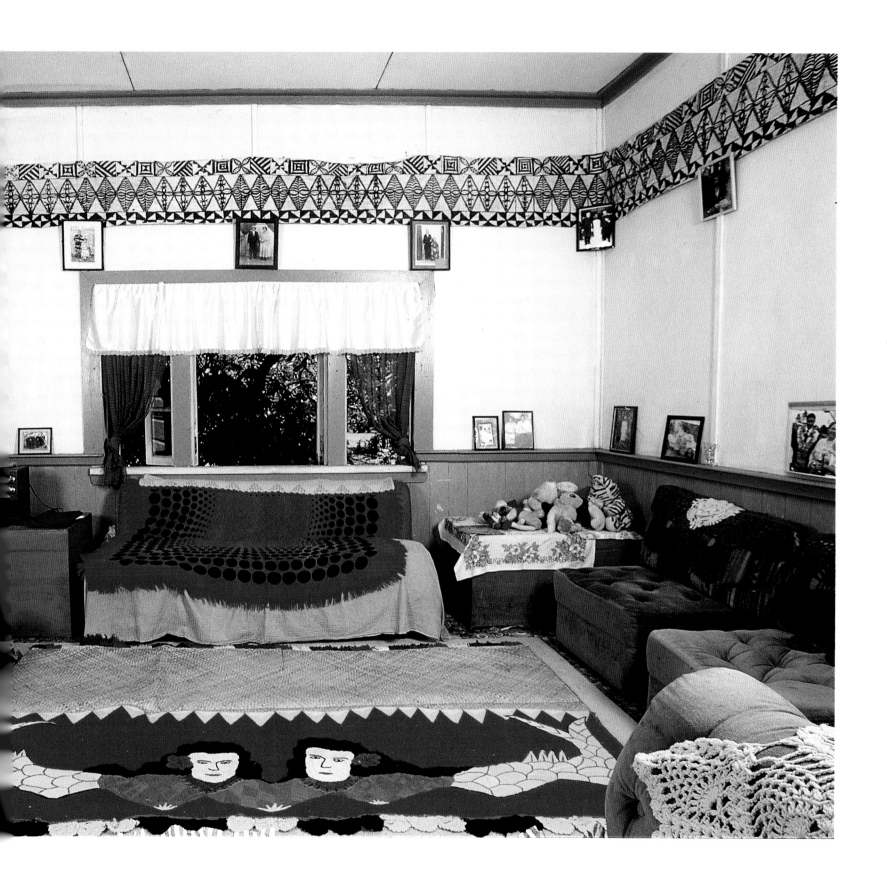

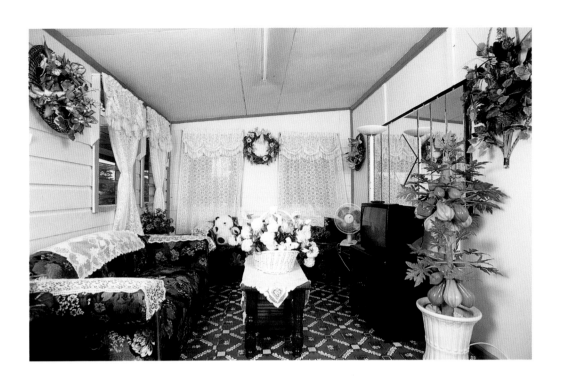

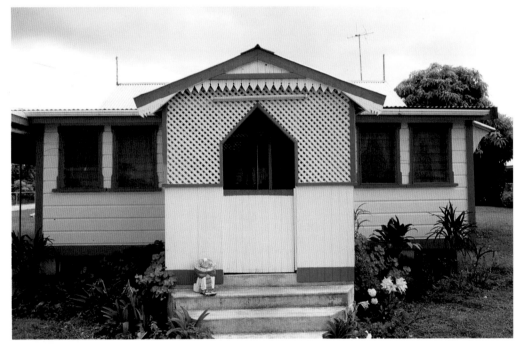

This so-called "hurricane style" wooden house was built in 1954 at Nukunuku on Tongatapu. Decorated to the hilt, it illustrates the Tongans' fondness for covering interior surfaces with lace antimacassars or cloths. The crocheted wool bedspread features appliquéd pineapples.

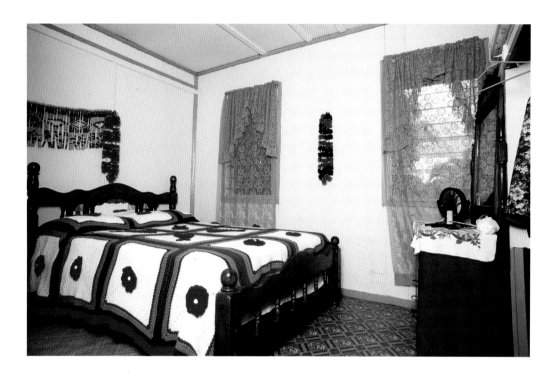

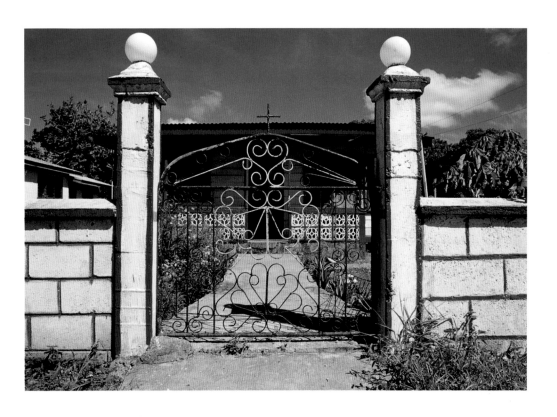

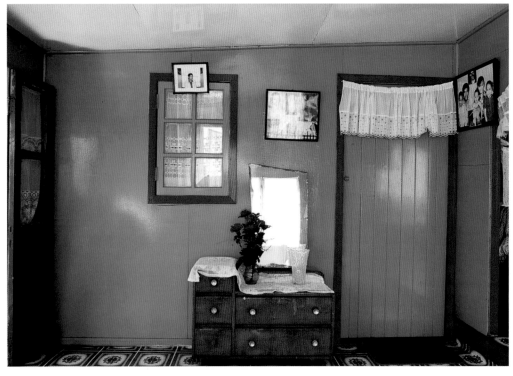

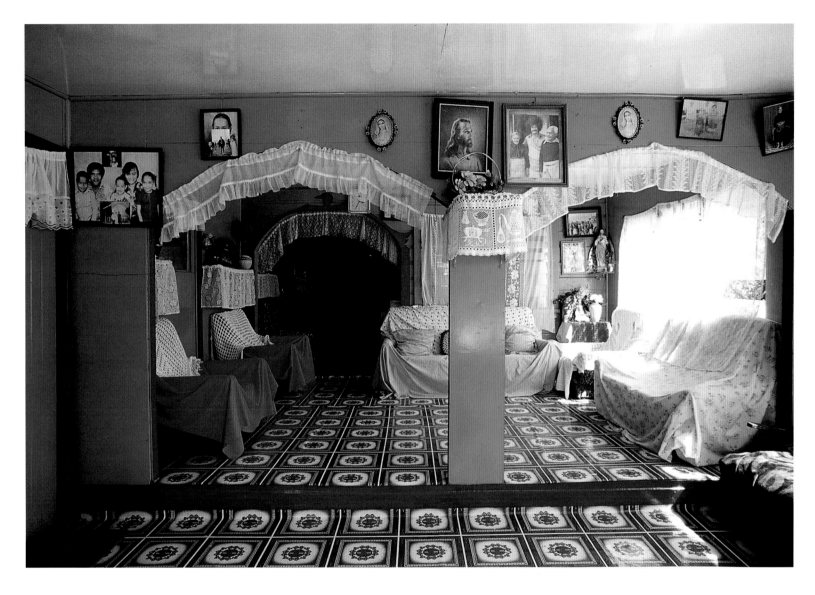

The owner, Fua Fatai, decorated his house in the village of Houma on
Tongatapu with family portraits and Roman Catholic pictures and motifs.

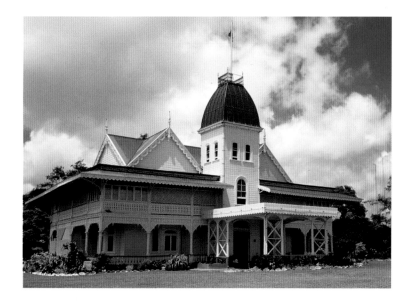

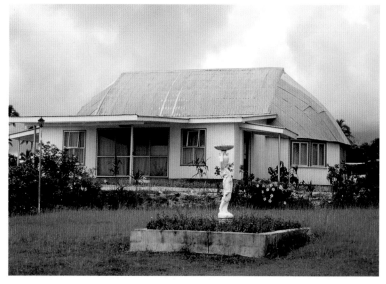

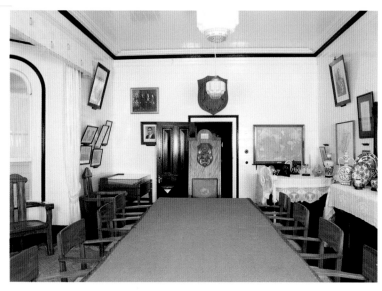

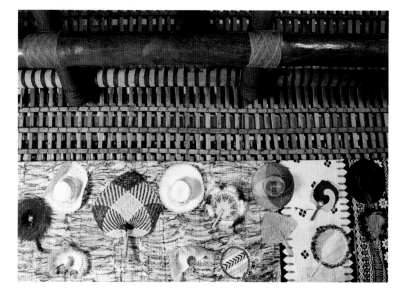

The Royal Palace at Nuku'alofa, which dates from 1867, is a typical two-storied Victorian villa, prefabricated in New Zealand then re-assembled in Tonga. The second storey verandah was added in 1882. The band rotunda in the spacious gardens (opposite) is a classic feature of the period.

The King also has a smaller coastal residence at Fua'amotu on the southern side of Tongatapu. It is a *fale tonga* built in traditional fashion with coconut palm logs supporting the structure. A frieze around the walls displays Pacific Island hats and fans gifted to the Tongan Royal family. A low partition has been built to break up the large open planned space inside. Directly below the cowry shell chandelier (opposite) hangs a portrait of the present King's mother, Queen Salote, who ruled from 1918 until 1965.

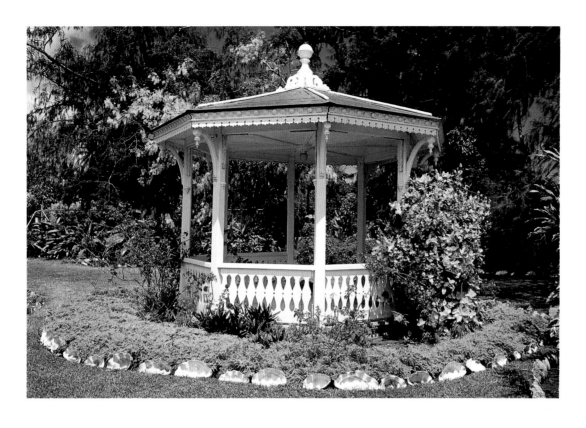

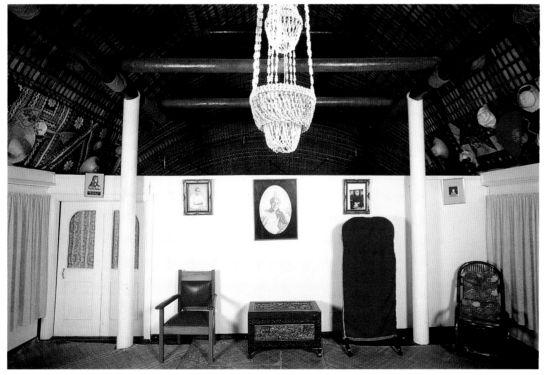

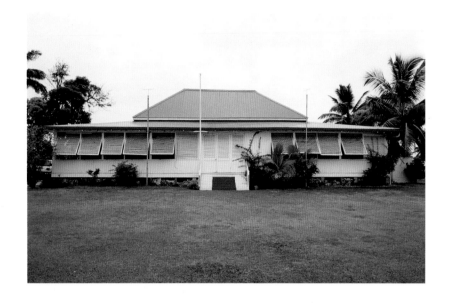

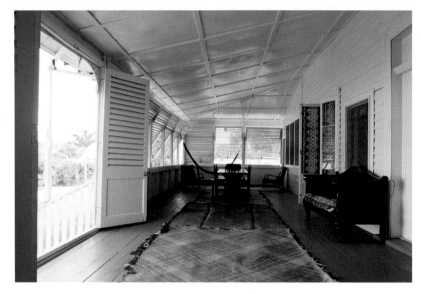

In 1953, when Queen Elizabeth II visited Tonga as part of her coronation tour of the Commonwealth, she and the Duke of Edinburgh stayed in the Royal Palace while Queen Salote moved into this smaller palace at Faiakoka on the beachfront at Nuku'alofa. Queen Salote had already achieved international fame at the coronation in London by riding in an open coach despite torrential rain.

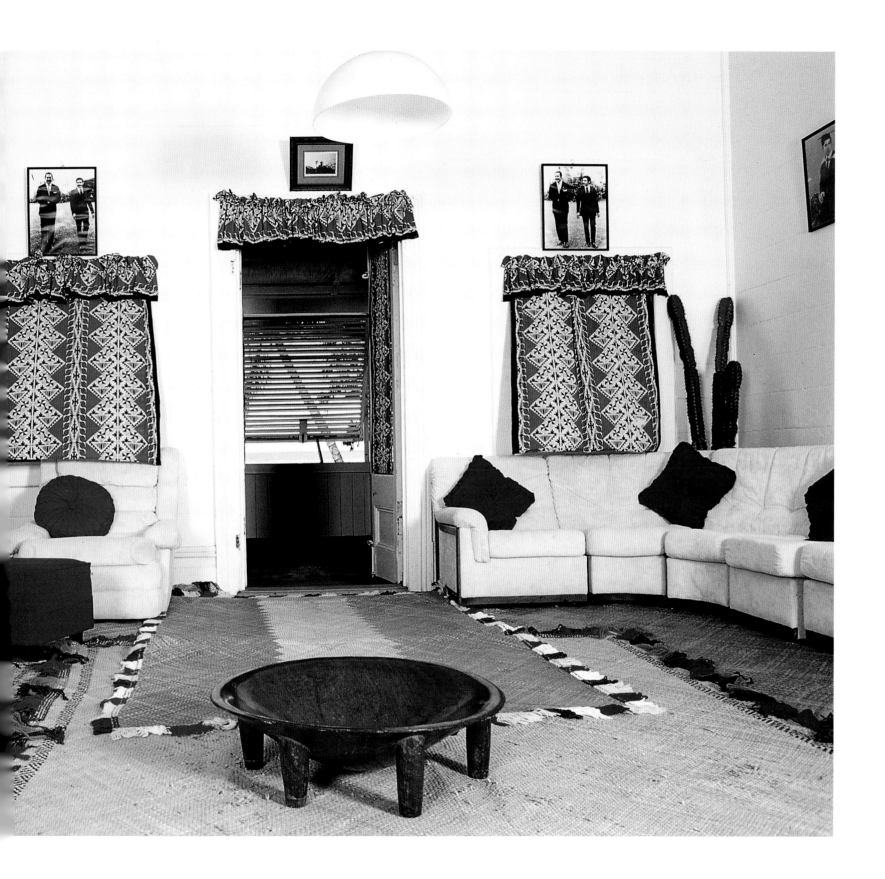

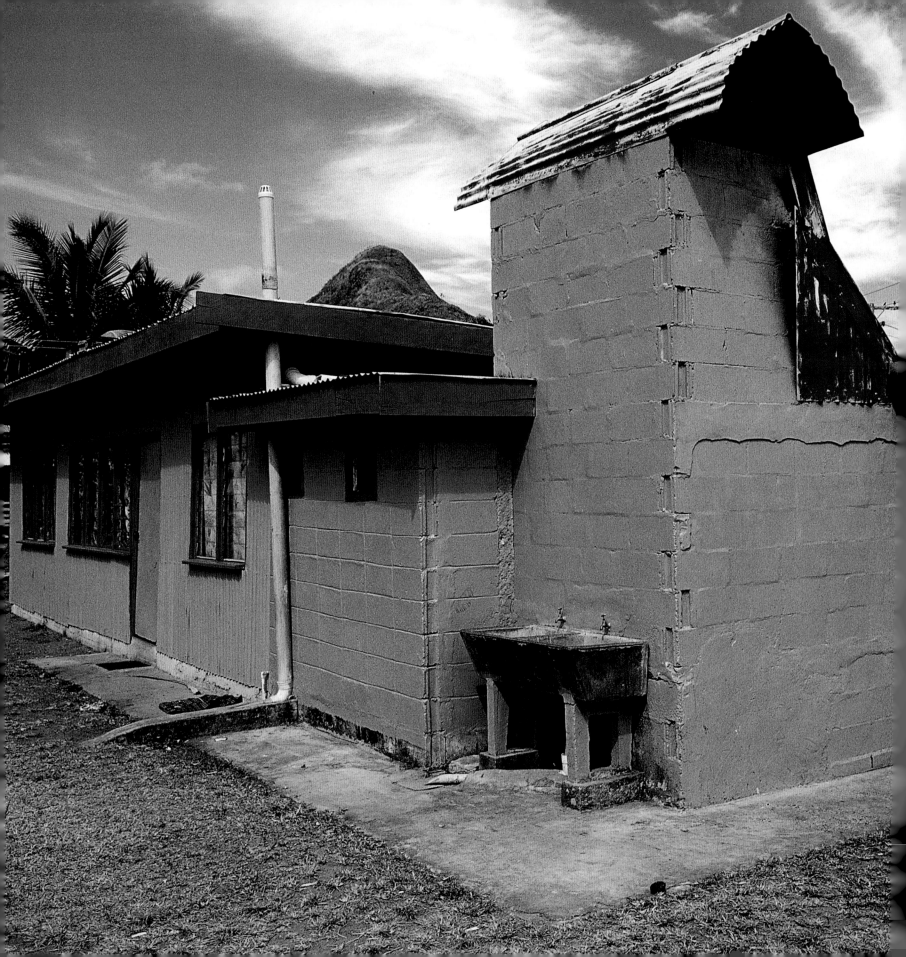

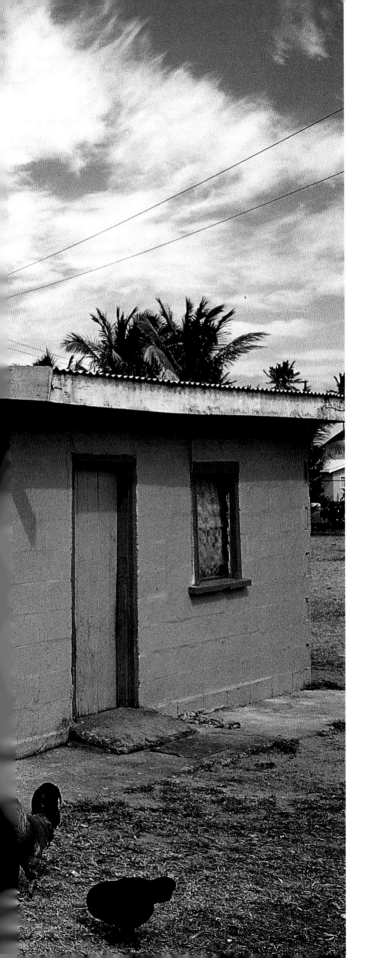

FIJI

An extraordinary diversity characterises the islands of Fiji. Of its thousands of islands, just over 300 are inhabited by Polynesians, Melanesians, Micronesians, East Indians, Chinese and Europeans, all of whom have made a distinctive contribution to the culture of the young republic.

Each racial group has preserved many of its traditional customs, which makes travelling in Fiji a fascinating experience. Most of its islands are volcanic, the two largest – Viti Levu and Vanua Levu – accounting for 87 per cent of Fiji's land area. Coastlines are fringed with coral reefs whose many dramatic crevices have always been an irresistible magnet for divers.

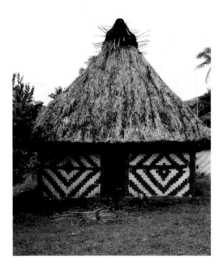

This *bure* or house at the village of Tobu has woven bamboo walls and a *gisau* reed roof.

(Opposite) The painting of this plastered brick house on the Coral Coast of the island of Viti Levu is quite typical. Both Fijians and Indians favour the brightest hues, often in sharp contrast.

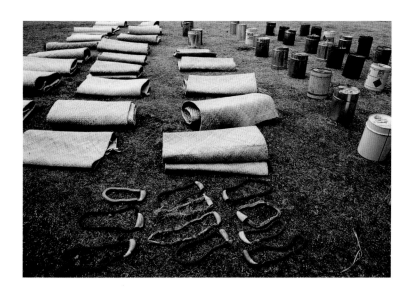

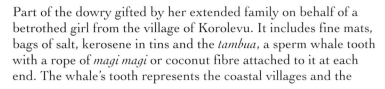

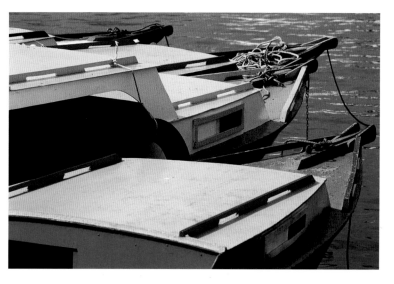

Part of the dowry gifted by her extended family on behalf of a betrothed girl from the village of Korolevu. It includes fine mats, bags of salt, kerosene in tins and the *tambua*, a sperm whale tooth with a rope of *magi magi* or coconut fibre attached to it at each end. The whale's tooth represents the coastal villages and the fibre the inland ones. *Tambua* have great value and are commonly exchanged at important functions.

(Above) The Fijian love of colour extends to these ocean-going fishing boats from Lautoka.

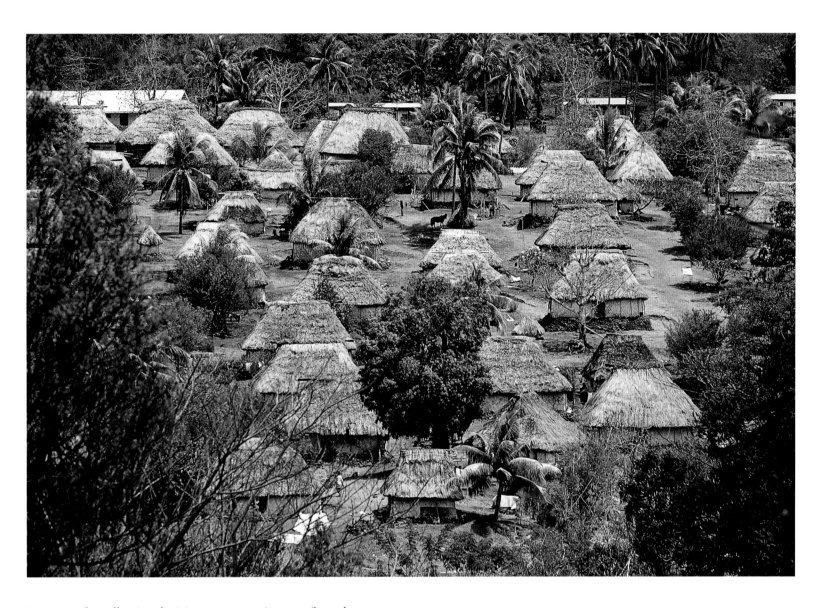

Because of a collective decision not to use iron roofing, these *bure* at Navala village inland on Viti Levu have the traditional pandanus leaf roof and cane sides.

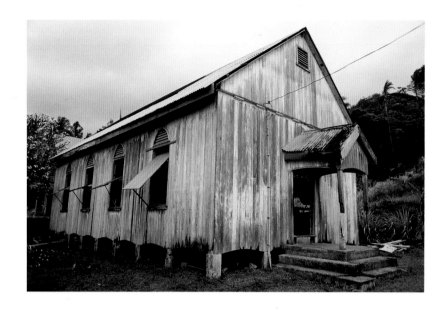

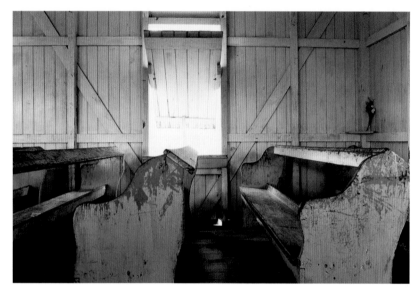

The wooden Wesleyan Church of Fiji at Vuna on the island of Ovalau was built in 1924. The wall hanging depicting Leonardo da Vinci's Last Supper is often found in Fijian churches.

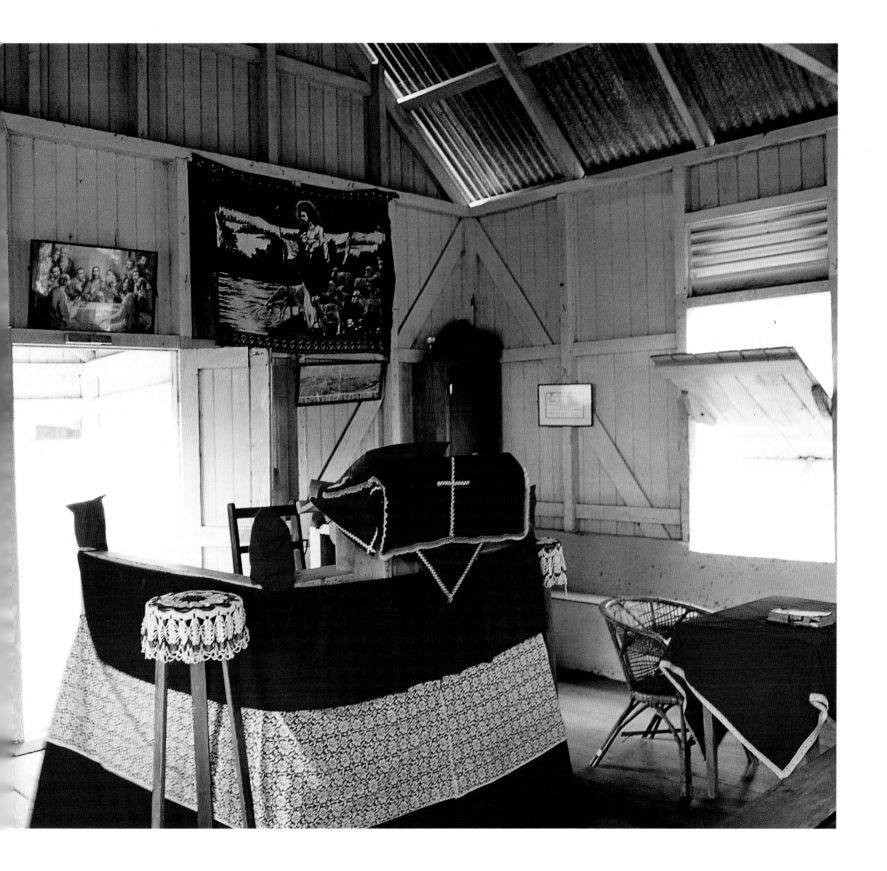

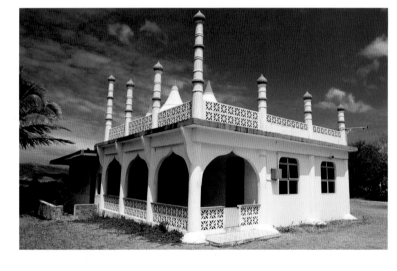

The Maro Jane Mosque at the village of Maro on Viti Levu was built by the Fijian Muslim League in the early 1970s. Twenty per cent of Fiji's Indians are Muslim while the rest are Hindu. All are descendants of indentured labourers brought to Fiji as employees of the Colonial Sugar Refining Company in the years after 1879. The elaborately painted Arulmigu Sri Siva Subrahmanya Swami Temple at Nadi (bottom and far right) is a centre of Hindu worship.

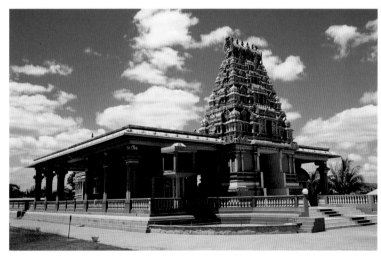

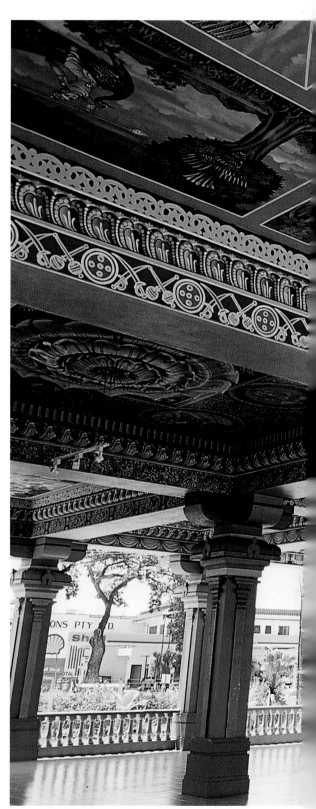

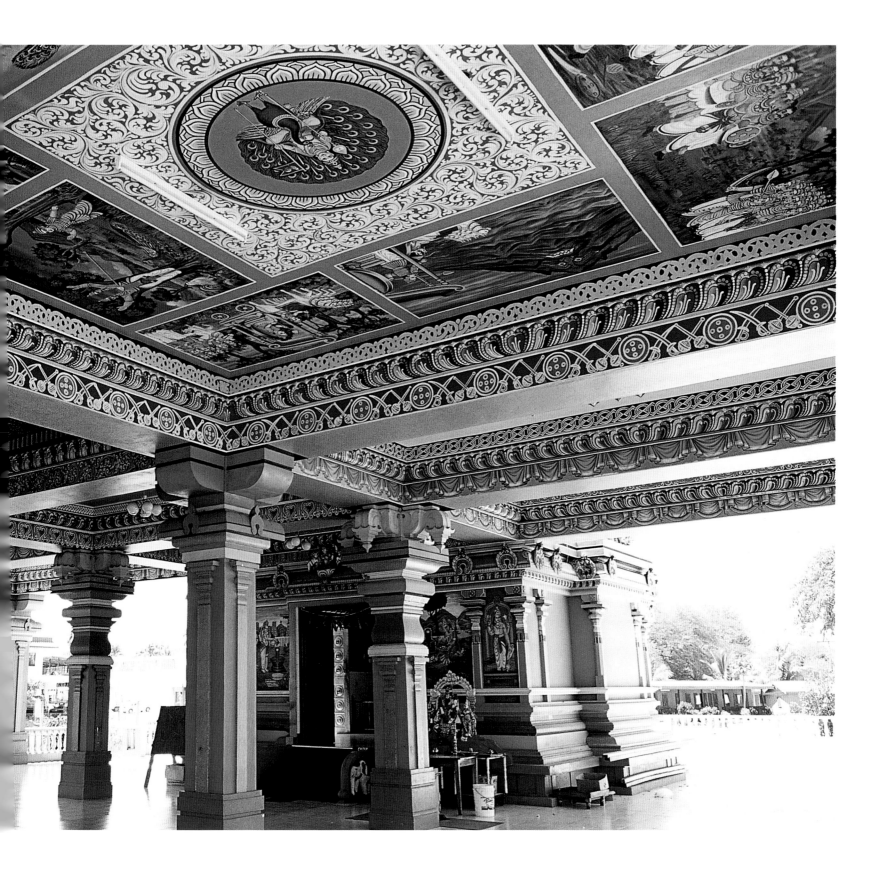

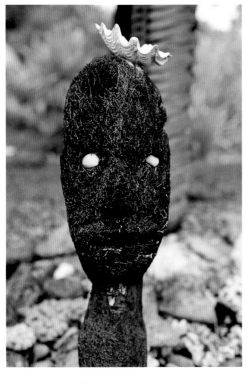
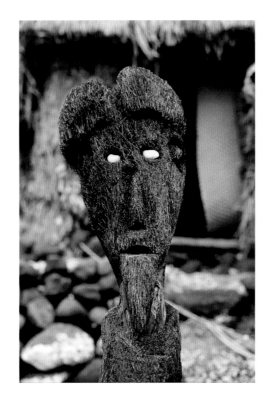

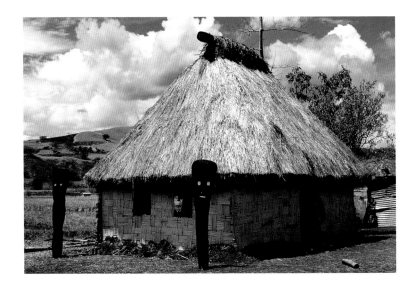

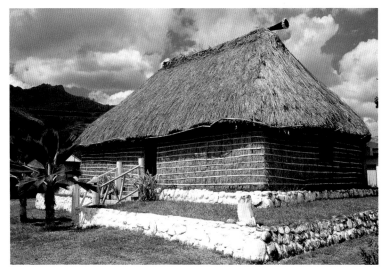

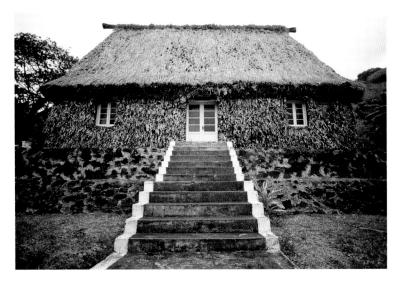

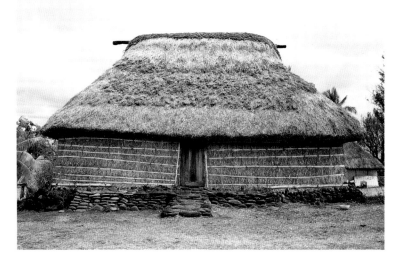

A house set above ground level on stone platforms denotes the high rank of its owner, as does the presence of white cowry shells wrapped around the central roof pole. The *bure* at bottom left is built on the original *yaru* or raised foundation where in 1874 the Fijian chiefs who ceded Fiji to the British met.

(Opposite and top left) Guardian figures made of the root end of the *balabala* tree are often found outside houses.

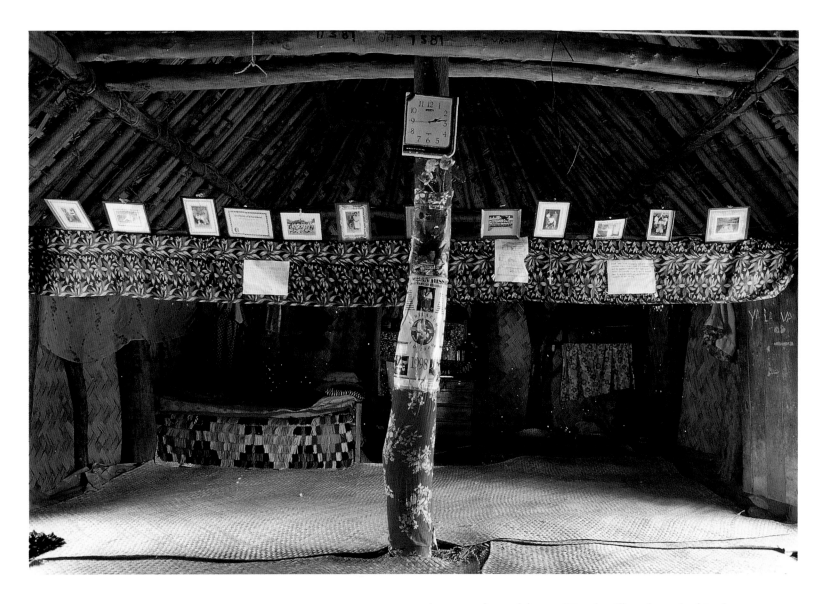

An open planned *bure* at Navala village has a bed in the corner and pandanus mats on the floor, with straw laid underneath to give a soft tread.

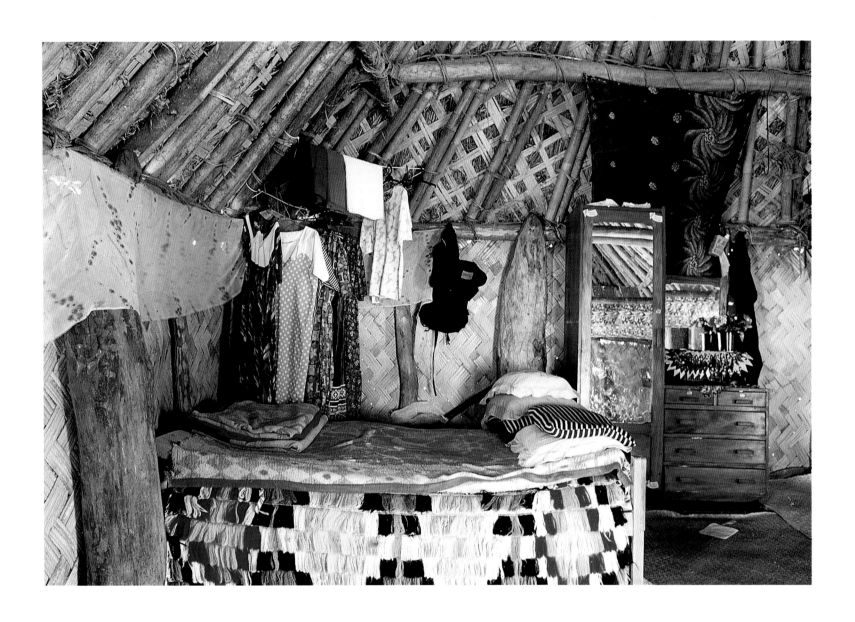

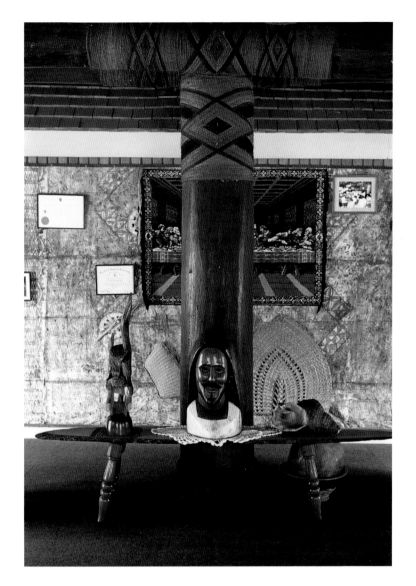

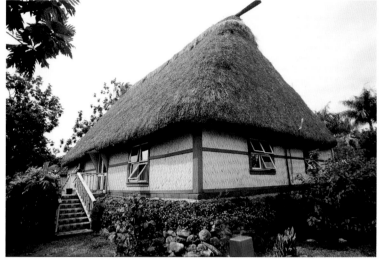

The house of Dr Timoci Bavandra, the main opponent of the 1987 coup which led to the formation of the Republic of Fiji. When Dr Bavandra died aged 55 in 1989 his house was retained as it existed in his lifetime as a memorial. The house is situated at Viseisei and is a traditional *bure* in both design and construction. Sixty thousand people came here on the day of his funeral, making it the largest in Fiji's history. The large painting (opposite) is of Dr Bavandra himself.

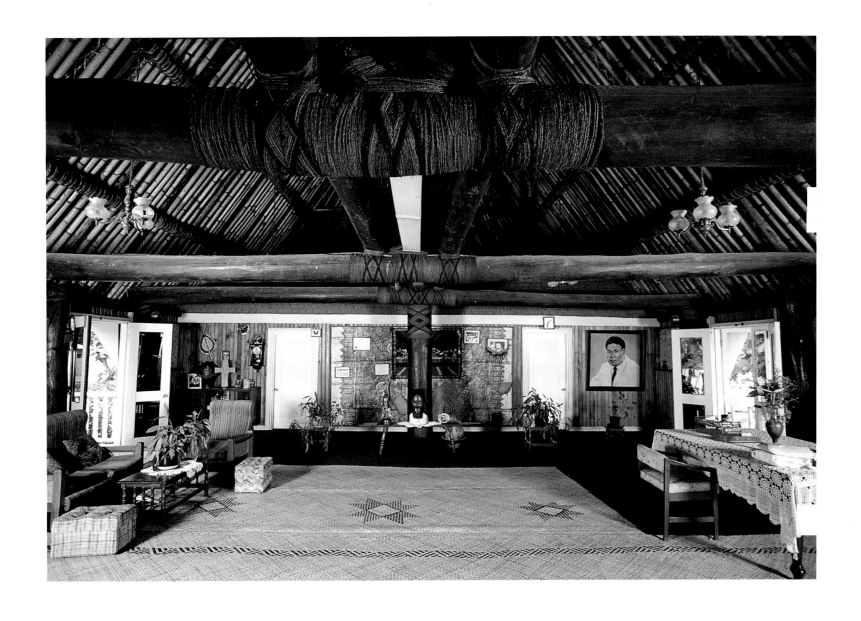

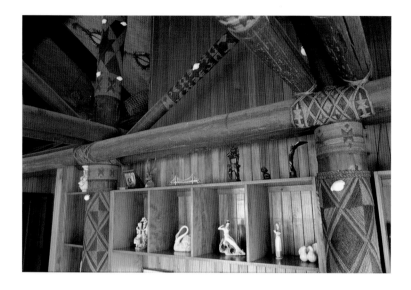

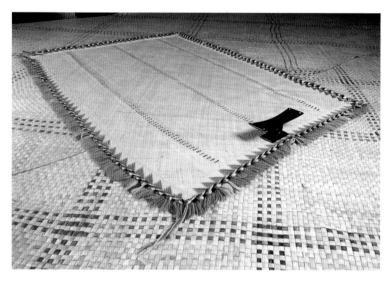

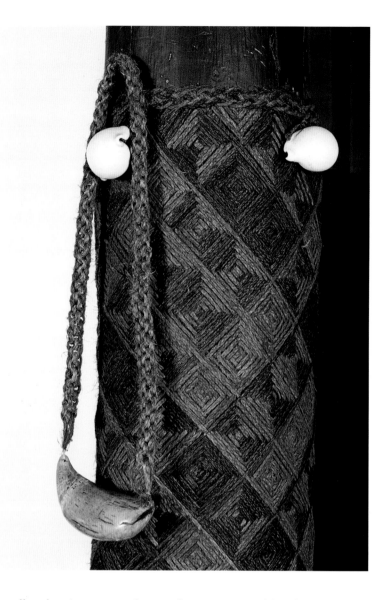

Inside this house called Natuaniarawa, at Natalau, emblems of chiefly rank abound: there is the *tambua* and cowry shells woven into the roof as well as magnificent large pandanus mats. On the smaller sleeping mat, or *loga*, with a woven wool border, sits a traditional head rest or *kali*.

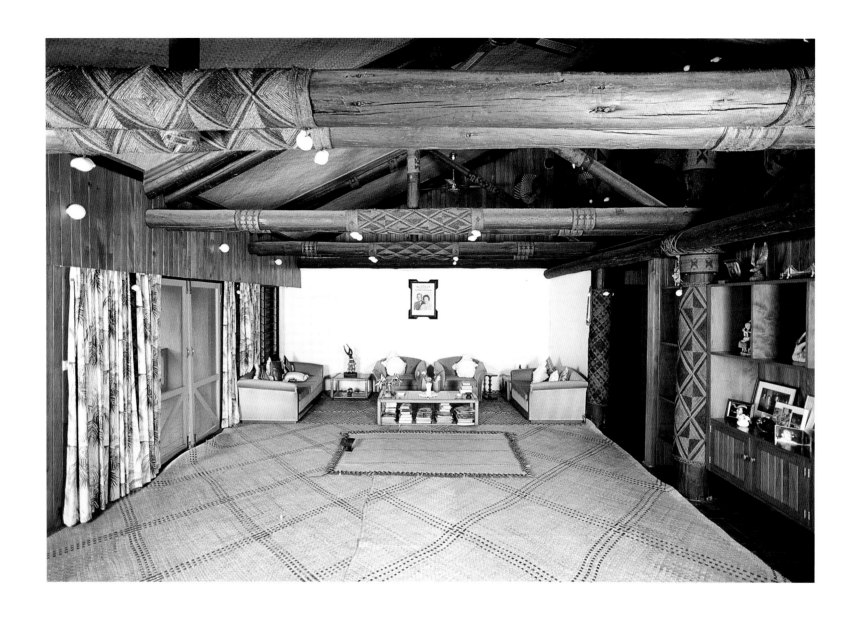

137

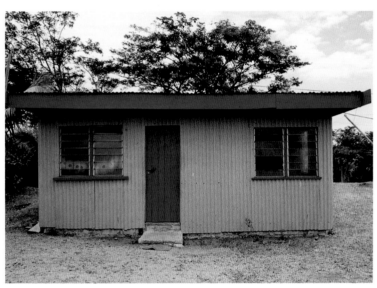

Houses belonging to Indian cane workers are customarily painted in the most intense colours, of which purple seems to be a strong favourite.

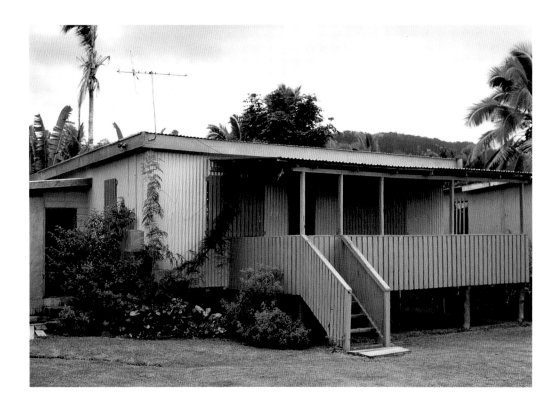

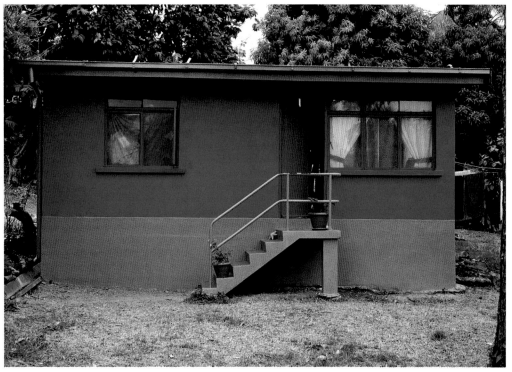

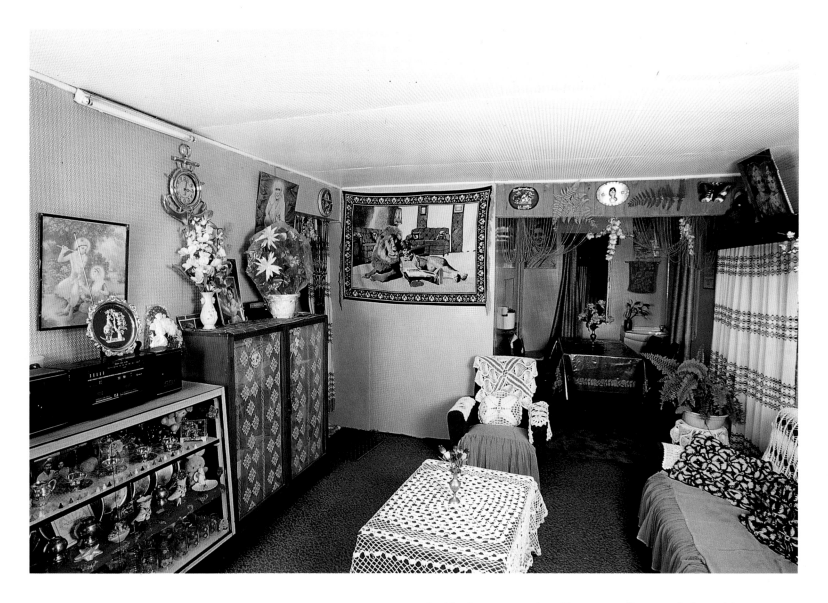

Inside the cane workers' houses surfaces are laden with ornaments and mementoes. Furniture surfaces are always protected with coverings of lace or a brightly coloured fabric.

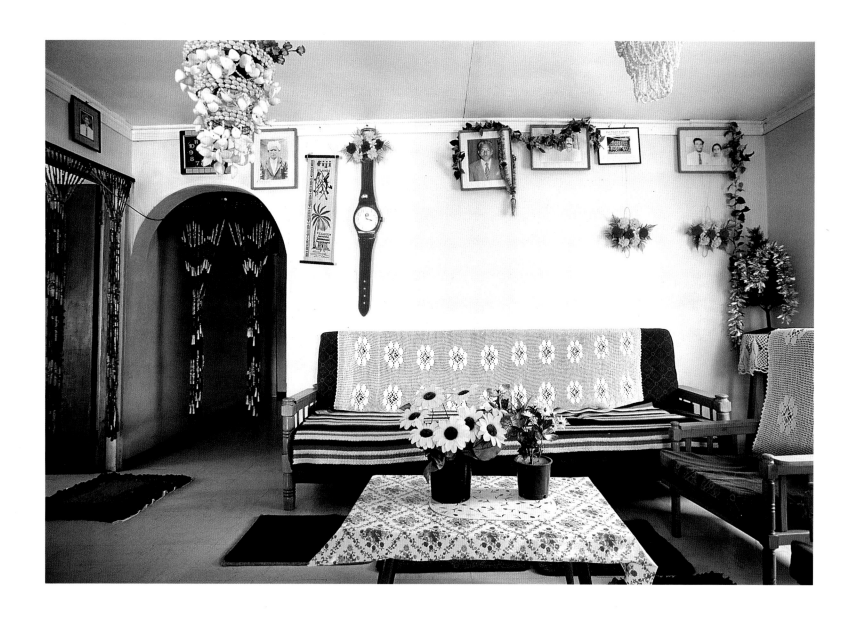

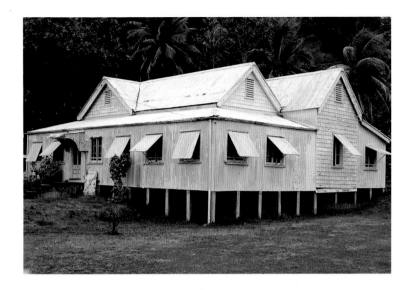

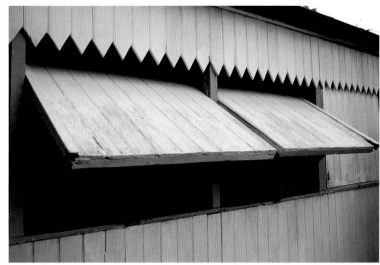

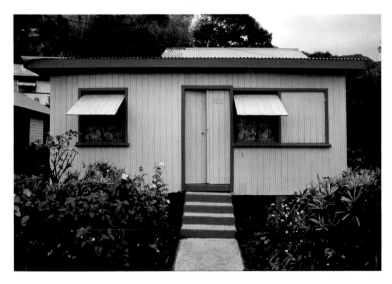

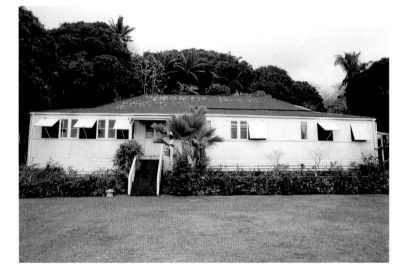

At top left is the former British Residence at Ovalau on Levuka, the first British capital of Fiji. It was here in 1874 that Fiji was proclaimed a British colony after Ratu Seru Cabokau, King of Fiji, decided to cede his kingdom. The house was damaged by fire and rebuilt between 1906 and 1912.

The 1880 Patterson House, above, on Levuka, called Nigau Hill, was built from imported Canadian Oregon pine and Californian redwood. The windows are angled to catch the updraught of wind rising from the sea.

Further examples of the angled window style are shown above left and top right. Opposite is an interior view of this very efficient cooling system.

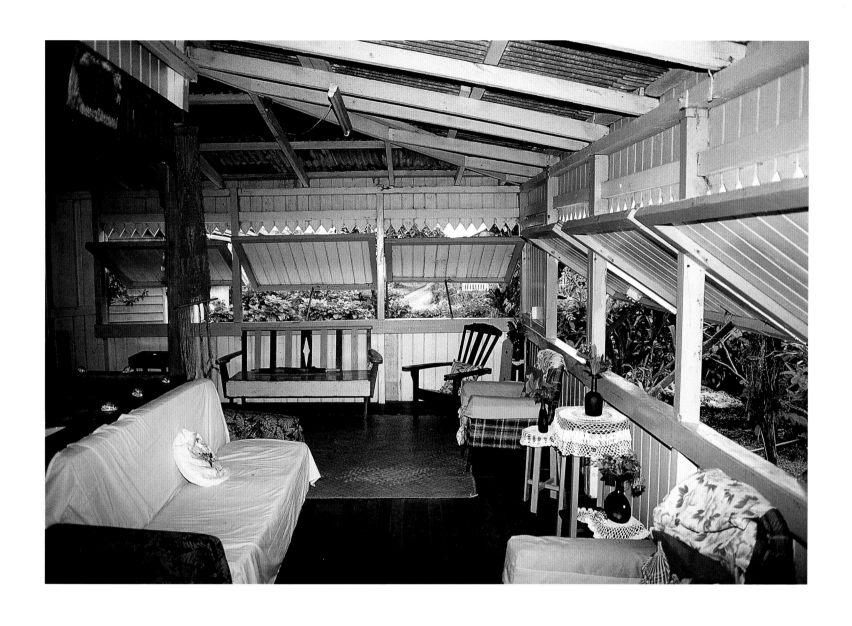

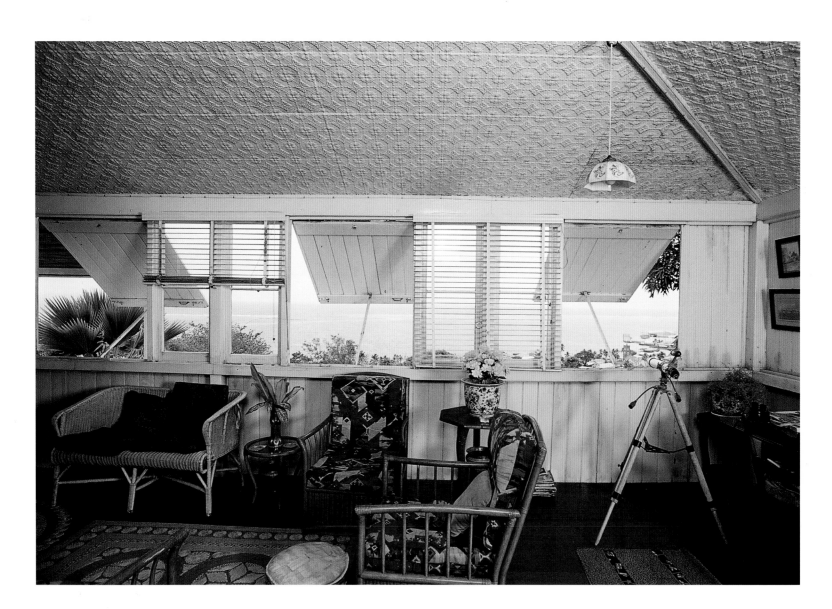

In tropical climates like Fiji's people like to sit out on shaded verandahs rather than inside rooms cut off from the outdoors. Houses are often completely surrounded with verandahs so that it is possible to move to the area with the greatest amount of draught. It is as though a sitting room wraps around the whole house.

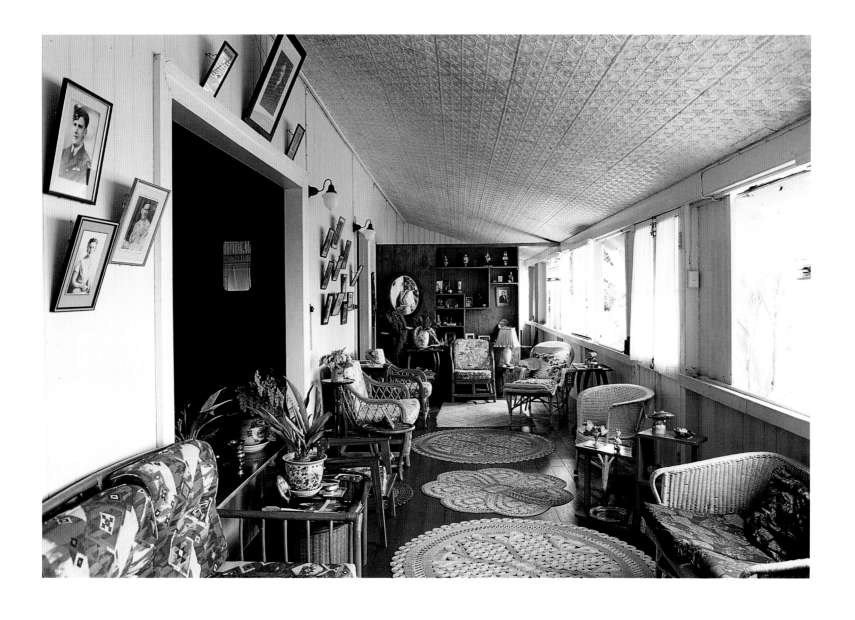

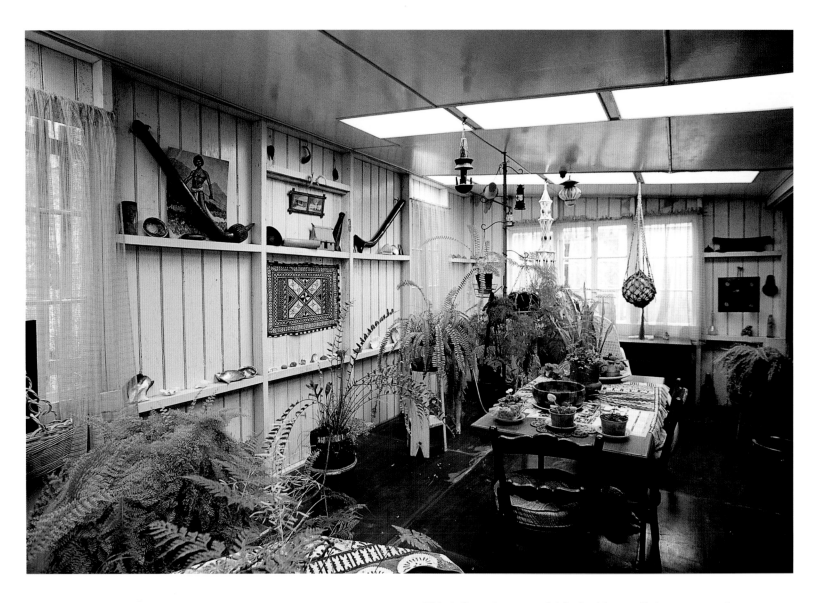

This informal room, which doubles as dining room and conservatory, is unlined and its framing timbers are used to display a collection of Pacific Island artefacts.

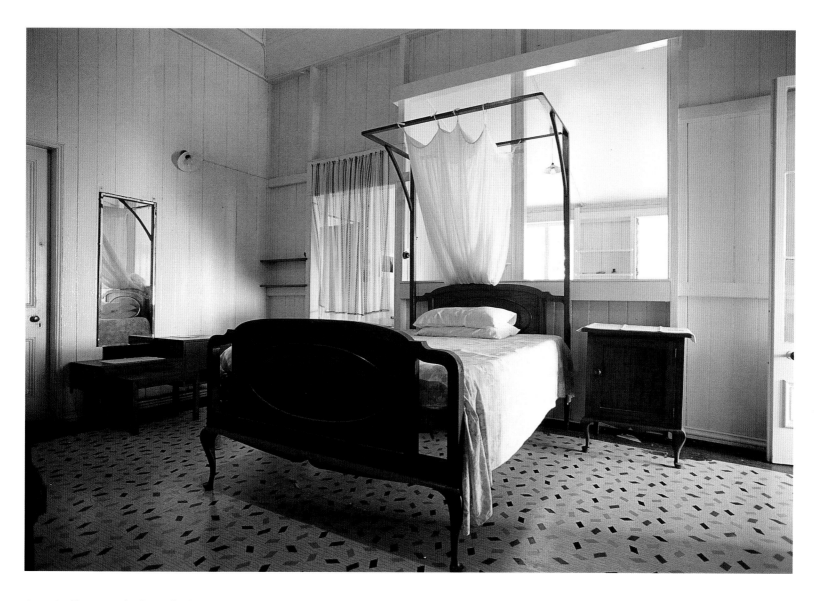

A typically sparsely furnished bedroom with iron bedstead and the essential mosquito net. Solid pieces of furniture tend to block the flow of air, so are generally avoided.

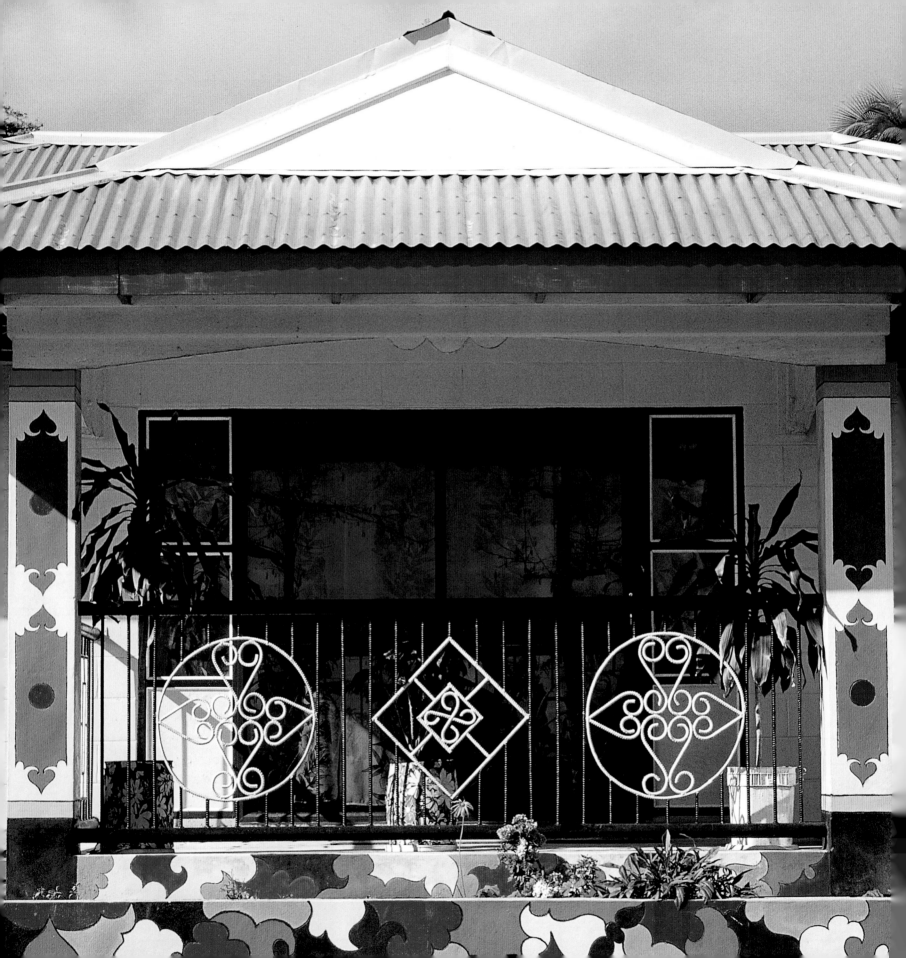

SAMOA

Brightly painted flower and wrought iron patterns adorn the end wall of a modern Samoan *fale* or house. Unusually, this *fale* is not open to the breeze but has glazed windows.

Situated in the eastern Pacific Ocean, the islands of Samoa are volcanic mountains rising out of the sea, their peaks covered in rain forest and their cultivated coastal plains ringed by coral reefs and shallow lagoons. Cooled by South East trade winds, these islands support a lush vegetation nurtured by a warm climate which provides long periods of sunshine even during the rainy months.

Of the country's nine islands, four only are inhabited: Upolu, the most populous; Savai'i, the largest; Manono and Apolima. The capital is Apia, on Upolu.

Samoa was settled by Polynesians in about 1000 BC. In 1830 Rev. John Williams of the London Missionary Society was welcomed by the chief Malietoa Vai'inupo. By 1840 most Samoans had been converted to Christianity. German colonial influence dominated the country from 1856 until the beginning of World War I, after which Samoa was politically closely linked with New Zealand until it was granted independence in 1962.

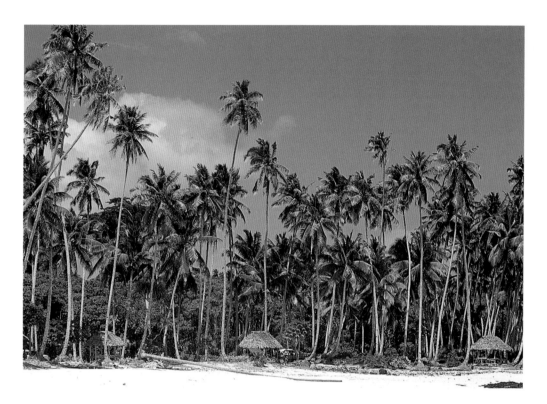

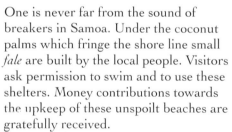

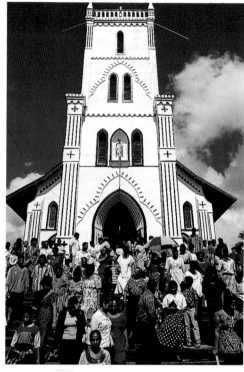

One is never far from the sound of breakers in Samoa. Under the coconut palms which fringe the shore line small *fale* are built by the local people. Visitors ask permission to swim and to use these shelters. Money contributions towards the upkeep of these unspoilt beaches are gratefully received.

The Church of the Sacred Heart on Upolu, built out of coral mortar between 1916 and 1936, was recently re-painted by the men of the congregation. On Sundays after the service it throngs with people who love to stand about chatting dressed in their best. This is the major social occasion of the week.

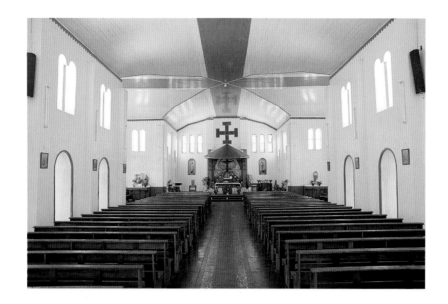

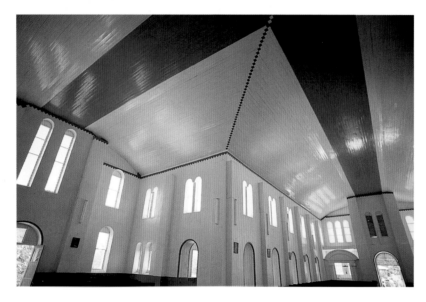

The Agelo Tausi Church on Upolu. The cross and circle on the central tower are painted exactly the same colour blue as the sky and therefore read as a void. Inside, the church's chief glory is its magnificent coved wooden ceiling.

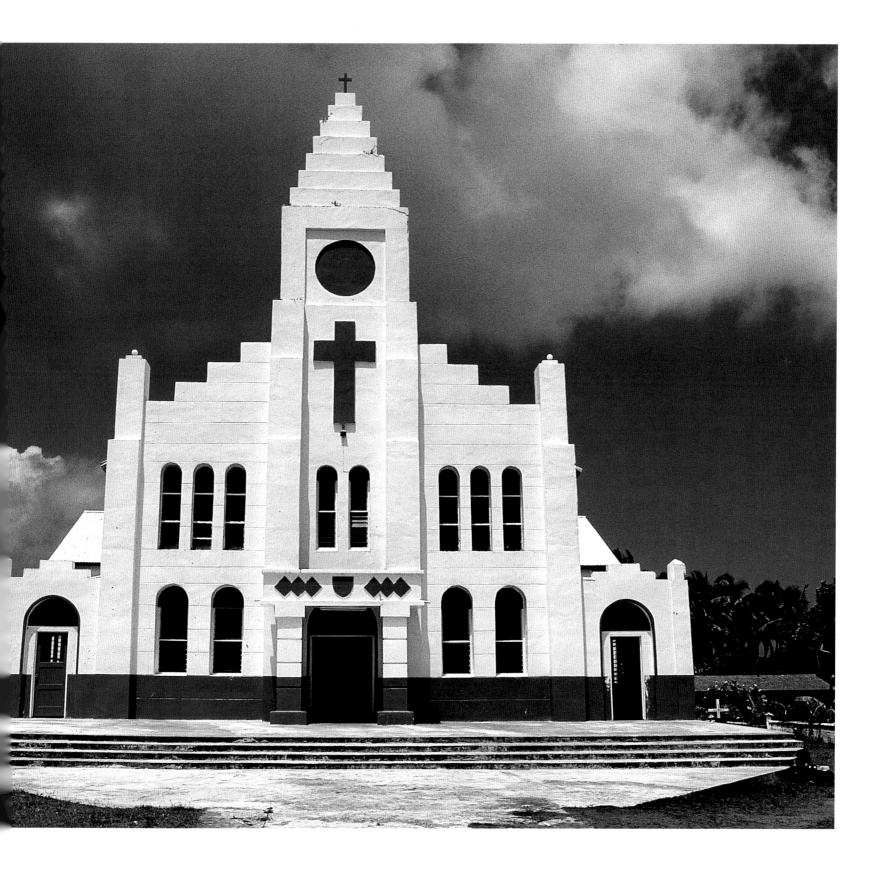

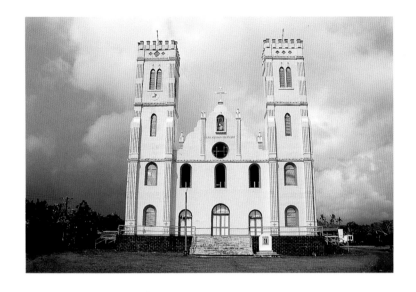

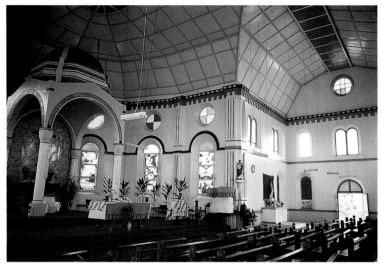

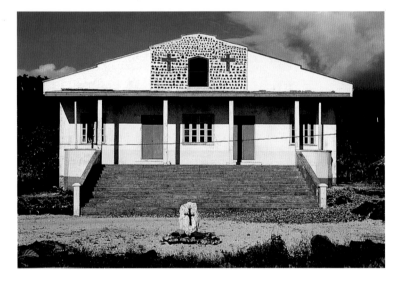

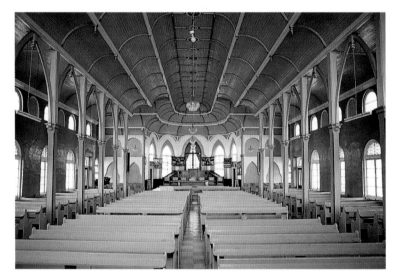

(Above) The Papa Methodist Church on Savai'i Island was built by men from the local village.

(Top left) The neo-Gothic Malumalu Aso Gata'aga Church on Upolu is situated in the grounds of Pope Paul VI College but is used by everybody in the local community. Its vibrant interior is shown top right.

Above is the interior of the Sapapali'i Methodist Church.

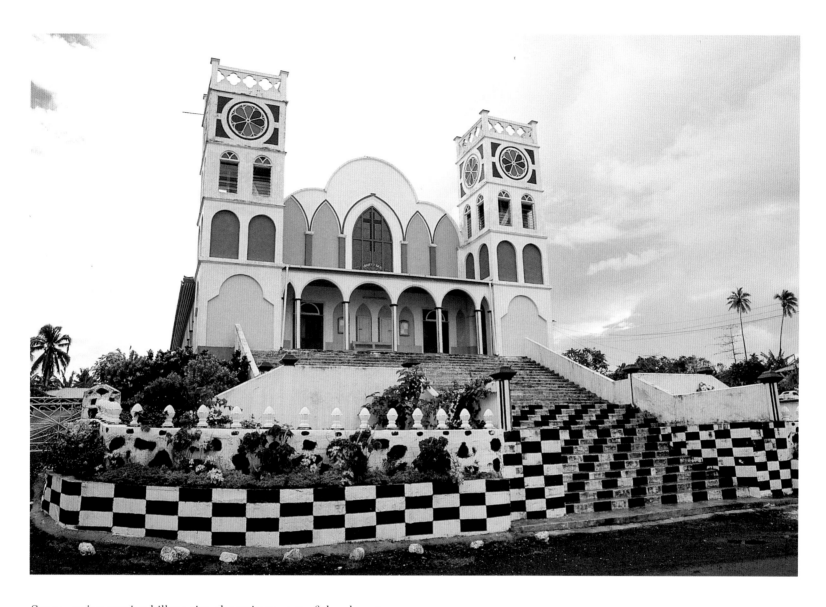

Set on an impressive hilltop site, the twin towers of the almost
Byzantine Sapapali'i Methodist Church on Savai'i commemorate
the arrival of Christianity in Samoa.

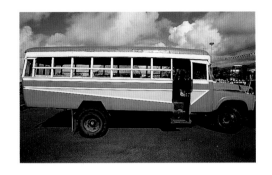
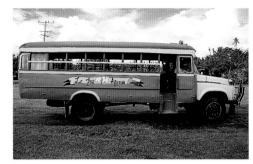
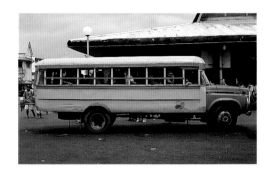
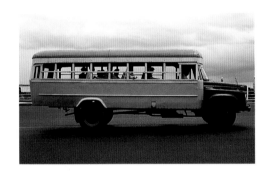
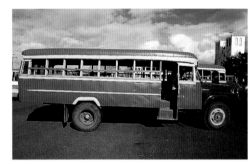
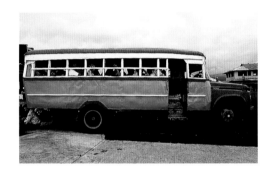
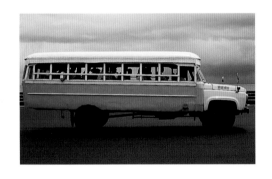
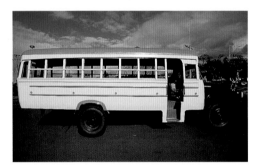
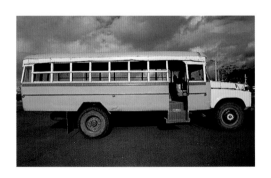
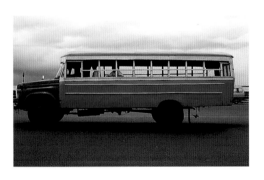
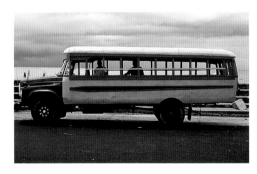
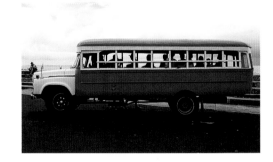

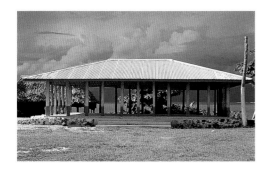
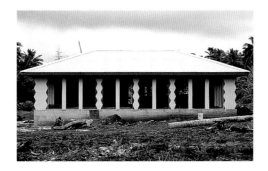
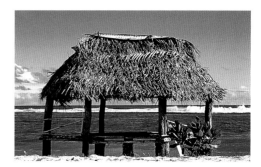
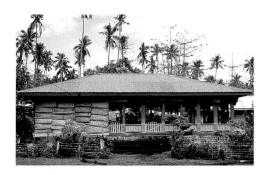
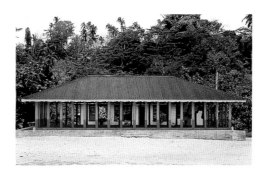
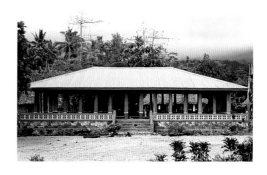
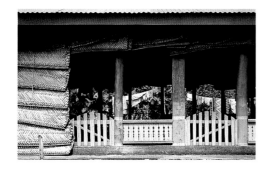

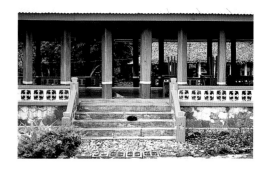

(Opposite) While the chassis and cabin of these brightly painted buses are imported from Japan, the coach work is made locally of beaten iron over a wooden framework. Each is colour coded according to destination. A ride in one of these airy buses is a good way to keep cool in Samoa.

Samoan *fale* are built without walls near the sea in order to take advantage of the breeze. Larger dwellings are equipped with blinds intricately woven from coconut fronds. These are lowered to keep the rain out.

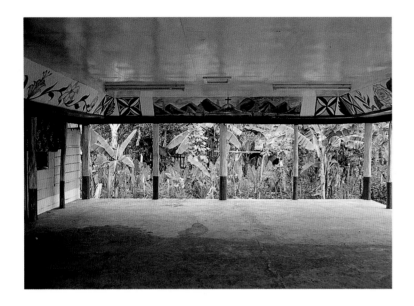

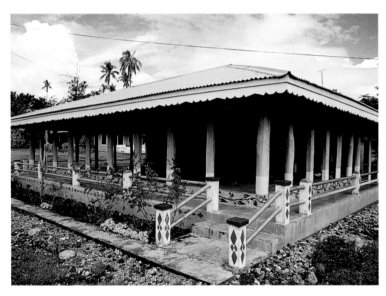

The decoration of the wooden ceilings of *fale* takes its inspiration from the flowers and leaves of the local vegetation and from religious symbolism. The rich creamy-yellow frangipani, the deep orange hibiscus or the brilliant red of Samoa's national flower, the *teuila*, are the most favoured images.

Sometimes the paint is applied to look like printed fabric or else an abstract pattern of flower petals is devised in the brightest colours. It is no wonder that Samoans who live surrounded by an intensely coloured vegetation should have such vivid colour sense.

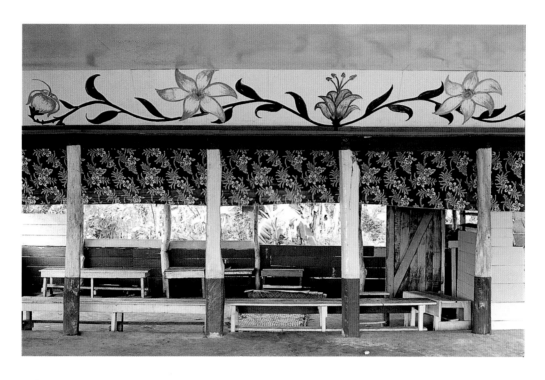

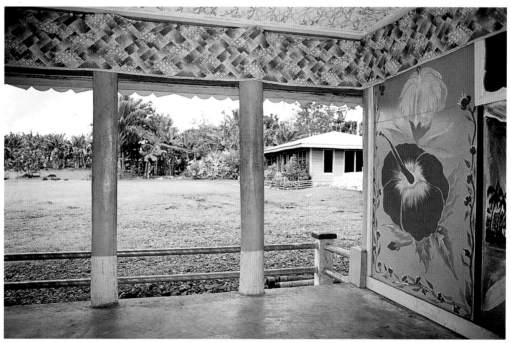

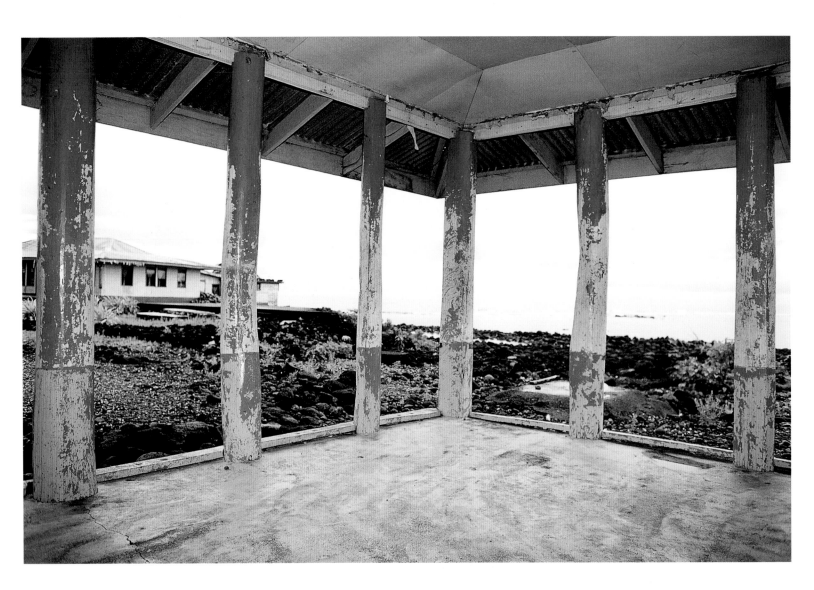

Although its shape remained the same, in the 1960s the traditional *fale* without walls was clad in weatherboard and given an iron roof as a protective measure.

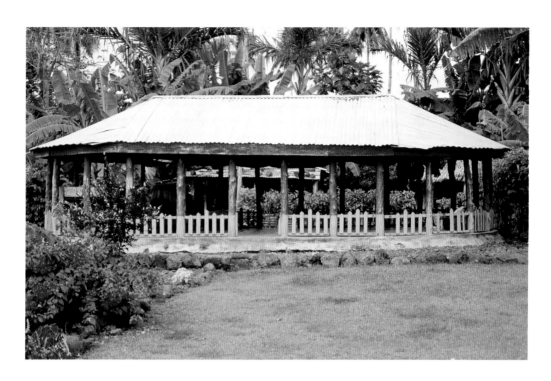

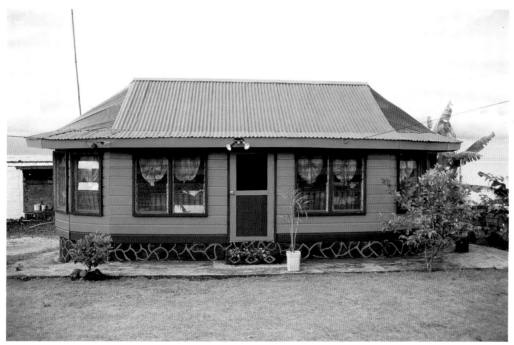

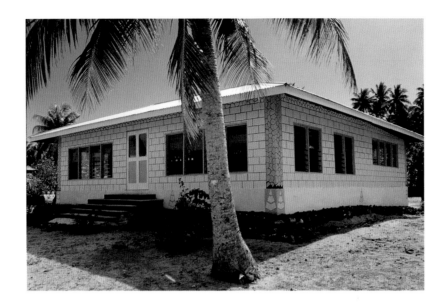

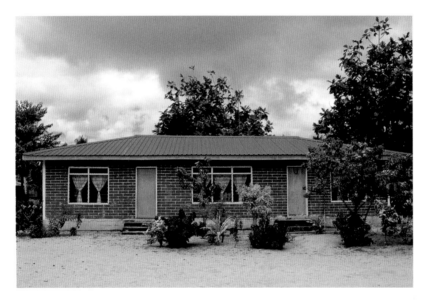

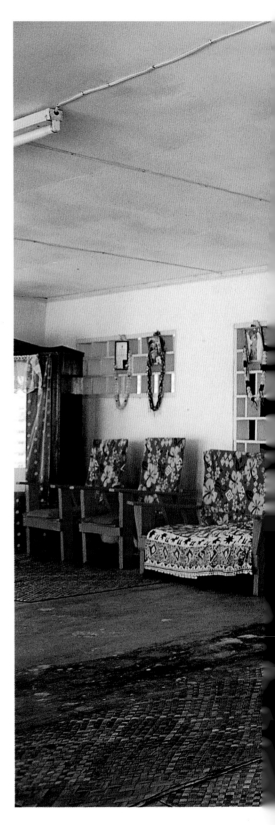

Brick hurricane houses were even more durable. Inside, open lattice woodwork ensured that the flow of air could be maintained. Privacy was never a major concern in the Samoan house.

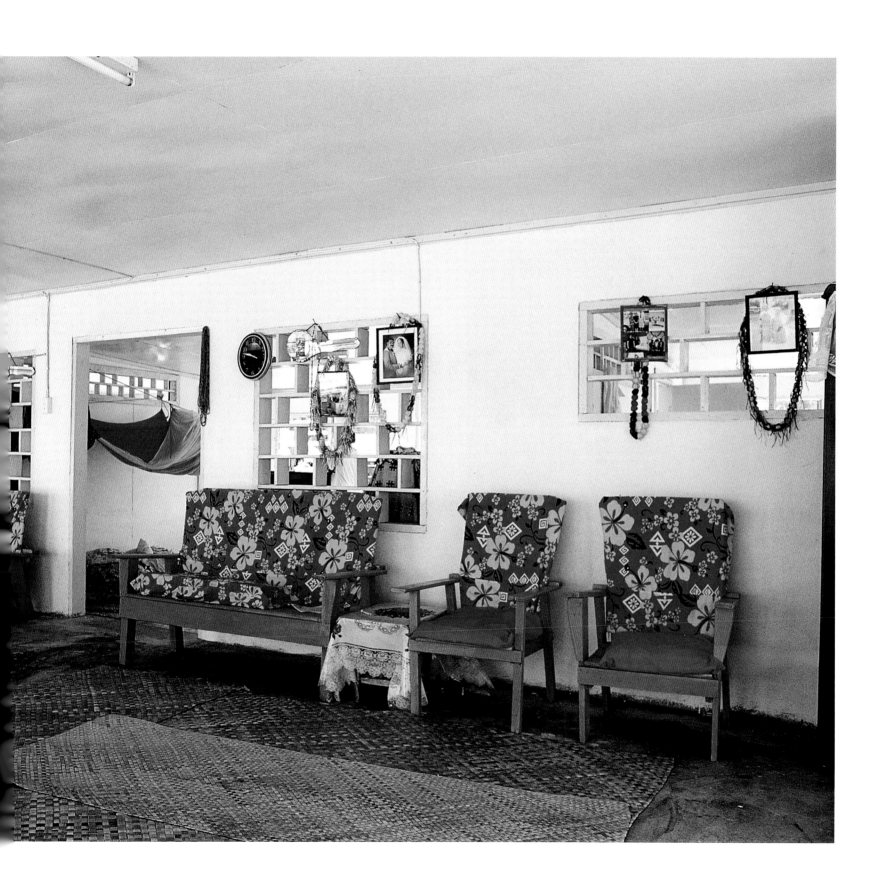

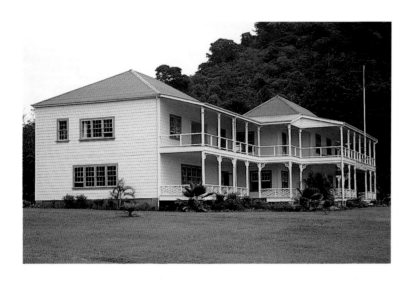

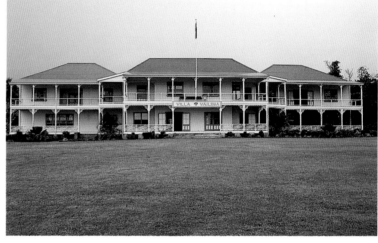

In 1889 the great Scottish novelist and poet Robert Louis Stevenson bought a bush property at the foot of Mt Vaea, just outside Apia. He named it Vailima or "five waters". Here he built a magnificent wooden two-storied villa with extensive verandahs and surrounded by gardens. In later years, after the house had two wings added, it became the residence of the German Governor and later the residence of the Head of State, His Highness Malietoa Tanumafili II. Since 1994, when it was restored, it has been known as the Robert Louis Stevenson Museum.

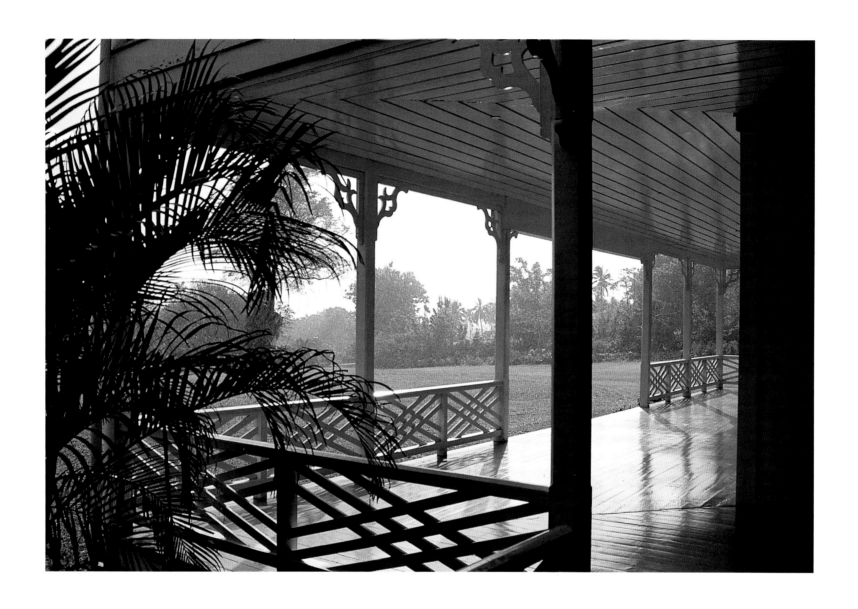

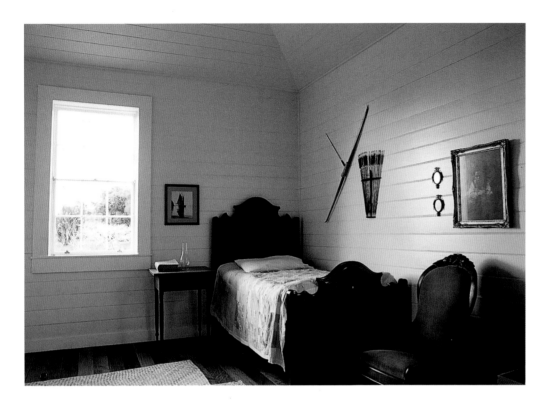

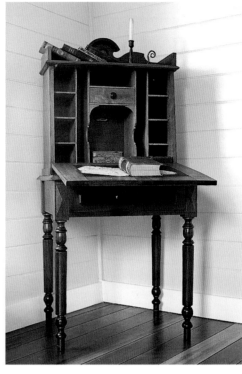

Inside the Stevenson Museum floors are covered with elegant Persian carpets and woven Samoan mats. The walls of the Tapa Room (opposite left and following pages) are covered with *siapo* – tapa cloth decorated with inked patterns. Other items of furniture in the guest room and bedroom were brought from Europe.

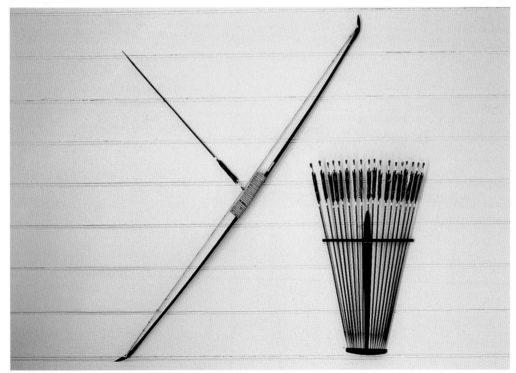

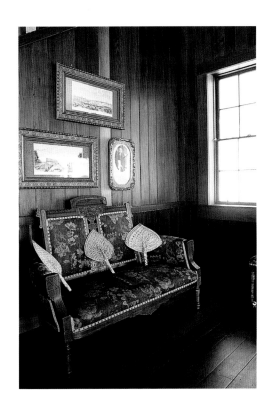

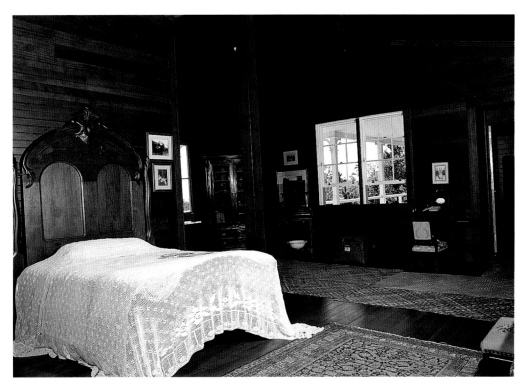

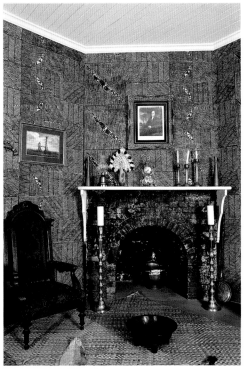

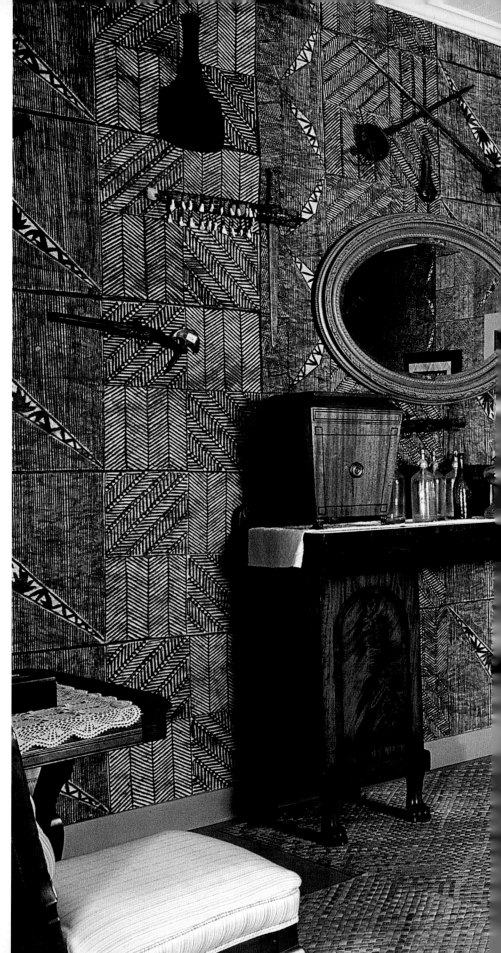

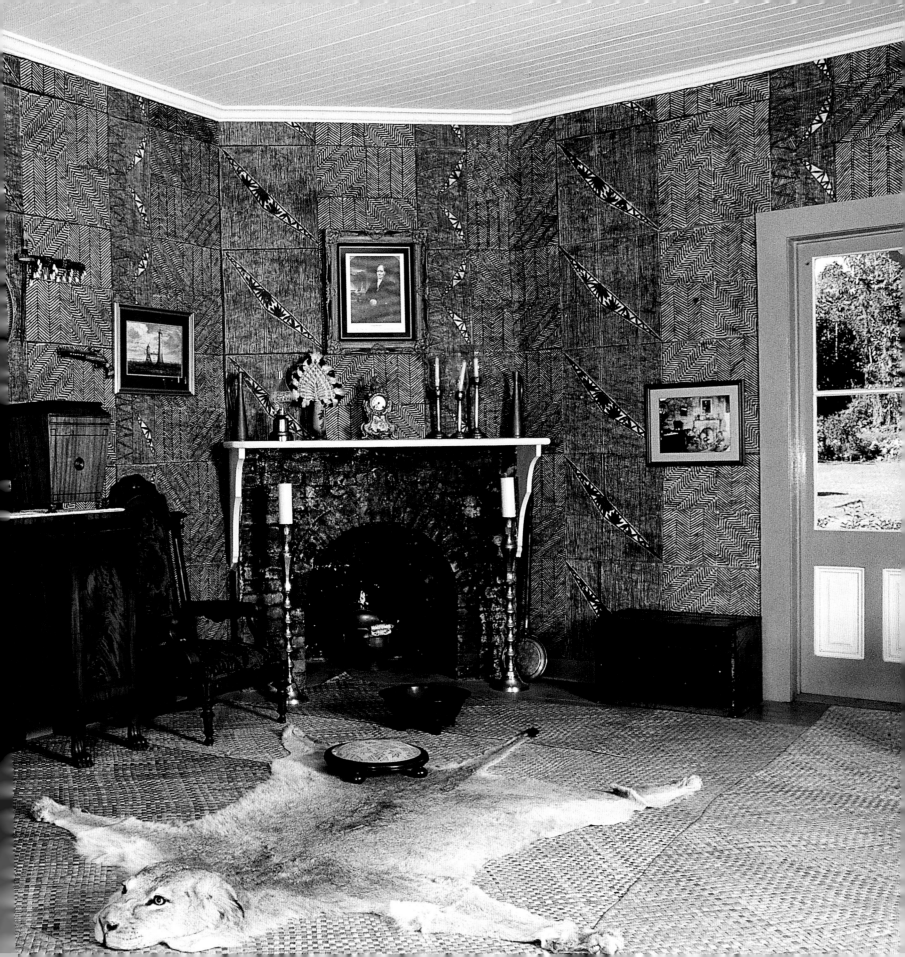

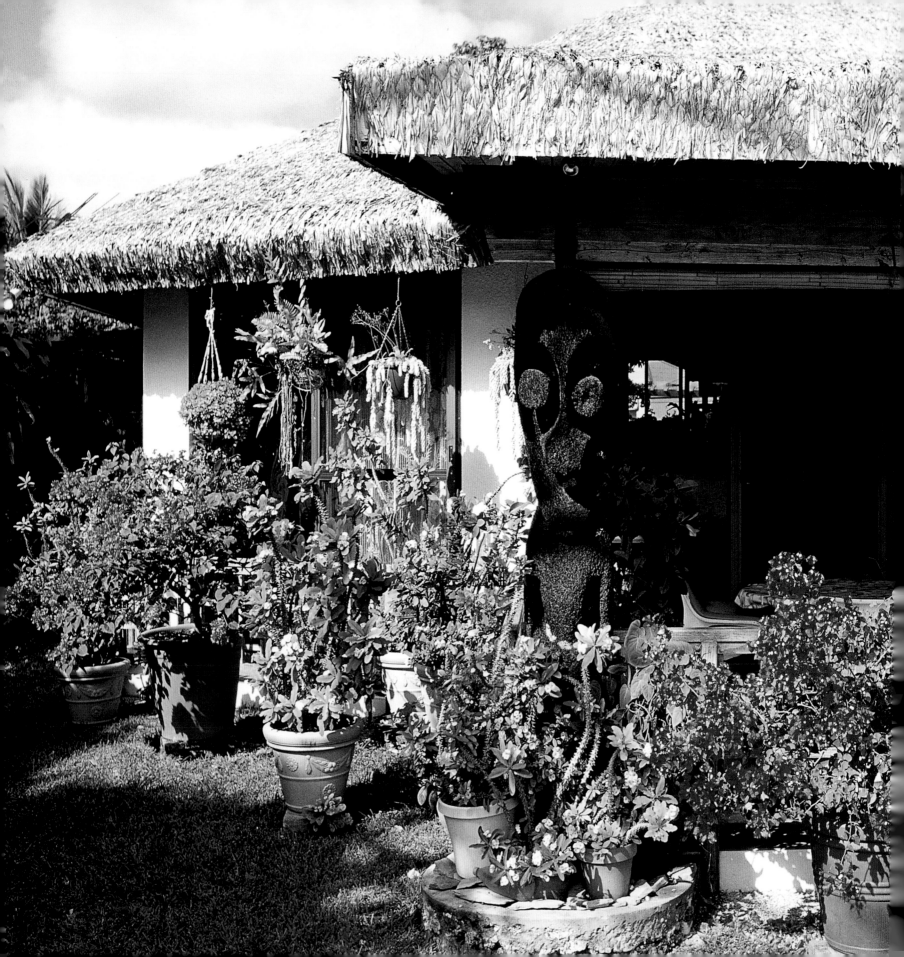

VANUATU

Eighty-two islands make up the Ripablik Blong Vanuatu, as it is known in the national Bislama pidgin. Formerly the New Hebrides islands, Vanuatu became independent from the cumbersome dual British and French condominium administration in 1980 after a ten-year struggle for a Melanesian national identity. Geographically fragmented, Vanuatu is a country characterised by enormous diversity: 113 distinct languages are spoken as well as many more additional dialects. Many ni-Vanuatu speak a number of these as well as Bislama, English and French. There is also a wide variation in forms of social organisation, ritual life, cultural and artistic expression.

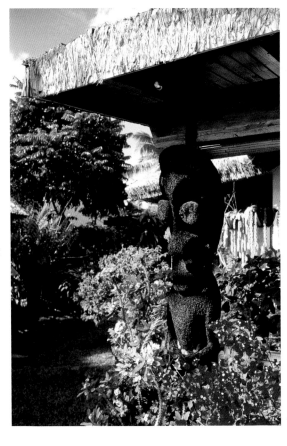

Bougainvillea in pots surround the house of Dominic and Edwina Dinh, a couple of French and Vietnamese origin who chose to make Port Vila their home, which is watched over by a male guardian figure. The roof is made of sago palm leaves woven together.

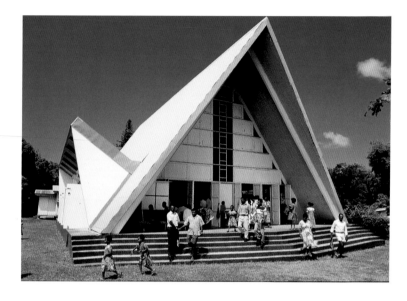

The Easter Sunday congregation leaves the modern PMC Church built in the mid 1980s at Independence Park, Port Vila. The roof pitch reflects that of much local architecture, where it is essential to deflect torrential rain.

(Right) Slit drums were traditionally used by chiefs to summon people for meetings. Their carved heads signify their function as spiritual protectors.

(Opposite) Outrigger sailing canoes, like this one at Wala Island off Malekula are used for moving cargo between islands.

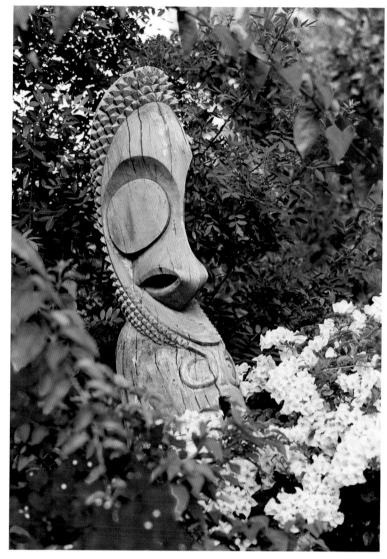

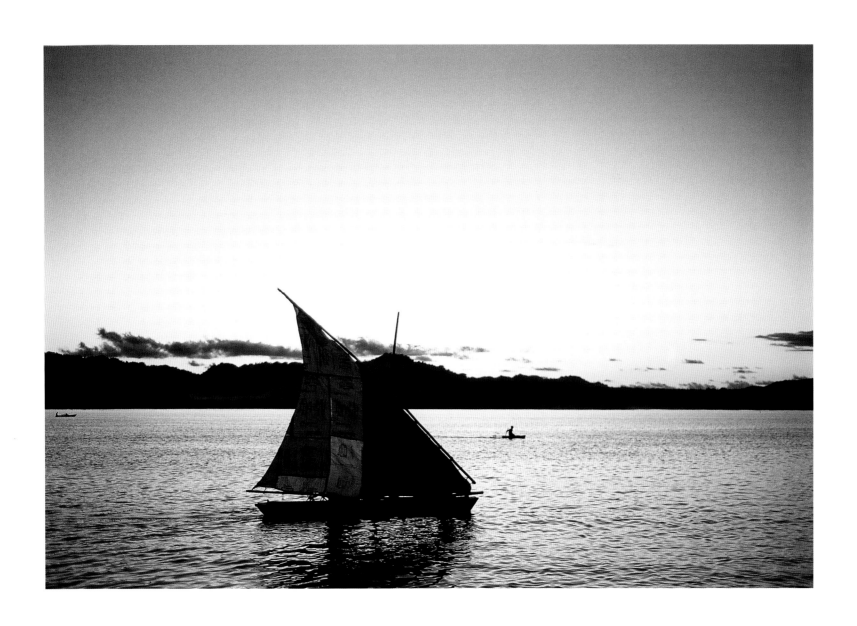

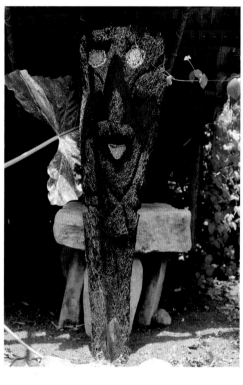
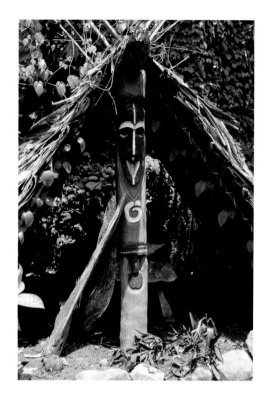
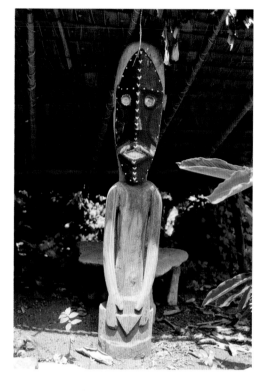
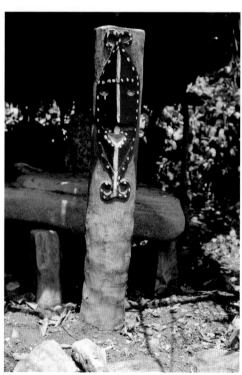
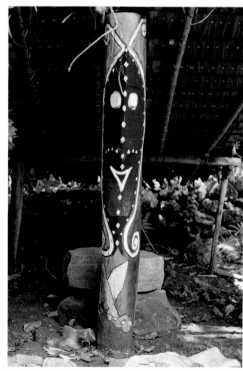
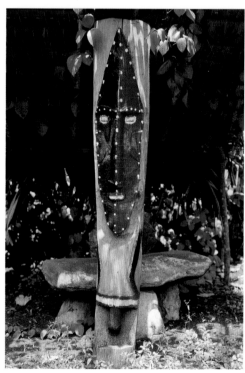

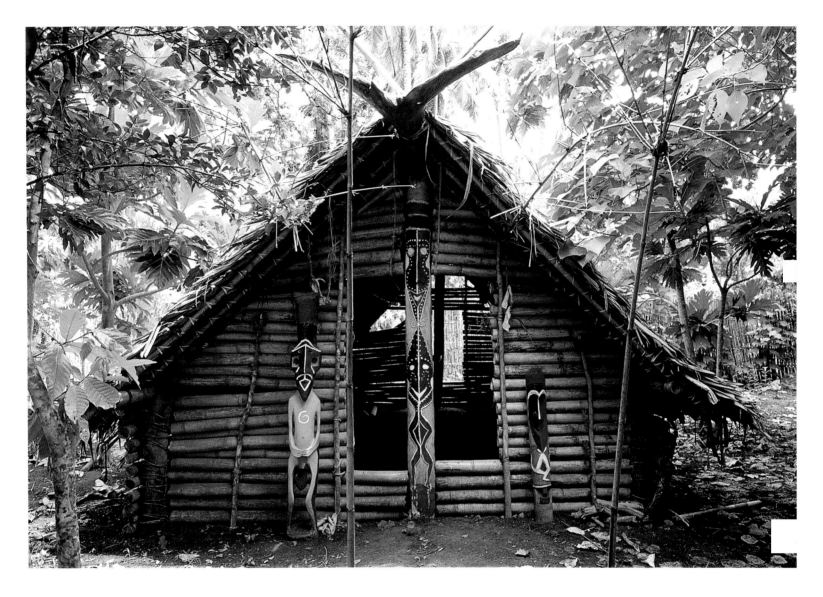

The ceremonial house of Chief Emile Talibu is built of split cane.
Its gable is dominated by a carved wooden frigate bird whose
function, like that of the house guardians at the door, is to keep
its inhabitants safe.

(Opposite) A large meeting area at Ami Boas on Malekula is sited
at the centre of ten villages and is decorated with wooden statues
representing the gods of each village.

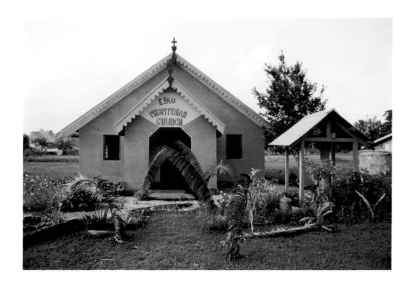

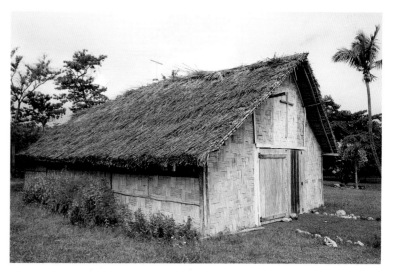

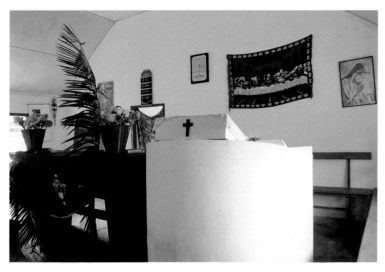

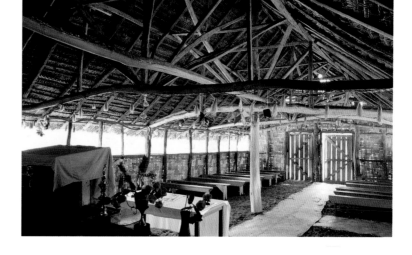

The modern Epua Presbyterian Church at Port Vila is made of crushed limestone concrete blocks and is designed to last.

By contrast, cane walls and reed roofs are commonly used in the construction of traditional buildings such as the Loukatai Presbyterian Church which is only ten years old. The cane is split, then wet to flatten it and finally left to dry in the sun, after which it becomes pliable enough to weave.

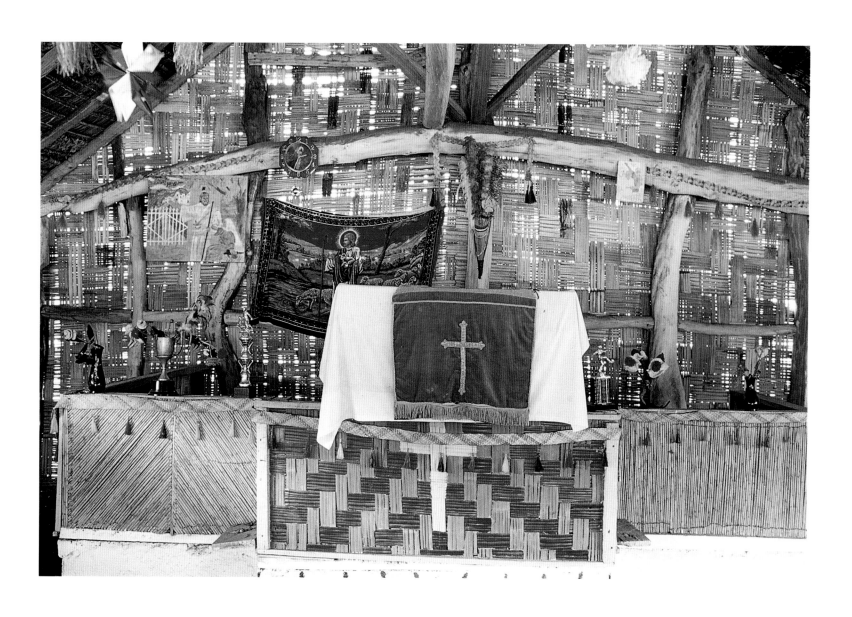

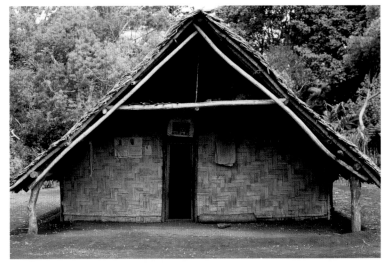

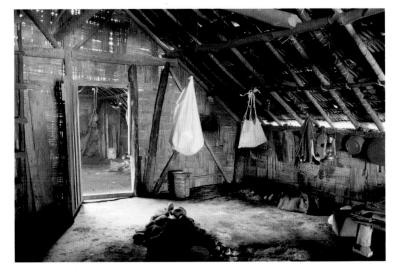

This house under construction at the village of Lenakel on Tana Island has a frame of *burðo* wood which is clad with split bamboo and painted on completion.

At Tanofo village on Espiritu Santo the house of the paramount chief's wife has no windows because the bamboo walls breathe. The interior is shown opposite top.

(Opposite) Wild cane bound at the top and placed over a hardwood frame were used in the construction of this circular house at Epule village near Port Vila.

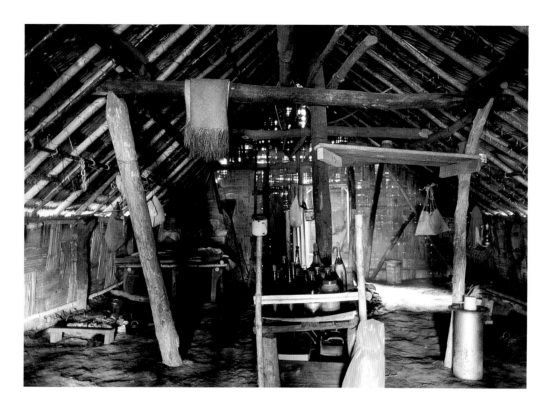

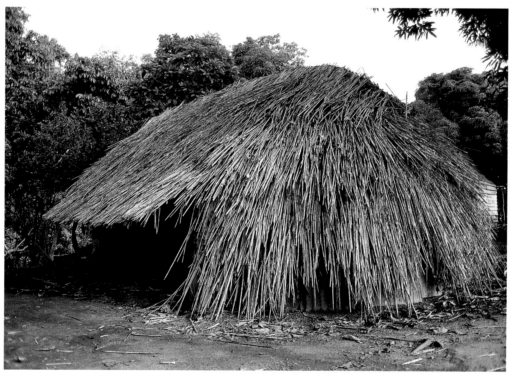

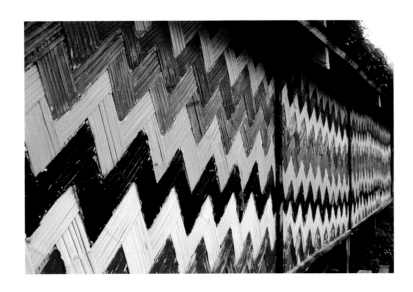

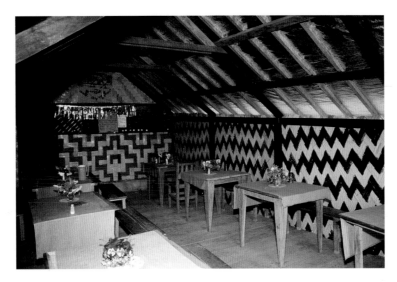

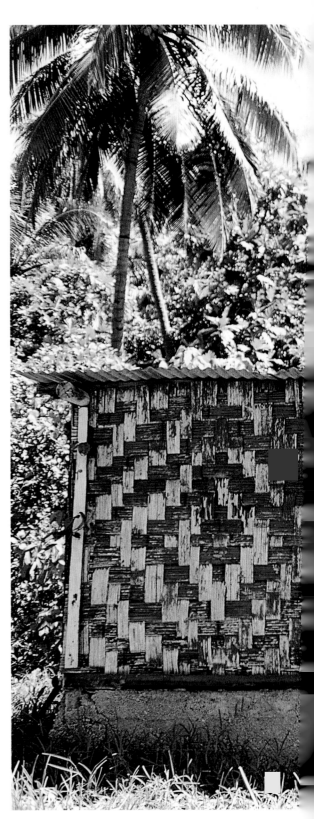

The walls of the restaurant at Lenakel on Tana Island and the storehouse on Malekula Island demonstrate the variety of patterns that can be achieved using painted split cane.

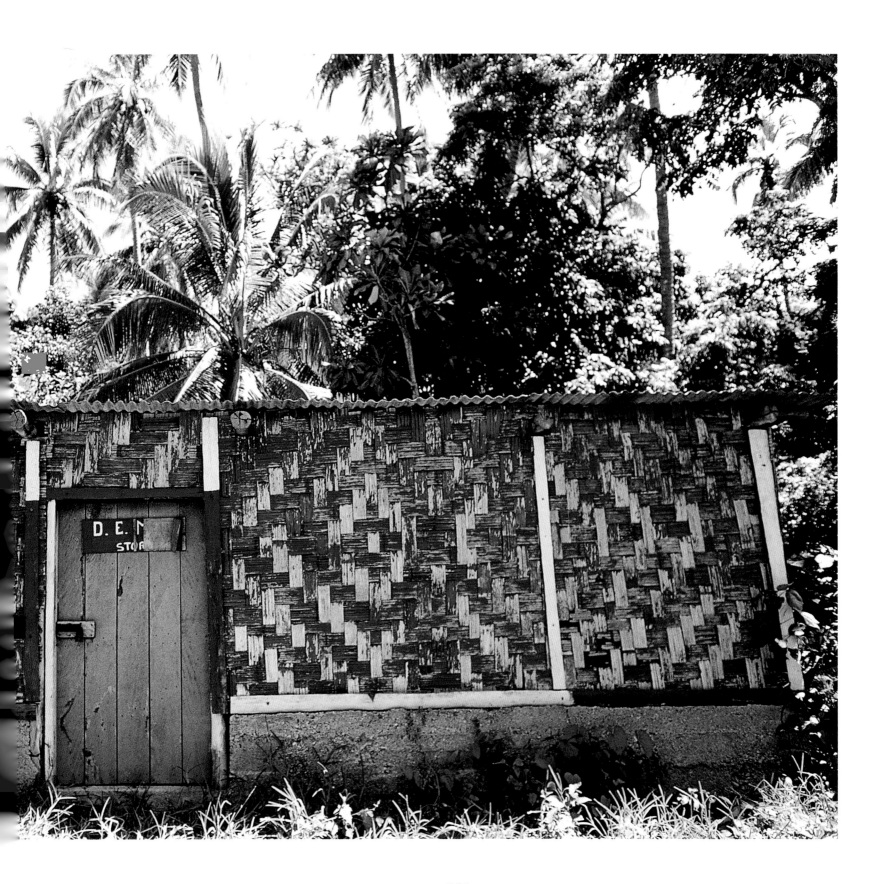

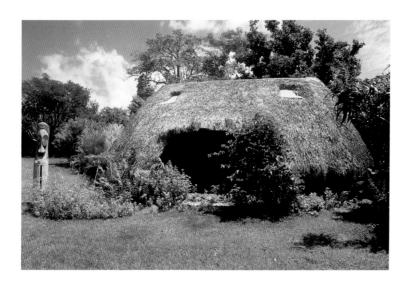

School teacher Suzanne Bastien's house near Port Vila is based on the style found on the Sheppard Islands. It uses traditional materials and has an oval-shaped pandanus roof which embraces its walls. Inside the *burdo* hardwood roof rafters are clearly visible.

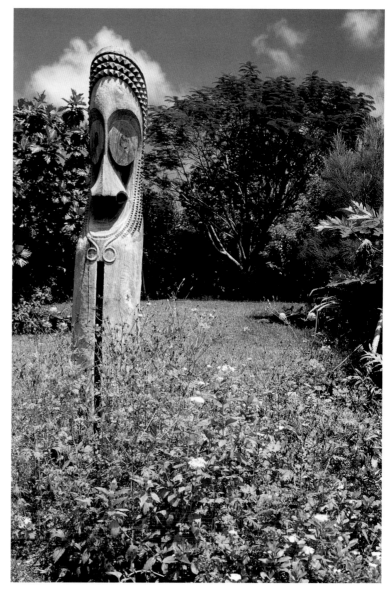

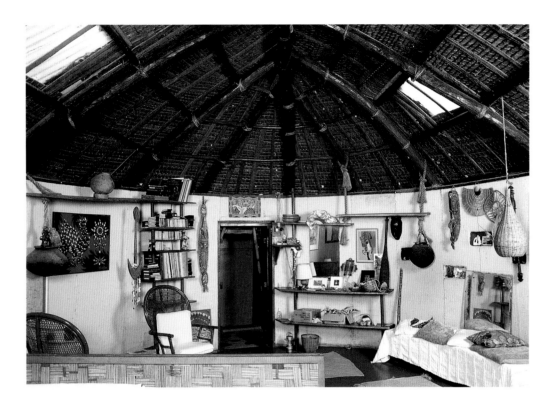

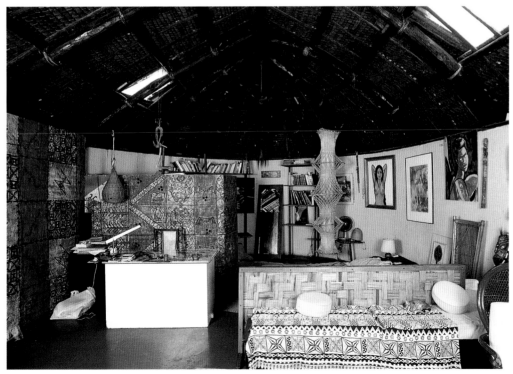

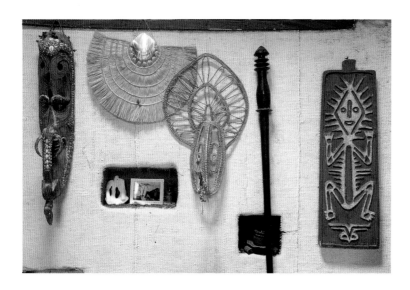

Various Pacific Island artefacts decorate the walls of Suzanne Bastien's house. The large wooden carved figure (opposite) attached to the woven pandanus roof is designed to ward off evil and is distinctive to the Big Nambus tribe from Amok on Malekula.

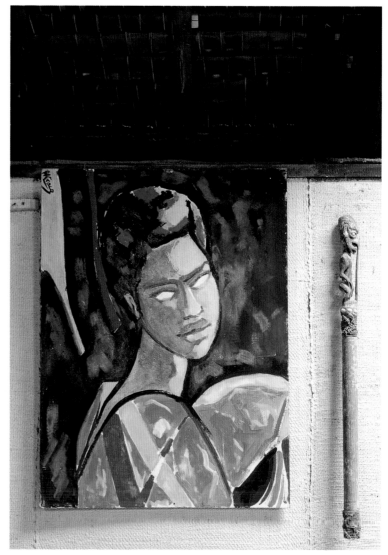

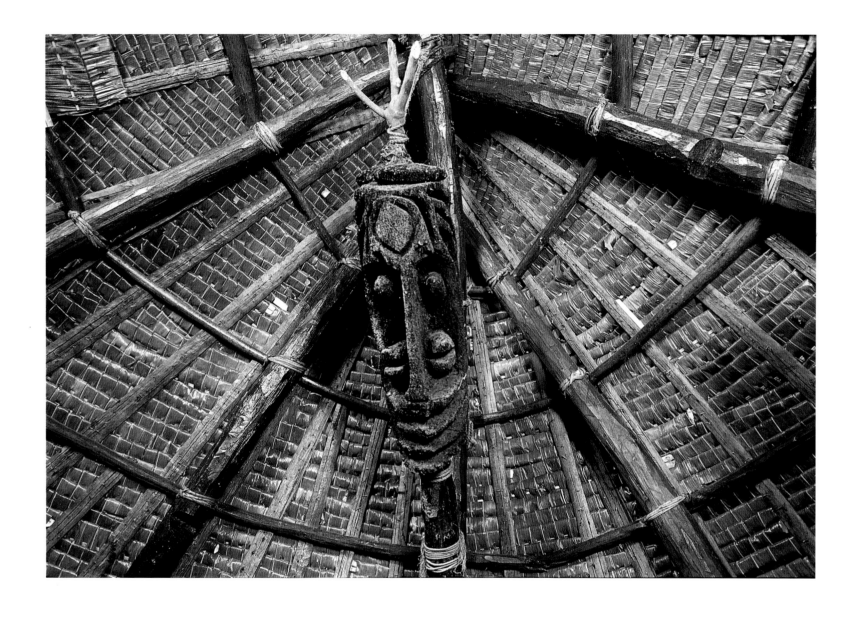

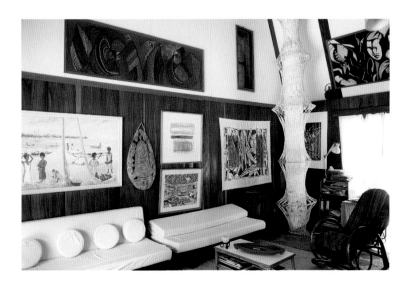

Inside this house, irregularly shaped split ponga logs (right and opposite), more commonly found as exterior cladding, have been used to create an interesting wall texture.

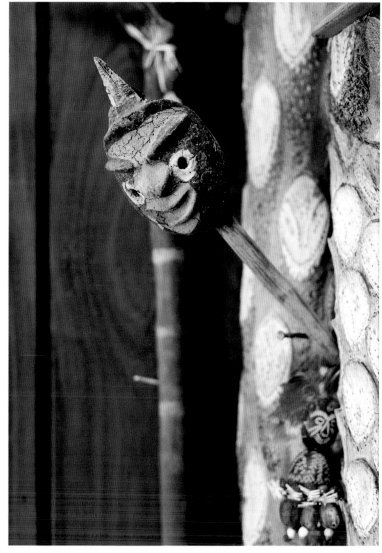

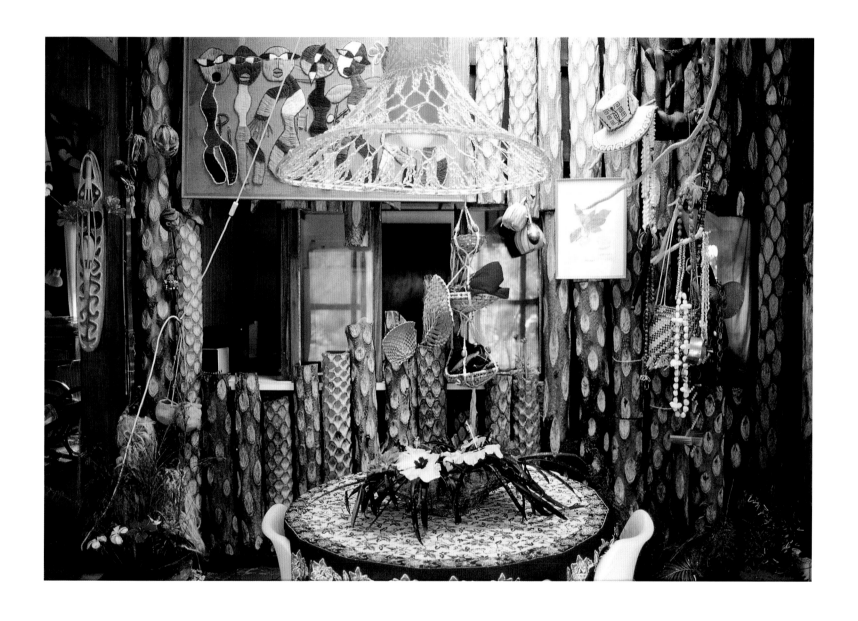

ACKNOWLEDGEMENTS

Chromozone Colour Lab Auckland, Kodak New Zealand Limited, Tourism Cook Islands, Tahiti Tourism, Fiji Visitors Bureau, Solomon Islands Visitors Bureau, Musée de la'Ville Noumea, Province Sud Southern Region New Caledonia, Dateline Hotel Tonga, Air Vanuatu, Air Rarotonga, Donna Hoyle, Peter Thompson, Jason Brown, Alec Ata, Barbara Myers, Faleso Leute and Tuliloa Ene.

INDEX

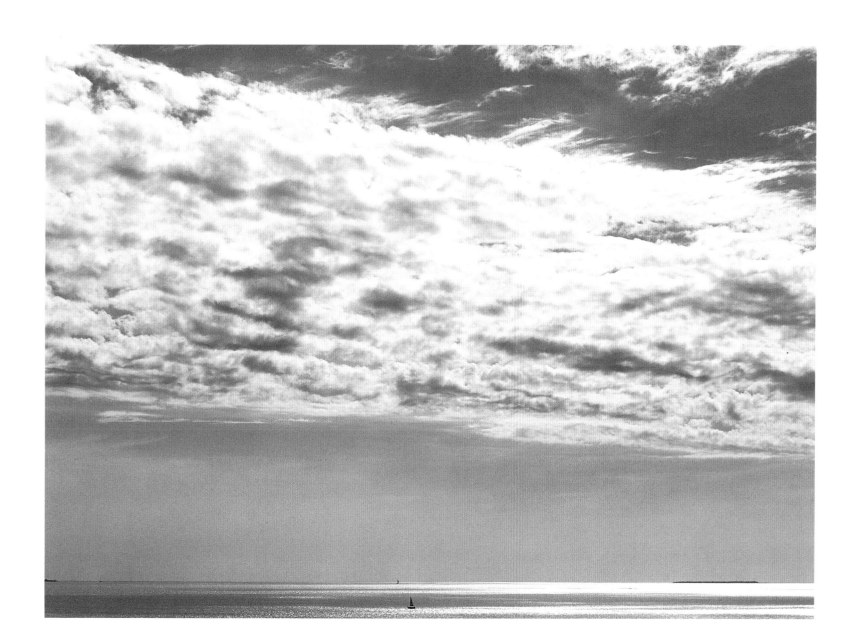